Kandinsky: Compositions

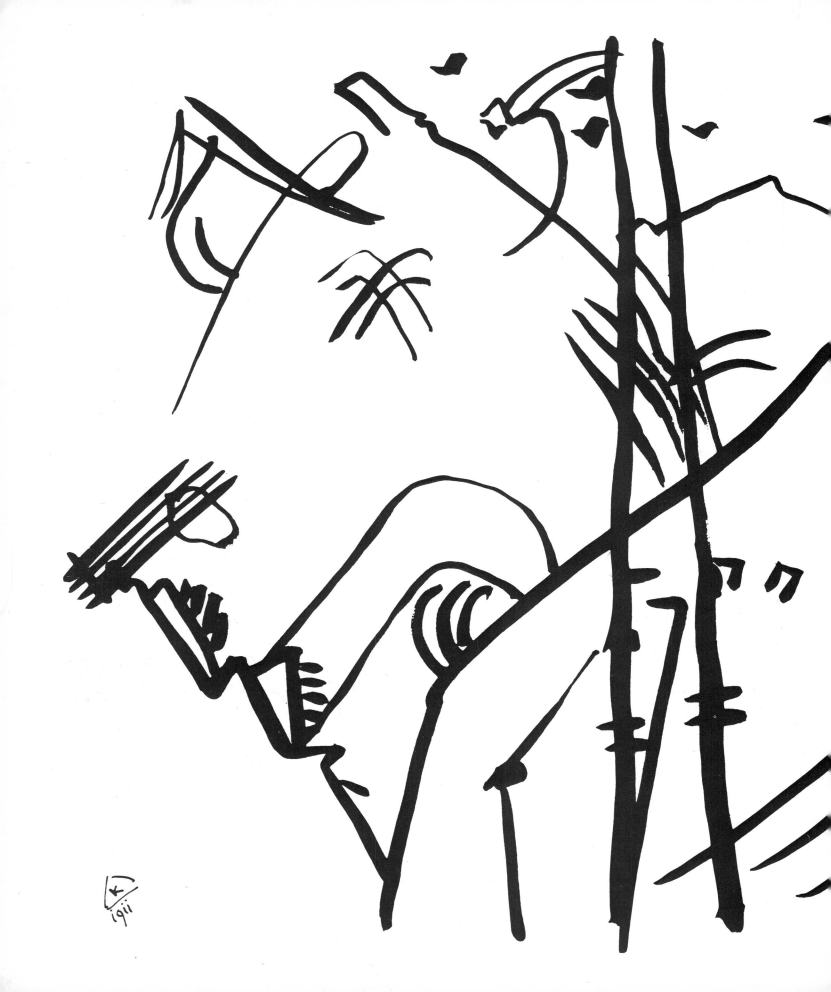

Magdalena Dabrowski

Kandinsky
Compositions

The Museum of Modern Art, New York

Published in conjunction with the exhibition
Kandinsky: Compositions, organized by Magdalena
Dabrowski, Senior Curator, Department of Drawings,
The Museum of Modern Art, New York

Schedule of the Exhibition
The Museum of Modern Art
January 25–April 25, 1995
Los Angeles County Museum of Art
June 1–September 3, 1995

The exhibition is supported by a generous grant from
ROBERT LEHMAN FOUNDATION, INC.

Additional support has been provided by Lufthansa
German Airlines and the National Endowment for
the Arts. An indemnity for the exhibition has been
granted by the Federal Council on the Arts and the
Humanities.

This publication is supported in part by
Mr. and Mrs. Perry R. Bass.

Produced by the Department of Publications
The Museum of Modern Art, New York
Osa Brown, Director of Publications
Edited by Mary Christian
Designed by Phillip Unetic
Production by Amanda W. Freymann, assisted by
Cynthia Ehrhardt
Composition by U.S. Lithograph, typographers,
New York
Printed and bound by Arnoldo Mondadori, Verona,
Italy

Library of Congress Catalog Card Number 94-79430
ISBN 0-87070-406-0
(The Museum of Modern Art, paperbound)
ISBN 0-87070-405-2
(The Museum of Modern Art, clothbound)
ISBN 0-8109-6142-3
(Harry N. Abrams, Inc., clothbound)

Published by The Museum of Modern Art,
11 West 53 Street, New York, New York 10019

Clothbound edition distributed in the United States
and Canada by Harry N. Abrams, Inc., New York,
A Times Mirror Company

Printed in Italy
Second printing

Cover:
Composition IV. 1911. Oil on canvas. 62⅞ x 98⅝" (159.5 x
250.5 cm). Kunstsammlung Nordrhein-Westfalen, Düsseldorf

Title page:
Drawing for *Composition IV*. 1911. Pencil and india ink on
paper. 9⅞ x 12" (24.9 x 30.5 cm). Musée National d'Art
Moderne, Centre Georges Pompidou, Paris; bequest of Nina
Kandinsky, 1981

Page 10:
Composition VI (detail). 1913. Oil on canvas. 6' 4¾" x 10'
(195 x 300 cm). The Hermitage Museum, Saint Petersburg

Contents

Foreword

This book is published on the occasion of the exhibition *Kandinsky: Compositions*, the first presentation to focus on the artist's most important group of works—the Composition paintings. Executed between 1910 and 1939, these ten monumental works, seven of which survive, represent the culmination of Kandinsky's pictorial achievement, attesting to the unique creative vision and innovative spirit of this seminal artist of the modern era.

The organization of this exhibition has been made possible by the cooperation of Mme Monique Barbier-Müller, Geneva; the Hermitage Museum, Saint Petersburg; Kunstsammlung Nordrhein-Westfalen, Düsseldorf; Musée National d'Art Moderne, Centre Georges Pompidou, Paris; the Solomon R. Guggenheim Museum, New York; and the Tretyakov Gallery, Moscow. Thanks to their generous interest and assistance, we were able to assemble all of the extant Compositions, which have never been shown together, and offer this unique opportunity to view them in their proper context, complemented by related studies.

For the participation of the Hermitage Museum I would like to express our special gratitude to Mikhail B. Piotrovski, Director, and Boris I. Asvarishch, Curator of European paintings. For essential loans from the Kunstsammlung Nordrhein-Westfalen, Düsseldorf, we are most grateful to its director, Dr. Armin Zweite. At the Musée National d'Art Moderne, Centre Georges Pompidou our warm thanks are due to M. Germain Viatte,

Director. For a crucial loan from the Tretyakov Gallery, Moscow, we owe our deep gratitude to Valentin A. Rodionov, General Director, Lydia I. Iovleva, Deputy Director, and Lydia I. Romashkova, Deputy Director. The gracious cooperation and involvement of these and other lenders, and the crucial support of Eugene Y. Sidorov, Minister of Tourism of the Russian Federation, have been essential to this exhibition and publication.

Generous support for the exhibition has been provided by grants from Robert Lehman Foundation, Inc., Lufthansa German Airlines, and the National Endowment for the Arts. An indemnity has been granted by the Federal Council on the Arts and the Humanities. This assistance and encouragement are very deeply appreciated.

Finally I want to express our admiration and gratitude for the work of Magdalena Dabrowski, who directed the exhibition and was also responsible for this accompanying publication. This ambitious project was her conception, and she pursued its realization with exemplary professionalism, tact, and determination. She deserves our very warm thanks.

Richard E. Oldenburg
Director
The Museum of Modern Art
New York

Preface and Acknowledgments

Vasily Kandinsky is closely identified with the beginning of abstract painting in the second decade of this century. During the almost fifty years of his artistic career he created hundreds of paintings, watercolors, drawings, and prints, but he assigned the title *Composition* to only ten of his works. These ten monumental paintings, executed between 1910 and 1939, convey the fundamental principles of art that Kandinsky expounded in his treatises *On the Spiritual in Art* (1911) and *Point and Line to Plane* (1926).

Kandinsky viewed the Compositions as the most important works of his entire oeuvre. In them he resolved his most ambitious philosophical, formal, and iconographical puzzles, meticulously reworking the complex pictorial concepts that were embodied in his emotionally evocative abstraction.

Although there is an extensive body of literature treating in depth various aspects of his art, there has been no full-length study of his Compositions. By presenting these extraordinary paintings together as a group for the first time, this exhibition and catalogue offer the viewer and reader the unique opportunity to trace the evolution of Kandinsky's ideas and pictorial imagery from the figurative toward an increasingly abstract language and from an expressionistic abstraction to a cooler, more geometric manner.

Only seven of the ten Compositions survive. These are shown in the context of selected preliminary studies in pencil, pen and ink, watercolor, and oil that provide insight into Kandinsky's unusually systematic creative process. As a whole, this distinctive body of interrelated works represents a synthesis of Kandinsky's philosophical and spiritual concerns while illustrating the transposition of these ideas into his unique pictorial vision.

This volume traces the genesis of each of the ten Compositions, examining how the studies reveal the development of the iconography and abstract principles of the final works and how they help to decipher their multivalent meanings. Benefiting from and summarizing the interpretations of other scholars, this study situates these pivotal paintings in the broad context of Kandinsky's art and thought.

Every exhibition is a result of the collaboration of many individuals and institutions. This project could not have come to fruition without the generosity and good will of the lenders, public and private, to whom we owe the greatest debt of gratitude.

Several museums have made exceptional concessions in lending their crucial works to the exhibition. We are especially indebted to the Kunstsammlung Nordrhein-Westfalen, Düsseldorf, and Director Dr. Armin Zweite, for his willingness to support this project with important loans. Special thanks are owed to the Musée National

d'Art Moderne, Centre Georges Pompidou, Paris and Germain Viatte, Director, for his generous response to our many loan requests. We are grateful as well to the Hermitage Museum, Saint Petersburg; Dr. Mikhail B. Piotrovski, Director, and his colleagues, Boris I. Asvarishch and Albert Kostenevich, should be thanked for their enthusiasm for this project. Numerous other museums assisted with particular professional courtesy: the Albright-Knox Art Gallery, Buffalo, New York; Kunstmuseum Bern; Milwaukee Art Museum; Solomon R. Guggenheim Museum, New York; The Tate Gallery, London; and the Tretyakov Gallery, Moscow. Special thanks are owed to Eugene Y. Sidorov, Minister of Culture and Tourism of the Russian Federation, for his crucial assistance in the successful realization of this exhibition. Among the staff members of the Tretyakov Gallery we extend our special expressions of gratitude to Valentin A. Rodionov, General Director; Lydia I. Iovleva and Lydia I. Romashkova, Deputy Directors; Aleksei P. Kovalev, Chief Conservator; Natalia B. Avtonomova, Chief Curator of Twentieth-Century Art; and Tatyana Gubanova of the Foreign Department. Their collective efforts to lend one of the most crucial paintings in spite of their own pressing commitments deserves our deepest thanks. Among the private lenders, we are particularly indebted to Mme Monique Barbier-Müller for her extraordinary generosity as well as to Werner and Gabrielle Merzbacher and Deutsche Bank AG, Frankfurt, for graciously making available works that were critical to the success of the exhibition. We also thank Stephanie Barron and the Los Angeles County Museum of Art for their cooperation and enthusiasm in arranging a second showing for the exhibition.

Thanks are also due Marie-Laure Bernadac and Jessica Boissel at the Musée National d'Art Moderne, Centre Georges Pompidou, Paris; Brigid Pudney-Schmidt at the Kunstsammlung Nordrhein-Westfalen, Düsseldorf; Imogen Winter at The Tate Gallery, London; and Lisa Dennison at the Solomon R. Guggenheim Museum, New York, for their kind assistance. We also thank the staff of the Städtische Galerie im Lenbachhaus, Munich for providing us promptly with the numerous photographs of the works in their collection. Our collaboration with them was an enriching educational experience.

Many people have assisted in the difficult task of securing important loans. We are immensely indebted to Jeanne Thayer, H.R.H. Prinz Franz von Bayern, William Bernhard, and Princess Laetitia Boncompagni, members of The International Council of The Museum of Modern Art, who from the beginning of this project shared our enthusiasm and assisted graciously with obtaining some critical loans. We particularly thank Christian Strenger of Deutsche Bank for his unsparing efforts on our behalf. We also wish to extend special thanks to Nicolas Iljine, General Manager, Public Affairs, Lufthansa German Airlines for his tireless efforts to help with vital aspects of the exhibition.

This undertaking has benefited from the expertise of several renowned Kandinsky scholars. We are indebted to Vivian Endicott Barnett, who patiently answered numerous queries concerning different aspects of Kandinsky's oeuvre and scholarship and generously gave of her time to discuss important issues of dating and chronology. I am particularly indebted to her for reading the manuscript of this catalogue and making various helpful suggestions. My thanks are also owed to Rose-Carol Washton Long, who willingly shared with me her knowledge of Kandinsky's work. I am especially grateful to Peg Weiss, who not only discussed with me important aspects of Kandinsky's evolution, but who most kindly allowed me to read the manuscript of her forthcoming book on the artist; her generosity and assistance with many other scholarly questions is greatly appreciated. Special thanks are due David J. Nash, who shared his time and expertise in connection with our application for U.S. Government Indemnification. Also in this respect, we have relied upon the help of Ingrid Hutton, which proved invaluable.

We warmly thank Leonard Giannada of the Pierre Giannada Foundation in Martigny, Switzerland, for his assistance with the international loan negotiations and his enthusiasm for our project. An immense debt of gratitude is owed to Philip Isles whose conviction as to the uniqueness and importance of this project was instrumental in obtaining funding for the exhibition.

At The Museum of Modern Art many people contributed to the successful completion of both the exhibition and the catalogue. I am infinitely grateful to Richard E. Oldenburg, Director of the Museum, for his enthusiastic support of this undertaking. My very special thanks go to James S. Snyder, Deputy Director for Planning and Program Support, who with great skill, perseverance, and enthusiasm handled the most difficult aspects of loan negotiations and fundraising issues. I am immensely indebted to him for his unfailing patience

and dedication to this project. His assistant, Mary Anisi, should be thanked for all of her help provided to this project.

A particular debt is owed to John Elderfield, Chief Curator-at-Large, who despite his heavy schedule was willing to read my manuscript and provided many helpful suggestions. His advice and assistance with various issues related to the exhibition and the publication have been invaluable. I would also like to thank Kirk Varnedoe, Chief Curator in the Department of Painting and Sculpture, for his generous support of this exhibition from its inception. In the Department of Drawings my greatest debt of gratitude is to Mary Chan, Curatorial Assistant, who with inexpressible dedication, patience, and professionalism attended to the most complex details of the exhibition and the catalogue. Her impeccable organization, intelligence, great sense of responsibility, and excellent research ability, evident in the preparation of the biography, exhibition history, and bibliography, were crucial to the successful completion of this undertaking. I am immensely grateful to her. Other members of the department, Alexandra Ames, Kathleen Curry, and Anne Ormonde provided invaluable help with many aspects of the exhibition and the manuscript, and I owe to them my warmest thanks.

In the Department of Publications I would like to thank Osa Brown, Director, and especially Harriet Schoenholz Bee, Managing Editor, for her understanding, counsel, and support in the difficult task of completing this publication under unusual pressures. Amanda Freymann, Production Manager, is owed my special thanks for her good humor and professionalism in overseeing all phases of the production of this book; she has been ably assisted throughout by Cynthia Ehrhardt, who also merits my sincere thanks. I am grateful to Michael Hentges, former Director of Graphics and to Jody Hanson, its present director, for their valuable input. My deep appreciation goes to Phillip Unetic who, with great skill and sensitivity, designed this book and calmly handled the complications that arose from pressing deadlines. I am especially grateful to my editor, Mary Christian, who, working under an impossibly tight schedule, patiently, and with consummate skill, contributed innumerable insightful suggestions and improvements to the manuscript, all of which have made this book more complete. Her exemplary professionalism deserves my heartfelt thanks.

This project received essential help from the staff of the Museum's library. Eumie Imm, Associate Librarian, arranged the many interlibrary loans with great efficiency. Rona Roob, Museum Archivist, was particularly helpful with our research efforts and I am very grateful to her. Very special thanks must go to Richard Palmer, Coordinator of Exhibitions, and Eleni Cocordas, Associate Coordinator, Exhibition Program, for their expert handling of the complicated logistics of organizing the exhibition and indemnity. They were efficiently assisted in their efforts by Rosette Bakish. In the Registrar's Office, I would like to express my gratitude to Diane Farynyk, Registrar. It was a pleasure to work once again with Ramona Bannayan, Associate Registrar, who expertly coordinated all aspects of the shipping and reception of the works of art with her usual proficiency and skill. Many other colleagues should be thanked for their help in making this exhibition and publication a reality. Mikki Carpenter, Director of Photographic Services and Permissions; Riva Castleman, Director of Prints and Illustrated Books; Kate Keller, Chief Fine Arts Photographer; Antoinette King, Director of the Conservation Department and her staff; Nancy Kranz, Manager, Promotion and Special Services, Publications; Pete Omlor and his staff in the Registrar's Office; Romy Phillips, Public Programs Coordinator, Education; Cora Rosevear, Associate Curator, Painting and Sculpture; Jessica Schwartz, Director, and Beth Horn in Public Information; John Wielk, Manager, Exhibition and Project Funding, Development; Beverly Wolff, Secretary and General Counsel; and Jerome Neuner, Director of Exhibition Production and Design, and members of his staff, whose help in devising the exhibition installation was inestimable.

Many friends have helped with their advice and support, among them Barbara Mathes, Lisa Messinger, Sabine Rewald, and Gunnard Theel should be especially thanked. To others who remain anonymous I also owe my deep gratitude.

M.D.

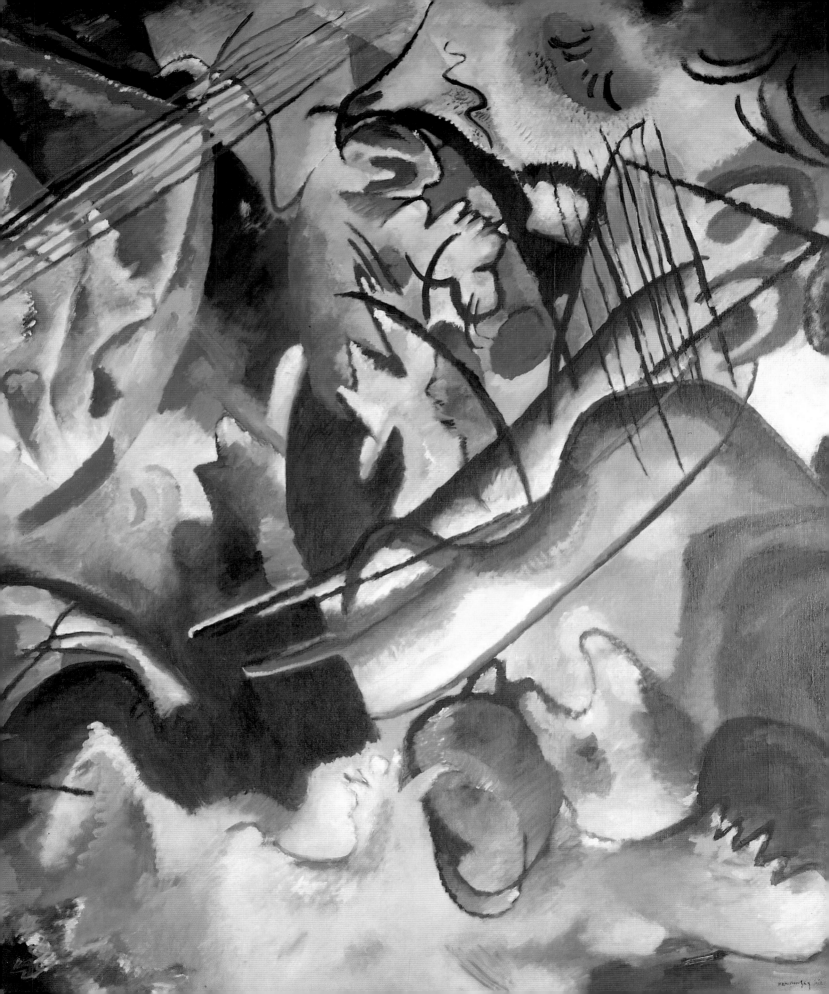

Compositions

The Creation of
a New Spiritual Realm

*P*ainting is like a thundering collision of different *worlds that are destined in and through conflict to create that new world called the work. Technically, every work of art comes into being in the same way as the cosmos—by means of catastrophes, which ultimately create out of the cacophony of the various instruments that symphony we call the music of the spheres. The creation of the work of art is the creation of the world.[1]*

The very word composition *called forth in me an inner vibration. Subsequently, I made it my aim in life to paint a "composition."[2]*

Vasily Kandinsky, 1913

These two quotations summarize the essence of Kandinsky's artistic goals and his fundamental reason for creating the Compositions. In the conclusion to his seminal pre–World War I treatise, *On the Spiritual in Art*, published in Munich in December 1911, Vasily Kandinsky defined the works that he considered to be examples of the "new symphonic construction" in painting.[3] He divided them into three categories: Impressions were the pictures stimulated by "direct impressions of ex-

ternal nature," expressed in "linear-painterly form." Works that were intended to convey "impressions of internal nature" and that represented "chiefly unconscious, for the most part, suddenly arising expressions of events of an inner character" were called Improvisations. He then described the most ambitious of these categories, Compositions, as "the expressions of feelings that have been forming within me in a similar way (but over a very long period of time), which, after the first preliminary sketches, I have slowly and almost pedantically examined and worked out. This kind of picture I call a 'Composition.' Here, reason, the conscious, the deliberate, and the purposeful play a preponderant role. Except that I always decide in favor of feeling rather than calculation."[4]

Kandinsky's guiding principle in the creation of a Composition is the "expression of feelings"—or as he puts it elsewhere, the "inner necessity"—that is, the artist's emotional response to events of an internal nature. That feeling is a result of a combination of experiences: on one hand, those perceptions that arise from the artist's inner world, on the other, the impressions the artist receives from external appearances, events, or concepts. These impressions find emotional resonance as they enter the artist's inner world, and through "reason, the conscious, the deliberate, and the

purposeful" they solidify to find concrete expression in art through the external pictorial form.[5] As a result, the work of art becomes "the inseparable, indispensable, unavoidable combination of the internal and the external element, i.e., of content and form."[6]

The concept of art as a synthesis of these inner and outer elements permeates Kandinsky's prolific writings and art and is central to his definition of "Composition." He understands the internal element to be the emotion—or "vibration"—of the soul that corresponds to the "external elements," or an appropriate visual form.[7] He intends his pictorial rendering of this spiritual feeling to strike the same emotional chord in the spectator through the expressive qualities of the work.

These works—simply titled *Compositions I through X*—were painted at different stages of Kandinsky's artistic development. The first seven were created during his pre–World War I Munich period: he worked on the first five between 1909 and 1911, and *Compositions VI and VII* were created in 1913. He painted the remaining three in the later periods: *Composition VIII* in 1923, that is, in the early Bauhaus years, and *Compositions IX and X* in 1936 and 1939, during his years in Paris, only several years before his death there in 1944. At any given time over the course of his career, his most complex and ambitious work of art was his most recent Composition.

The designation "Composition" carried for Kandinsky a very special significance—as he himself once stated, an almost religious one. Several characteristics distinguish the Compositions: their almost mural-like scale, their deliberate, premeditated process of creation, and an overt transference of value from subject matter to pure painting.

As Kandinsky explained many times regarding the Compositions, pure painting is the result of the combination of color tones and linear elements of form determined by the internal necessity of the artist when creating a work. It is the kind of painting that discards the superfluous, mimetic form, and in which the essentials are examined in every detail. In pure painting, the pictorial means, devoid of specific references to objects of visible reality, become the prime vehicles of expression and create a universal content. As such, pure painting is the expression of the soul of the artist. The emotional response of the viewer is conditioned by the pictorial

means rather than by the objects depicted. Pure painting contains an inherent potential for non-objective art and for expressing an abstract content. In the Compositions these principles take on a more complex aspect than in Kandinsky's other works.

Their complexity is expressed through their eloquent and highly developed spatial, formal, and coloristic relationships and the underlying iconography. Multiple levels of meaning are conveyed through rich layers of seemingly disjointed imagery within skewed spaces. These result in a dream-like quality and more potential levels of interpretation than are found in his other works. In the first seven Compositions, this is augmented by the use of veiled imagery and a tenuous link to natural objects that are dissolved within forms and colors, imparting a sense that the work is a self-referential abstraction.

The descriptive, generic title "Composition" in itself supports more than one reading. First and foremost, it defines the final, fully executed painting resulting from long and profound considerations of all its formal elements and sections, relationships, and interplay that led to a harmony of expression. In addition, as Kandinsky's writings demonstrate, the term described the actual process of constructing the work with all of its intricacies, philosophical meanings, and references, as well as its formal complexities. Kandinsky discusses this aspect in his essay "Painting as Pure Art" (1913),[8] in which he writes of the necessity to supplant the subject matter of a painting with "another equally essential component" that is "a purely artistic form of such strength that it will be able to endow that work with an independent life and make it become a spiritual subject." Such a substitution, he felt, could only be arrived at through "construction," which is characteristic of "compositional painting."[9]

Formation of the Artist

When Kandinsky began to create the first Compositions toward the end of 1909, he was in his early forties. He had been painting for over a decade, but his personal style had only begun to evolve about a year earlier.

Born in Moscow in 1866 into an enlightened family of a well-to-do merchant, Kandinsky initially studied law, economics, and ethnography at the law school of the University of Moscow, where he later held an academic position. As a member of the upper tier of society he possessed a broad cultural background; a good classical

education; and familiarity with current philosophical, literary, musical, social, and artistic ideas. He was well traveled, and two trips to France in 1889 and 1892, for instance, acquainted him with the current artistic movements, such as Neo-Impressionism and various Symbolist modes of painting. Only at the age of thirty did he decide to abandon a successfully begun academic career in order to devote himself entirely to painting.

In his decision to become an artist, Kandinsky was prompted by two aesthetic and emotional experiences that would fundamentally affect his future. The first was viewing an exhibition of French Impressionists in Moscow in 1896, where his attention was attracted to a Monet Haystack painting. It was while looking at the Monet that he realized how a picture can hold the viewer's attention even if the subject cannot be immediately identified, for it was the combinations of color and form that elicited in him the first emotional response. The recognition of the subject was secondary and essentially inconsequential to his appreciation of the work. The evocative power of color and form enraptured Kandinsky and caused him to understand the superiority of the emotional over the perceptual in art. This observation became particularly relevant to the course his painting took later in its evolution toward eliminating the object and creating an abstract language.

The second critical event for Kandinsky's career change was seeing the performance of Richard Wagner's *Lohengrin* at the court (Bolschoi) theater in Moscow in 1896, when he had the realization that music can evoke pictorial images, their colors, and mood. This experience that united painting and music, combined with Wagner's notion of *Leitmotif*, became exceptionally relevant to the creative process of the Compositions.

Kandinsky pursued his studies in Munich, which then was the mecca of art for Russian artists and an important center of cultural life in Europe. Several of his compatriots also had gone there to study. Except for extended periods of travel, he remained there until the outbreak of World War I in August 1914. It was in Munich—or specifically, nearby Murnau—where his individual style developed, matured, and culminated in a non-objective, evocative, abstract language.

This evolutionary process was stimulated by many sources: Munich Jugendstil; the philosophy of Symbolism in its different versions (French, German, and Russian); his interests in theosophy, occultism, and mysticism; his special sensitivity to music and visual stimuli; and above all, his Russian background. All these elements converged in his search to create art that would express the spiritual.

When Kandinsky arrived in Munich in 1896, Jugendstil, the German version of Art Nouveau (or the Modern Style, as it was called in Russia), flourished as the prevailing artistic expression, and Symbolism was the dominant philosophy.[10] Kandinsky settled in Schwabing, the bohemian quarter of the town, and quickly became an active participant in Munich's cultural life. Many of his compatriots, for instance Vladimir von Bechtejeff, Mstislav Dobuzhinsky, Igor Grabar, Dmitrii Kardovsky, Alexei Jawlensky, and Marianne von Werefkin, also lived and worked there. Kandinsky first began to study art at the private school of a Slovenian painter, Anton Ažbè, where he remained for two years (1897–98) before eventually continuing his studies at the Munich Academy of Art under Franz von Stuck, who was considered a master draftsman in Germany and a leading proponent of Jugendstil.

Kandinsky's work and his artistic outlook benefited from principles he acquired from his teachers during this period. From Ažbè he learned the importance of attention to essentials at the expense of detail; Stuck taught him clear composition, the search for the essence of things, a deep sense of form in itself, and different ways of applying color to achieve dramatic effects. These concepts were amplified by the formal influence of Jugendstil and the philosophies of the surrounding Symbolist milieu that began to affect Kandinsky's creative principles and style. The works of that period included many figure drawings and small landscape paintings, often from nature, that were characterized by bright, sonorous color and thick, expressive brushstroke. In keeping with the Jugendstil's arts-and-crafts spirit, Kandinsky also executed many woodcuts and designs for decorative arts, such as ceramics or jewelry.

He was very active in the artistic community. In 1901 Kandinsky cofounded an exhibition society, Phalanx, and created the Phalanx Art School. He began exhibiting and also taught drawing and painting at the Phalanx school. There, in 1902 he met Gabriele Münter, a student in one of his painting classes, who became his companion until 1916.[11]

Jugendstil and the Symbolist milieu—which included such figures as the bohemian leader Karl Wolfskehl, the poet Stefan George, and the artists August Endell, Hermann Obrist, and Adolf Hölzel, to name

only a few—attracted Kandinsky for several reasons. Jugendstil postulated the concept of a total aesthetic in the synthesis of all the fine and applied arts (painting, sculpture, architecture, decorative arts, poetry, music, and theater), a notion that originated in the Symbolist movements in France and Russia during the 1880s and the 1890s and greatly appealed to Kandinsky's sensibility. From the purely stylistic point of view, Jugendstil, with its emphasis on flat stylized pattern, rhythmic quality of line, and its appreciation of line as an expressive element in itself, provided the basis for a stylistic move away from naturalism and the representational aspect of painting. It contained an inherent element of abstraction. Additionally, and importantly for Kandinsky, Symbolism propagated the idea of the artist as prophet, seer, and crusader for change in society and culture—missions with which Kandinsky deeply identified. These concepts exercised an important influence on his early artistic formation and are essential to understanding his works of the later Munich period, especially his Compositions.

Kandinsky's affinity for German culture and German philosophical thought was partly due to his background. His maternal grandmother was a Balt and therefore spoke German; according to the artist's own account, he also spoke German as a child and developed, due to his grandmother, a love for German fairy tales,[12] which he would later incorporate in the subject matter of his pictures. But there were also French influences that were crucial to the development of Kandinsky's artistic language. In 1906–07 he spent a year in Sèvres, near Paris. His initial reasons for the trip were to better acquaint himself with Neo-Impressionism, the art of the Nabis, and French Symbolism; the stay provided first-hand contact with these artists and movements as well as with emerging Fauvism.

The theories of French Symbolism, with its emphasis on synaesthesia, or the correspondences among diverse arts, had a lasting influence on Kandinsky. He was also attracted to the predilection of Symbolist artists to express the mysterious and intangible, to suggest rather than to describe, and to appeal to feeling. And so, for instance, among the western Symbolists, he admired particularly the Belgian writer Maurice Maeterlinck, whom he praised highly for the new ambience and the means of expression that emphasized "feeling" as the element of primary importance in art.[13]

The year 1906 in Paris also saw a number of important exhibitions of early modernism, including the Salon des Indépendants, where the Fauves exhibited their brightly colored works and Matisse his Le Bonheur de vivre; and the Salon d'Automne, which included a retrospective of Gauguin's work and a section on Russian art. It was Fauvism particularly that liberated Kandinsky's color sensibility and reconfirmed his innate tendency toward expression through color.[14]

In addition to the German and French inflections, Kandinsky's works until late 1908 were influenced greatly, both in subject matter and style, by his Russian background. Kandinsky's Russianness had a vital impact on his art, his art theory, and his creative process. These influences operate on several complex levels, both formal and spiritual, throughout his career. In his early works of around 1901 to 1909, they are mainly evident in a rather literal way—as Russian motifs, such as a walled city with onion-domed cathedrals, romantic knights and riders, fairy-tale subjects of riding couples, and promenading maidens in Russian dress. In their flat patterning and compositional arrangement, evident in his Arrival of the Merchants (fig. 1), his works recall the style of the Russian artists belonging to the Mir Iskusstva (World of Art) group,[15] whose stylizations were close to those of Jugendstil. Other examples of this Russian connection are his so-called colored drawings, or tempera paintings on dark paper of 1901–08. For instance, in Motley Life (fig. 2) of 1907, a mosaic-like arrangement of rectangular blocks of color and flat patterning of forms against a dark background convey a dream-like, fairy tale mood and explore the figure-ground relationship in a way he would return to in his modernist works.

After about 1910 there is a shift in Kandinsky's art away from the literal use of Russian motifs toward a more allusive, spiritual element that is reminiscent of Russian Symbolism. This plays a significant role in his progress toward abstraction and his creation of Compositions. Clearly, although these artistic advances in his work might be explained within the context of German thought and French Symbolist philosophy, a characteristically Russian tenor of Symbolism heightened by mystical overtones is intrinsic in his work. As Will Grohmann aptly points out in his early monograph on the artist: "Possibly Kandinsky would have become a pro-Westerner in Moscow; in Munich he remained a Russian."[16] While living in Germany he maintained a close contact with his native country and its cultural life in Moscow, Odessa, and Saint Petersburg. He fre-

quently visited his family in Moscow and Odessa, contributed to the Russian artistic journals *Mir Iskusstva* and *Apollon*,[17] and participated in Russian exhibitions. Kandinsky also invited Russian artists—David Burliuk, Natalia Goncharova, and Mikhail Larionov, among others—to participate in exhibitions he organized in Munich.[18] In fact, Kandinsky's artistic outlook, expressed in *On the Spiritual in Art*, attests to the fact that he remained spiritually akin to the second generation of Russian Symbolists such as Viacheslav Ivanov, Alexander Blok, and Andrei Bely, and even to their predecessors, the first generation—Konstantin Balmont, Valerii Briussov, and Dmitrii Merezhkovski.

The philosophies of these precursors of the Russian avant-garde aimed at the renewal of life and art, emphasizing the spiritual and challenging the prevailing attitudes of the two preceding decades. They turned against, as Briussov indicated in 1909, "the materialism of science, the positivism of philosophy and the naturalism in the arts."[19] Kandinsky shared that attitude with conviction and felt that representation in painting was irrevocably related to the superficiality of nineteenth-century materialism, which precluded the "soul" and the spiritual dimension of art. Expressing that spiritual dimension became Kandinsky's primary goal as an artist and culminated in his Compositions, most consummately in the creation of his great *Composition VII* in 1913.

Ever since 1901, Kandinsky had searched for ways to eliminate traditional representation in art. The catalysts for this change were Russian motifs from old fairy tales and medieval chivalric legends, and subjects from folk art, such as *loubki*, or primitive folk prints (fig. 3). Kandinsky's interest in folk art related in part to a more general revivalism of the genre in Russia, which was enhanced in Germany by his contact with the arts-and-crafts attitude of Jugendstil and by the discovery of Bavarian folk art techniques such as painting on glass.[20] Folk art provided a new source of motifs, an abstract treatment of space, a coloristic quality, and the directness of meaning that affected him on formal and spiritual levels. To him the formal simplicity of folk art reflected the pure soul of the people. That he was interested in and collected *loubki* is evidenced by a photograph taken by Münter in 1913, where on the wall above his desk we can recognize a *loubok* representing an angel.[21]

Other forms of folk art were of even greater importance. In his autobiographical essay "Reminiscences" (1913), Kandinsky described when and how his love of

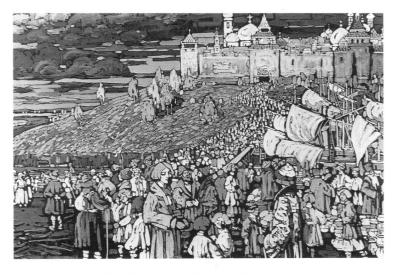

1. Kandinsky, *Arrival of the Merchants*, 1905, tempera(?) and gouache on canvas, 36³⁄₈ x 53¹⁄₈" (92.5 x 135 cm), private collection, Germany.

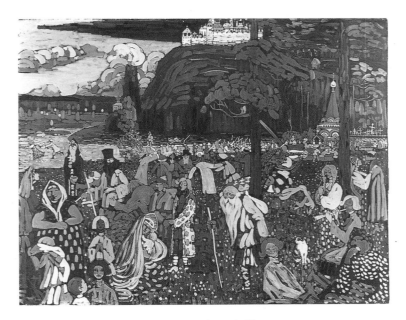

2. Kandinsky, *Motley Life*, 1907, tempera and gouache(?) on canvas, 51¹⁄₈ x 64" (130 x 162.5 cm), Städtische Galerie im Lenbachhaus, extended loan of Bayerische Landesbank.

folk art originated. In 1889, as a student of law, economics, and ethnography at the University of Moscow, he became interested in Russian peasant law and was commissioned by the Russian Imperial Society of Friends of Natural History, Anthropology, and Ethnography to undertake an expedition to the remote province of Vologda. For some two months, between May 28 and July 30, 1889, Kandinsky studied the customs, laws,

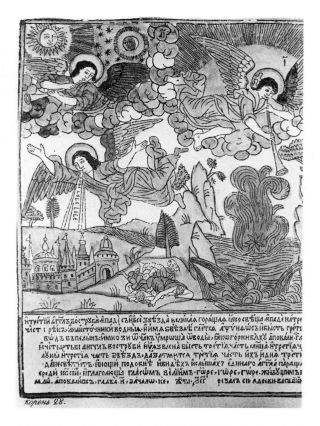

3. Vasilii Koren, *Scene from Rev. VIII: 10–13*, 1696, colored woodcut.

In a sense, the Compositions are constructed like the images Kandinsky perceived in folk art that had influenced him over a decade before: a profusion of forms, often self-contained, with power to envelop the viewer, to let him enter the picture and be submerged in its complexities, whether pictorial or iconographic. When viewing the pre–1914 Compositions there is a distinct sense of the spectator being placed within the picture, surrounded by the multitude of forms that create an all-encompassing environment, affecting the spectator both emotionally and visually. The viewer perceives the picture from the inside: he becomes the protagonist of the picture and imposes his mental imagery on it.[24] But it is the artist who conditions the spectator's repertoire of responses by opening up the possibilities through pictorial attributes of the picture, through its inner life. In his Compositions Kandinsky invites these possible readings through the veiling of representational imagery.

What captivated Kandinsky in the wooden houses, besides the simplification of forms, was the great profusion of them, and the colors, "so strongly painted that the object within them became dissolved."[25] This impression probably intensified his special color sensibility, which became more pronounced around 1902 and took on a particular strength and brilliance around 1908 and 1909. This experience also inspired in him the idea that color and the profusion of forms can obliterate an image and can possess their own affective powers, independent of the object. Although he uses this device extensively in the Compositions, particularly in *Compositions IV* through *VII*, Kandinsky is conscious of the fact that the spectator is not yet ready to accept art entirely devoid of subject matter, therefore the object must be retained to guide the spectator to the intended response. As an artist he is not yet ready to create works without objects. But this predicament was solved for him through the lesson learned from his experience of folk art in Vologda. There he acquired the preference for the use of a hidden image; we find the culmination of that device in *Composition VII*. The powerful impression of the peasant room taught him the experience of living within a painting, of being so surrounded by images that their specific identities become dissolved and are perceived as though they are particles in a kaleidoscopic image. This kind of pictorial construction affects the spatial structure of the works, thus allowing the artist to create complex heterogenous spaces and avoid the ornamental.

and religious beliefs of the local people. He subsequently published an essay on the pagan religions of the Zyrians, a Finno-Ugric tribe of northeastern Siberia.[22] During this trip he discovered folk art "in its original form" and those first impressions, according to him, would become important to his later development. As he described in the "Reminiscences":

I shall never forget the great wooden houses covered with carvings. . . . They taught me to move within the picture, to live in the picture. I still remember how I entered the living room for the first time and stood rooted to the spot before this unexpected scene. . . . Every object [was] covered with brightly colored, elaborate ornaments. Folk pictures on the walls: a symbolic representation of a hero, a battle, a painted folk song. The "red" corner (red is the same as beautiful in old Russian) thickly, completely covered with painted and printed pictures of the saints I felt surrounded on all sides by painting, into which I have thus penetrated.[23]

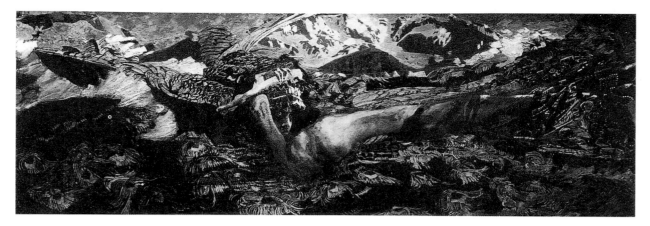

4. Mikhail Vrubel, *The Demon Downcast*, 1902, oil on canvas, 54¾ x 12' 8⅜" (139 x 387 cm), Tretyakov Gallery, Moscow.

Kandinsky's attraction to the native folk art of the Zyrian people from the remote Vologda region and its profound special motifs, often both religious and shamanistic, offered him a vocabulary with which to identify himself as a shaman, an intercessor between the earthly and the spiritual.[26] His sense of the mysterious was aroused by the coexistence of two essentially opposed pagan and Christian traditions whose symbols were often interchangeable. Such dualisms of imagery are central to interpreting the Compositions, in which the veiled imagery has undercurrents of Christian as well as pagan meaning.

Kandinsky's Compositions of 1911 through 1913 (that is, *Compositions V* through *VII*), which are based on apocalyptic themes, seem particularly indebted in a spiritual sense to Russian sources. One of these influences might have been the Symbolist artist Mikhail Vrubel, with whom Kandinsky was personally acquainted and whose work was much talked about in the first decade of the century. Not only Vrubel's style, in which the figure is dissolved in the pictorial *matière* in a work as his *The Demon Downcast* (fig. 4), would have interested Kandinsky, but also Vrubel's Symbolist philosophy, his conception of the messianic role of the artist, and his interest in the inner soul of man all intersect with Kandinsky's ideas.

Understanding Kandinsky's general interest in theosophy is also important for interpreting many of his works. Theosophy, a spiritual way of life and a doctrine propagated since 1875 by the Russian Madame Helena Petrovna Blavatsky, emphasized an omnipresent, infinite foundation of all life and a universal brotherhood. Drawing from traditions such as Eastern religions and Orthodox Christianity, the doctrine emphasizes the in-

herent rhythms of nature—such as succeeding seasons and the ages of man—and accepts multiple cycles of reincarnation as a path to spiritual perfection.

These theories were influential in Russia, where they were propounded by the first generation of Symbolists, active during the 1880s and 1890s, namely the poets Konstantin Balmont and Valerii Briussov, and the philosopher Vladimir Soloviev. Probably as a result of the mysticism inherent in the Orthodox faith, which was further strengthened by this climate of Russian Symbolism, Kandinsky was also susceptible to such Eastern spiritual influences and theosophist theories. He was known to admire the poetry of Balmont and was probably familiar with his ideas, which were published in numerous contributions to *Mir Iskusstva* or later *Zolotoe Runo* (The Golden Fleece), *Vesy* (The Scales), and *Apollon*.

Kandinsky's view that the world was at the threshold of the third Revelation, expressed in the "Reminiscences," echoes Soloviev's conviction that the cleansing power of the Apocalypse will soon bring about a new spiritual epoch.[27] Such a belief in apocalyptic redemption also reflects the theories of the German Christian theosophist Rudolf Steiner, to whom Kandinsky makes reference in *On the Spiritual in Art*. According to Steiner's vision, the Revelation to John, the last book of the New Testament, contained the key to understanding the universe, an idea subscribed to by some of the second generation of Russian Symbolists, such as Andrei Bely.

Yet Kandinsky had never been a practicing theosophist, and at the time of the preparation of the *Blaue Reiter Almanac* (between fall 1911 and May 1912) he emphasized to his coeditor Franz Marc that any men-

tion of theosophy had to be temperate. Still, there is no question that he was very interested in theosophist ideas.[28] There is even a certain analogy between theosophy (in Steiner's theory of three ascending degrees of knowledge) and Kandinsky's division of works into Impressions, Improvisations, and Compositions, with only the latter leading to the epoch of the great spiritual.

Although in Kandinsky's *On the Spiritual in Art*, written during the period when he was painting the first five Compositions, he only parenthetically mentions Steiner, he does briefly discuss Madame Blavatsky and the Christian conception of art, stressing the many affinities between art and religion. He also addresses his beliefs regarding art and religion in the "Reminiscences," written in 1913. In the third chapter of *On the Spiritual in Art*, titled "The Spiritual Turning Point," Kandinsky elaborates on the healing power of theosophist ideas,[29] mentioning Madame Blavatsky and the religions with which she became acquainted during her years in India. He forges a link between the two, creating a spiritual involvement that would achieve union through the Theosophical Society, a brotherhood of "those who attempt to approach more closely the problems of the spirit by the path of inner consciousness." He points out that the methods of the theosophists are opposite to those of the positivists, reason enough for his enthusiasm. Kandinsky concludes that theosophy is "a powerful agent in the spiritual climate, striking, even in this form a note of salvation that reaches the desperate hearts of many who are enveloped in darkness and night—a hand that points the way offers help."[30] Such ideas have a resounding affinity to those of Soloviev, Bely, and Blok, who all believed in the inevitable approach of a cosmic catastrophe followed by the rebirth of the new spiritual epoch—all concepts that are implicit in the pictorial content of *Compositions V* through *VII*.

Kandinsky's philosophical outlook and his perception of the surrounding world also reveal a knowledge of the ideas of the German philosopher Arthur Schopenhauer, whose influential treatise *The World as Will and Representation* (1818) described human experience as resulting from two forces: emotions and strivings—which he called the Will; and ideas, morals, and reason—Representation. He believed that experiences of the Will were superior to those of Representation. These concepts are also reflected in the views of Kandinsky, who believed that pictorial representation should be eliminated in order to arrive at the spiritual, a concept that could be equated with Schopenhauer's notions of emotions and strivings. Interest in the theories of Schopenhauer was also prevalent within Kandinsky's immediate orbit; Franz Marc and the composer Arnold Schönberg, with whom Kandinsky maintained regular contact through letters and visits, were inspired by *The World as Will and Representation*. Marc, in an essay published in the periodical *Pan*, stated emphatically that "in Schopenhauer's terms, the world as Will today takes precedence over the world as Representation."[31] Such belief was akin to Kandinsky's own concepts and his quest for the new expression in art that relied primarily on intuition and the internal necessity of the artist, allowing for the abstract reading of his pictures.

The affinities to Schopenhauer's ideas also manifest themselves in Kandinsky's color theory. It has been pointed out by various authors that Kandinsky's color theory was heavily indebted to that of the German Romantic writer Johann Wolfgang von Goethe, particularly in its emphasis on the metaphorical and associative values of color. But it also reflected, more directly, some of the precepts of Schopenhauer; in fact, the artist's annotated copy of Schopenhauer's *Farbenlehre* was found among the books he left with Gabriele Münter when he left Germany at the outbreak of World War I.

Color and form are the fundamental vehicles of content in painting and Kandinsky's primary aim was to achieve the ultimate harmony of these means in a way that would best reflect the beauty of inner feeling, the beauty of the new spiritual.[32] For that reason, in the works executed between 1909 and 1914 he increasingly obscured or veiled the subject matter. The experience of folk art from his trip to the Vologda province had taught him that a profusion of forms and colors can dissolve the object; in this way it could be abstracted and transformed through such means as signs and symbols borrowed from the "primitive" arts of tribal or peasant cultures. It also reinforced his innate tendency to use color as the primary means of expression. He composed his pictures in such a way that they were not only exquisite examples of pure painting, they were also a vital record of his unconscious and spiritual inner self—the expressions of his "inner necessity." Through their combinations of forms and colors, the Compositions created before 1914—*Compositions I* through *VII*—embody these characteristics to the fullest.

The degree to which Kandinsky saw color as conveying the spiritual quality and content in painting is

clear from *On the Spiritual in Art*, where he devotes three chapters to that issue. In the chapter "Effects of Color,"[33] Kandinsky demonstrates his awareness of how different colors affect the emotional responses of the spectator and how the psychological power of color results in special "vibrations of the soul." Believing colors to transcend the sense of sight, he writes of the "scent of colors," and of hearing colors. He compares, for instance, bright yellow to the bottom register of the piano and dark madder to a soprano voice.[34]

In his theories, writings, and in the actual works, Kandinsky assigned much greater evocative power to color than to form, although what he calls a "purely pictorial composition" (one must assume this means one devoid of clearly evident subject matter) can only be achieved through the appropriate combination of color and form. Yet according to Kandinsky, it is color that, like musical sound, is the direct gateway to the soul.[35] Form, whether the delineation of an object or an abstract division of a space or a surface, always operates with color; the triangle, the circle, and the square each interact in unique ways with each color, which can either reinforce or weaken their effect. Kandinsky's color symbolism is very specific; for instance he associates red with a spiritual vibration caused by a flame or, in a different hue, blood. As such, the psychological effect can be either stimulating or painful, and can be enhanced by a circular, triangular, or square form.[36] Such color symbolism looks back to Goethe and to Eugène Delacroix. The philosophical elements come to play a significant role in the interpretation of the Compositions, where different color combinations and formal arrangements provide the insight into the mood of the paintings, the imagery itself being hidden within the ostensibly abstract form.

Certain combinations of forms and colors are for Kandinsky clearly incompatible, while other combinations offer new possibilities, comparable to a harmonic form that calls forth a vibration of the soul. In that sense, form itself has an inner content that stimulates a psychological and emotional response. For Kandinsky, the most expressive works are not those that present an obvious geometric or Cubist construction, arrived at by distorting and manipulating the object in space, but those in which the subject is obscured, in which forms that appear to be randomly scattered across the canvas in fact have precise relationships to each other by both linear and coloristic constructions. These objectives come across very distinctly in the Compositions, particularly when one analyzes the numerous sketches and studies for different sections of these paintings and their relationships with the final works.

Kandinsky and Music

The term "Composition" can imply a metaphor with music. Kandinsky was fascinated by music's emotional power. Because music expresses itself through sound and time, it allows the listener a freedom of imagination, interpretation, and emotional response that is not based on the literal or the descriptive, but rather on the abstract—a quality that painting, still dependent on representing the visible world, could not provide.

Kandinsky's special understanding of the affinities between painting and music and his belief in the *Gesamtkunstwerk*, or the total work of art, came forth in his text "On Stage Composition," his play "Yellow Sound," and his portfolio of prose poems and prints *Klänge* (Sounds, 1913).[37] Music can respond and appeal directly to the artist's "internal element" and express spiritual values, thus for Kandinsky it is a more advanced art. In his writings Kandinsky emphasizes this superiority in advancing toward what he calls the epoch of the great spiritual.[38]

Wagner's *Lohengrin*, which had stirred Kandinsky to devote his life to art, had convinced him of the emotional powers of music. The performance conjured for him visions of a certain time in Moscow that he associated with specific colors and emotions. It inspired in him a sense of a fairy-tale hour of Moscow, which always remained the beloved city of his childhood. His recollection of the Wagner performance attests to how it had retrieved a vivid and complex network of emotions and memories from his past: "The violins, the deep tones of the basses, and especially the wind instruments at that time embodied for me all the power of that pre-nocturnal hour. I saw all my colors in my mind; they stood before my eyes. Wild, almost crazy lines were sketched in front of me. I did not dare use the expression that Wagner had painted 'my hour' musically."[39]

It was at this special moment that Kandinsky realized the tremendous power that art could exert over the spectator and that painting could develop powers equivalent to those of music. He felt special attraction to Wagner, whose music was greatly admired by the Symbolists for its idea of *Gesamtkunstwerk* that embraced

word, music, and the visual arts and was best embodied in Wagner's *The Ring of the Nibelung*, with its climax of global cataclysm. One can also presume that Kandinsky, philosophically a child of the German Romantic tradition, was strongly attracted to Wagner's use of medieval Germanic myths and legends, including those of the world's creation and destruction, as symbols that allowed for the translation of his philosophical attitudes toward the world view, religion, and love. For instance, Kandinsky was enthralled by *Tristan and Isolde* as an expression of undying love and spiritual transformation. But in Wagner there is also an affinity with the philosophy of Schopenhauer, who considered music to be of central importance in man's emotional life.

Among his musical contemporaries, Kandinsky admired the work of Aleksander Scriabin, whose innovations he found compatible with his own objectives in painting. What especially intrigued Kandinsky were Scriabin's researches toward establishing a table of equivalencies between tones in color and music, a theory that Scriabin effectively applied in his orchestral work *Prometheus: A Poem of Fire* (1908).[40] These tonal theories parallel Kandinsky's desire to find equivalencies between colors and feelings in painting: indeed, one of the illustrations included in the essay on Scriabin published in the *Blaue Reiter Almanac* was a color reproduction of *Composition IV*.

Kandinsky's conviction that music is a superior art to painting due to its inherent abstract language came out forcefully in the artist's admiration for the music of the Viennese composer Arnold Schönberg, with whom he initiated a longstanding friendship and correspondence and whose *Theory of Harmony* (1911) coincided with Kandinsky's *On the Spiritual in Art*.[41] Kandinsky's complex relationship to Schönberg's music is central to his concept of Composition, since Schönberg's most important contribution to the development of music, after all, occurred in the area of composition.

Schönberg's innovations, such as discarding chromaticism and abandoning tonal and harmonic conventions, unleashed a new future for musical explorations and formed an important turning point for compositional practice. In particular, two of the composer's innovations radically opened musical compositional structures. Beginning with his First String Quartet in 1905, Schönberg introduced a chromatic structure that he defined as a "developing variation," in which there was a continual evolution and transformation of the thematic substance of the musical piece, rejecting thematic repetition. This inspired the constant unfolding of an unbroken musical argument without recourse to the symmetrical balances of equal phrases or sections and their corresponding thematic content. As a result of this practice, Schönberg achieved a musical continuum that was richly structured, densely polyphonic, and in which all parts were equally developmental.

These new compositional structures led him toward free chromaticism, which emphasized nonharmonic tones and "emancipation of dissonance" (i.e., unresolved dissonance), one of the principal features of atonal music. Having such constant transformations, rather than the repetition of melodic pattern, endowed the work with a totally unconventional psychological depth, evocative power, and emotional strength. Schönberg's innovations, which permitted any pitch configuration, ruptured traditional conventions of musical composition.[42]

The magnitude of this revolutionary change can be compared to the fundamental transformation in Kandinsky's painting from a figurative idiom to free, expressive, abstract work. The kinship between Kandinsky and Schönberg (who was also influenced by the philosophy of Schopenhauer) is a special example of the intellectual affinity of artists in search of new vehicles for expressing their inner emotions. These diverse artistic and philosophical influences were all important for the conception of Kandinsky's first seven Compositions before World War I.

Although Kandinsky created *Composition I* about a year before he became immersed in Schönberg's new musical concepts, the objectives of his pictorial search seem nevertheless to coincide with those of the composer. As Schönberg had done, Kandinsky searched for a free chromatic field, probably best exemplified in his *Composition VII* (1913, pl. 81), where richly structured, polyphonic motifs create spatial and compositional ambiguities, visual beauty, emotional impact, and intellectual stimulation. The elements "constructing" Kandinsky's Compositions that are at first glance abstract, such as in the three pre-war works, *Compositions V, VI,* and *VII* (pls. 34, 47, 81), could be compared to Schönberg's use of unresolved dissonance: one dissonance, followed by another, and then the next, without completing the expectations of the musical destination. In Kandinsky's Compositions, numerous motifs—either abstracted from natural objects as in the first six works, or more purely abstract as in *Composition VII*—are or-

ganized into visual structures that can be experienced simultaneously, without expecting a resolution, and that can exert emotional impact on the viewer on several physical, psychological, and emotional levels.

In his conclusion to *On the Spiritual in Art*, Kandinsky again resorts to a musical metaphor to describe the deliberately cloaked pictorial construction of form and color. In a passage in which he is primarily concerned with the issues of composition and where *Composition II* is reproduced as a reference, he divides compositions into two groups: "1. Simple composition, which is subordinated to a clearly apparent simple form. I call this type of composition melodic. 2. Complex composition, consisting of several forms, again subordinated to an obvious or concealed principal form. This principal form may externally be very hard to find, whereby the inner basis assumes a particularly powerful tone. This complex type of composition I call symphonic."[43]

He goes on to discuss diverse elements of the Compositions in overtly musical terms, clarifying his understanding of a melodic composition as being that in which the objective element is eliminated to leave only the basic pictorial form—such as simple geometrical forms or a structure of simple lines that create general movement. The movement is either repeated in the individual parts of the painting or is varied by using different lines or forms. These are compositions that possess a simple inner soul; their creation and perception occur on a less complex level, where the perceptual and spiritual elements are fairly simple.

In Kandinsky's view, melodic compositions were revitalized by Paul Cézanne and later by the Swiss Symbolist Ferdinand Hodler. As an example of melodic composition, Kandinsky illustrated Cézanne's *Large Bathers* (fig. 5) within the text of *On the Spiritual in Art*, stating that the picture represents "an example of this clearly laid out, melodic composition with open rhythms."[44] Indeed, one observes a clear rhythm in the arrangement of trees and the figures gathered under the triangular canopy of rhythmically leaning trees. As in a musical composition, the rhythms add vitality to the pictorial composition, inviting the eye to travel from one form to the next according to a regularly determined motion.

The emphasis on compositional rhythm is distinctly more obvious in the work of Hodler (fig. 6);[45] Kandinsky explained that "many of Hodler's pictures are melodic compositions with symphonic undertones."[46]

The section on rhythm in his conclusion to *On the*

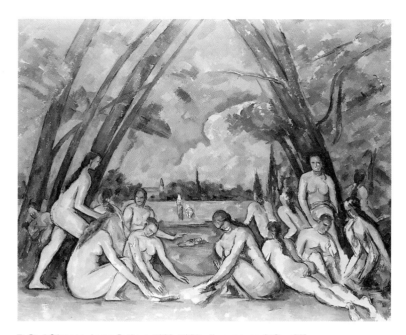

5. Paul Cézanne, *Large Bathers*, 1899–1906, oil on canvas, 81 7/8 x 98" (208 x 249 cm), Philadelphia Museum of Art, purchased: W. P. Wilstach Collection.

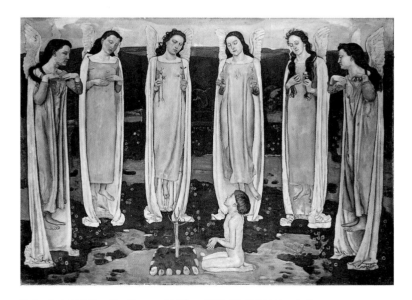

6. Ferdinand Hodler, *The Consecrated One*, 1893–94, tempera and oil on canvas, 7' 3¼" x 9' 9" (219 x 296 cm), Kunstmuseum Bern; Gottfried Keller-Stiftung.

Spiritual in Art reveals much about Kandinsky's philosophical approach, whereby every phenomenon in nature, not only in music but also in painting, has its own structural rhythm. He felt that numerous pictures, especially woodcuts and miniatures from earlier periods, represented excellent examples of "complex 'rhythmic' com-

position with a strong intimation of the symphonic principle."[47] Among these types he included the work of old German masters, of the Persians and the Japanese, Russian icons, and particularly Russian folk prints. But he observed that in most of these early works the symphonic composition is very closely tied to the melodic one, where principally the objective element underlies the structure.

For Kandinsky, if that objective element of a painting were taken away, the building blocks of the composition would reveal themselves to cause a feeling of repose and tranquil repetition, of well-balanced parts. A similar feeling is evoked by diverse modes of musical expression, for instance early choral music or the music of Mozart or Beethoven.[48] However, when the objective element is in place, especially beginning with *Composition IV* (pl. 31), all of the juxtapositions, conflicts, and dissonances are arranged in a manner that parallels Schönberg's own innovations.

Expression through Geometric Form

Kandinsky's greatest innovations occurred during his Munich years, particularly his Murnau period (1908–14). It was between 1910 and 1913 that he completed seven of his most important works—*Compositions I* through *VII*.

A decade elapsed between the creation of *Composition VII* in 1913 and *Composition VIII* in 1923,[49] and this juncture is marked by philosophical and stylistic evolutions in Kandinsky's art. Springing from the rich intellectual foundations of Kandinsky's pre-war years, the three last Compositions show another set of stylistic influences. In this next tumultuous period, Kandinsky was drawn by political events and a sequence of avant-garde artistic movements.

That decade, besides being a period of great upheaval in the world, was also chaotic in Kandinsky's personal life. At the outbreak of World War I in August 1914, Kandinsky left Munich and traveled with Gabriele Münter to Switzerland, returning to Moscow alone in December 1914. He remained there until the end of 1921, traveling only to Stockholm in winter 1916 to meet Münter for the last time.

In Russia, 1917 marked the February and the October Revolutions, which radically changed the country's political and cultural make-up. For about a decade, the new government, established as a result of the October Revolution, allowed artists the freedom of participating actively in building a new society and evolving a new art that could appeal to the masses and be directed toward creating a new pictorial idiom suited to that purpose. Through his contact with the avant-garde artists, Kandinsky was exposed to the newest tendencies in art: the non-objective geometric Suprematism of Kasimir Malevich, and the Constructivism of Vladimir Tatlin, Aleksandr Rodchenko, and El Lissitzky. These influences of Russian non-objective, geometric art would later surface in Kandinsky's work of the Bauhaus years.[50]

While in Russia, Kandinsky painted little, as he was preoccupied with his political, pedagogical, and editorial activities. Yet, as a result of his seven-year stay in Russia, his art underwent a crucial stylistic transition from the emotional expressionist idiom of the pre-war years to a cool, geometric, abstract vocabulary and clarified compositional structure. As a result of the contact with his Russian contemporaries, certain stylistic features entered his paintings: the superimposition of flat planes, a greater emphasis on shifting axes and the diagonal, the use of contradictory spatial effects, and centrifugal as well as dispersed compositional arrangements.

Artistic life in Germany had also been transformed since Kandinsky's Munich years. In 1921, when Kandinsky moved to Berlin, Constructivism was becoming an important influence on artistic developments in Germany, but devoid of the deeply ideological basis that had been integral to its development in Russia.[51] In June 1922 Kandinsky moved to Weimar, where Walter Gropius had offered him a professorship at the Bauhaus.[52] The works of Kandinsky's Bauhaus years (1922–33), such as *Composition VIII* (pl. 85), are characterized by controlled, strictly balanced arrangements of geometric forms in dynamic relationships, where form and color play an equally expressive role. During his Bauhaus period Kandinsky was deeply immersed in his pedagogical activities and his writings, producing in 1926 another seminal theoretical work, *Point and Line to Plane*.[53]

With the Bauhaus activities curtailed in 1933, owing to the Nazi's violently anti-modernist cultural policy, Kandinsky decided to settle in Paris. Although he had shown in galleries in Paris, and a monograph on him had been published by *Cahiers d'Art* in 1931, he was not widely known to the French public; the city's brisk pace and the unfamiliar artistic community made him apprehensive.[54] In France, Kandinsky's Russian identity surfaced more strongly, but the Russian community in Paris

was not ready to receive his art with understanding and enthusiasm. Kandinsky led a fairly isolated existence. Living on the outskirts of Paris rather than in its artistic center, his main contact was with Thomas von Hartmann and his wife, as well as occasionally the writer Aleksei Remizov and the sculptor Antoine Pevsner. His geometric abstract style continued to undergo noticeable changes, even though he was in his seventies.

The artistic scene in France was at that time essentially dominated by a few contrasting tendencies: Surrealism, traditional figurative painting, and geometric abstraction. However, Paris was becoming the new center of the avant-garde, which since before the mid-1920s had been focused in places like Germany (the Bauhaus), Holland (Piet Mondrian, Theo van Doesberg, and De Stijl), and Russia (Constructivism). But by 1930, geometric abstraction lost much of its utopian character and pure ascetic form; a more sensuous, almost romantic, as well as decorative element was introduced; Kandinsky's work of the period reflects that component of the younger generation of geometric artists, which included César Domela, Auguste Herbin, Sophie Tauber-Arp, and Joaquín Torres-Garcia. Concurrently, the Surrealist movement, whose proponents included artists Jean (Hans) Arp, Salvador Dali, Max Ernst, Alberto Giacometti, André Masson, Joan Miró, and Yves Tanguy, was attracting greater public attention and undergoing changes.[55] Geometric abstraction and Surrealism coexisted, and this stylistic fusion is evident in Kandinsky's late *Composition IX* (1936, pl. 86), in which the crisp geometries of the Bauhaus period are combined with softer, biomorphic imagery.

In the conclusion of *On the Spiritual in Art* Kandinsky describes three of the works he reproduced in the book: *Impression (Park)* (1910), *Improvisation No. 18* (1910), and *Composition II* (1910). He provides these as examples of his "new symphonic type of construction" in painting, in which the melodic element appears only occasionally, and then only in a subordinate form.[56] The paintings he illustrated represent Kandinsky's three diverse categories: Impressions, Improvisations, and Compositions. He sees future painting, and particularly his Compositions, as examples of an unconscious principle of construction that is already present, to a degree, in his Improvisations and is much more fully developed, both spiritually and formally, and combined with the conscious element in the Compositions. The Compositions constitute the kind of painting that is organically related to his epoch of the great spiritual.[57]

In the text "Painting as Pure Art" of 1913,[58] Kandinsky discusses painting in terms of the modes of depiction of the avant-garde styles that have followed from Impressionism through Cubism and Futurism. The period to follow those would include what Kandinsky calls "Compositional Painting," that is, painting in which form is free of the relationship to a specific object, whereby the artist can achieve a higher level of pure art. In such painting, the subject matter is replaced by pictorial construction and there is a transference of value from "practically purposeful to the spiritually purposeful. From subject matter to composition."[59]

Kandinsky's Compositions extend beyond the territories of Cubism, Futurism, and the movements of his contemporaries. Motifs evolve and transform as he charges new worlds of form and color with the driving energy he called his "inner necessity" and his cosmic content that embraced his "new spiritual." In decoding the visual thoughts and studies he has entwined in these ambitious and compelling works, we gain further insight into Kandinsky's epic process of creation.

Within Kandinsky's oeuvre, the Compositions occupy a singular position. They represent his strivings for pure painting, an idiom that would speak directly to the soul of the viewer and incite his response to it, unencumbered by a narrative quality. The Compositions chart new stylistic territories, developing a new language of color and form. While full of iconographical content, they are highly spiritual works, intensely personal documents of the artist's unconscious. In going beyond either literal depiction or spontaneous abstraction, they become symbols of pure, universal spirituality.

Like the three-step pattern in Wagner's *Ring*, the Compositions bring together the spiritual, the musical, and the visual, and follow a cycle evolving out of the old order to a new one. For Kandinsky, this is an evolution from the apocalyptic catastrophe to the epoch of the great spiritual.

Early Compositions

I

Composition I

According to Gabriele Münter's annotations on the back of an old photograph, *Composition I* (pl. 3) was executed in January 1910.[60] Destroyed during World War II and known to us only through black-and-white reproductions, the owner of *Composition I* described the painting as being executed in bright colors and conveying a joyful mood.[61] Klaus Brisch has identified the subject as a flood or deluge, and the three horsemen as the Riders of the Apocalypse.[62] Grohmann sees it as a bucolic scene of three riders in a beautiful landscape;[63] Rose-Carol Washton Long, following Brisch, proposes that all of Kandinsky's pre-1914 Compositions express his religious philosophy and his interest in theosophy, mysticism, Symbolism, and the spiritual.[64] She identifies three apocalyptic riders surrounded by groups of hunched, praying figures, separated by bushes and foliage and set against the background of mountains with several walled cities, whose diagonal axis suggests the motion of tumbling down.[65] Weiss, however, suggests that the picture represents a pleasant outing of two men and a woman on horseback, a theme that she connects to the subjects of Nordic myths and legends of the tribes within Kandinsky's early ethnographic experience and to his fascination with folk art and legends of old Russia.[66] Regrettably, we have little original evidence as to what Kandinsky intended the subject matter to be.

There exist two small drawings (pls. 1, 2), both executed in pencil on paper, and the *Study for a Wood-cut on the Theme of Composition I* (pl. 4). The smaller of the two drawings, in Munich (pl. 2), defines the compositional scheme as being fairly close to the final work. One can distinguish the three riders in vigorous motion within a cursory mountainous landscape and groups of people in the lower register among wave-like forms. The towers of Kandinsky's classic Russian walled city of onion-domed churches, in the background of the upper right section, above two horsemen, are visible in the drawing and painting. In each work, the two large trees, bent toward the left, create a diagonal counteracting the movement of the riders. The bottom section of the Munich drawing is filled with several figures in the corners and center, which he also included in the painting.

The lower right quadrant of the smaller drawing seems to relate to the other (pl. 1), which treats a rider with outstretched arms seated on a piebald horse. It includes almost the same motifs and an analogous arrangement of forms as the study, made on the verso of an invitation to the Berlin Secession exhibition of April 1910, thus after the painting had been completed.

The two preliminary drawings, with meticulous color notations in German, attest to Kandinsky's deliberations to "examine and work out" the composition, a method so succinctly described in his definition of Composition in *On the Spiritual in Art*.[67]

The color notations in the drawings—green, yellow, and rose, with areas of white, violet, blue, and perhaps brown—reveal the mood of *Composition I*. The painting probably followed this scheme, since the later woodcut also records those colors.

On the basis of the drawings, it is possible to ascertain whether the proposed interpretations of the subject hold up to scrutiny. In fact, Kandinsky later would choose to depict only three riders, not the traditional four, in his Apocalypse pictures, such as in a later glass painting *Horsemen of the Apocalypse* of 1911[68] and again in a 1914 glass painting of the same subject.[69] However, the colors of the horsemen that are indicated in the Munich drawing (w [white] on figures; grau [gray] and rosa [rose] on the horses), do not conform to the white, red, and black horses described in the Book of Revelation. In this interpretation, Kandinsky eliminates the fourth horseman, the pale horseman of death, creating a positive reading of the Apocalypse, possibly influenced by his familiarity with the teachings of the German Christian theosophist Rudolf Steiner. To Steiner, the Four Horsemen of the Apocalypse were not frightening

images of destruction but heralds of positive new events. The first white horse symbolized for Steiner "spiritualized intelligence"—an aspect that would have been especially appealing to Kandinsky, given his philosophical and spiritual preoccupations.

Although such an apocalyptic reading of this painting might have certain foundations, it also poses problems, for the mood of neither the small Munich study nor *Composition I* appears to be apocalyptic. The positions of the riders do not indicate violence, only swift motion forward, and the walled cities do not necessarily tumble, rather they might be represented as seen while galloping through the landscape. Some buildings appear to lean, in part because they are located on a mountain slope, but perhaps more to suggest the position of the rider on the horse: when riding uphill, one perceives the landscape at an angle.[70]

Another reading of *Composition I* is being proposed by Peg Weiss, who links the motifs in the painting to Kandinsky's knowledge of Finno-Ugric legends and artifacts that he explored in his paintings.[71] Weiss identifies the figure of a horseman with outstretched arms in the center of the untitled study for *Composition I* (pl. 1) as a symbol known as the World-Watching Man, which is always depicted in this position and often on the piebald horse. This motif, sometimes undergoing formal transformations, recurs in a number of Kandinsky's later works, such as *Composition IV* (1911, pl. 31), and a vignette for his volume of prose poems and prints, *Klänge* (1913). Kandinsky was familiar with shamanistic artifacts, as evidenced by his collection and library, and he intimately knew and understood their context, meaning, and function. In 1913 he spelled out the connection between his ethnographic interests and his depiction of those pictorial motifs in his autobiographical essay "Reminiscences."[72]

Indeed, at the beginning of "Reminiscences," Kandinsky sheds light on the origin of the piebald stallion motif, recounting fondly that in his youth he had "a piebald stallion (with yellow ochre on the body and a bright yellow mane) Love of such horses has not deserted me to this day. It is a joy for me to see such a horse on the streets of Munich This piebald nag suddenly made me feel at home in Munich."[73] Thus it was a motif that connected his Russian childhood to his German present.

Time and time again Kandinsky drew on the motifs that related not to one specific source, but rather that merged multiple references of diverse origins, from pagan myth as well as religious and mystical sources, permitting an interpretation on several levels. Certainly *Composition I* allows for such an open-ended, multilayered reading. The execution of the work adds to this impression: based on the reproductions, forms without heavy contours flow into each other and are set into relief by their adjacent colors. This is especially clear in the lower section of the painting. The spatial structure of the work forgoes the traditional spatial conventions, and the pictorial elements are tightly knit into a pattern that indicates space only by overlapping forms.

Kandinsky considered *Composition I* to be an especially important work at the time, for it was shown in an impressive series of exhibitions through 1916.[74] With this work, Kandinsky laid the foundation for a style that would be increasingly non-representational, in which the legibility of pictorial motifs becomes of secondary importance to the moods and meanings they evoke.

II Composition II

The Russian edition of Kandinsky's "Reminiscences" contains an extended passage in which he discusses the origin of his Compositions in more detailed terms than he had used in the German 1913 version.[75] In the section recounting his painting habits in his early years in Munich, he clarifies his concept of "Composition" and the origin of *Composition II* (pl. 12):

Once, in the throes of typhoid fever, I saw with great clarity an entire picture, which, however, somehow dissipated itself within me when I recovered. Over a number of years, at various intervals, I painted The Arrival of the Merchants, *then* Colorful Life [Motley Life]; *finally after many years I succeeded in expressing in* Composition 2 *the very essence of that delirious vision—something I realized, however, only recently. From the very beginning, that one word "Composition" resounded in my ears like a prayer. It filled my soul with reverence. And ever since it has pained me to see how frivolously it is often treated. I allowed myself complete freedom when painting studies, even submitting to the "whims" of my inner voice.*[76]

Composition II, also destroyed during World War II, was probably first conceived in 1909.[77] It was finished in 1910, not long after *Composition I*, so we can speculate that the two works might have developed simultaneously.[78] Besides the final study (half the size of the finished painting), there exists a group of related works that help us to understand better, although not unequivocally, the conception and development of the destroyed canvas.

The preparatory works include a small sketch for a watercolor study from one of the artist's sketchbooks (pl. 5) and a watercolor study for the lower central section of the painting, called both *Study for Composition II* and *Two Riders and a Reclining Figure* (pl. 9); both are in Munich. These two drawings are very close in compositional arrangement and color structure (indicated by abbreviations in the small drawing). Another small pencil drawing, in Paris, works out the right side of the composition and gives abbreviated color notations (pl. 6); it is a preliminary sketch for a larger oil study for the same right section of the painting (pl. 10). Two other drawings in Paris, an ink sketch indicating the general organization of elements, with some suggestion of movement marked with arrows (pl. 7), and a quick pencil diagram of the compositional scheme of the canvas (pl. 8) were both probably executed at a later date, since their quality of line has a rather "reminiscent" character.[79] A woodcut from Kandinsky's book of poems *Klänge* (pl. 13) relates closely to the final version of *Composition II* and was also probably executed after the painting. A small pencil drawing for the maquette of the Russian edition of *Klänge* (1910–11) depicts part of the lower central section, with a clearly drawn horseman climbing a mountain.[80] Each of these images, however, provides only fragmentary material with which to interpret the iconography of the final work, leaving the viewer with an ambiguous reading of the picture.

Such an open-ended freedom of response to the complex pictorial and iconographical motifs is even more evident in the painting. This intentional ambiguity aimed at evoking multiple "inner vibrations" and arousing the complex inner feelings that the artist considered to be essential to a truly creative work. The continually evolving forms unfold into new interpretative possibilities, both visual and emotional. Although the viewer attempts to discover the coherence of the subject matter behind innumerable perceptual clues, the response to the painting is not predicated on recognizing objects and their representational quality, rather one reacts to the harmonious arrangement of colors and forms—the qualities of "pure painting."

Kandinsky left only ambivalent information regarding the interpretation of *Composition II*, and it has been the subject of much discussion among scholars. In his draft of a manuscript for a lecture scheduled (but never delivered) in Cologne at the beginning of 1914,[81] Kandinsky asserts "*Composition 2* is painted without a theme, and perhaps at that time I would have been nervous of taking a theme as my starting point."[82] On the other hand, in the passage quoted at the outset of this discussion on how some of his imagery originated in his dreams, Kandinsky places *Composition II* in the sequence of two earlier works, *Arrival of the Merchants* (fig. 1) and *Motley Life* (fig. 2), and emphasizes that his "delirious vision" was finally successfully captured in *Composition II*. This would imply an iconographic and conceptual relationship among the three works, which were executed within five years of each other. Both *Arrival of the Merchants* and *Motley Life* depict nostalgically Russian crowd scenes set in landscapes with Kandinsky's classic motif of a walled city in the background.[83] Stylistically, they differ strongly: in the former the figures are broadly stylized in a manner related to his motifs influenced by Jugendstil and Mir Iskusstva, while the latter is a brilliant, mosaic-like, shimmering image. Both pictures, despite their stylistic differences, share the conception of disjointed elements presented as a seamless whole, a feature that is even more pronounced in *Composition II*. But Kandinsky points to a different intention: to experiment with and creatively manipulate pictorial means. To this end, he clarifies that in painting *Motley Life*, his main interest was "[in] creating a confusion of masses, patches, lines, I used a 'bird's eye view' to place the figures one above the other. To arrange the dividing-up of areas and the application of the brushstrokes as I wished, on each occasion I had to find a perspective pretext or excuse. Only very slowly did I come to free myself from this prejudice. In *Composition 2* one can see the free use of color without regard for the demands of perspective."[84]

It may have been the emphasis on purely pictorial qualities, then, which for Kandinsky linked these three works of 1905 to 1910, *Arrival of the Merchants*, *Motley Life*, and *Composition II*. If that were his connection, *Composition II* would indeed mark an unquestionable advance, for it shows the complete rejection of perspective: color and line become free contrapuntal el-

ements to suggest depth. Color is here the primary means that stimulates the emotional and spiritual response of the viewer.

Already around 1910, in his discussion of the role of pictorial means within the organization and expression of a painting in *On the Spiritual in Art*, Kandinsky declared that through color and line one could eliminate representation and focus on the material surface.[85] The varying thickness of line, the positioning of form on the surface, and the superposition of one form on another create an extension of space that would be given a third dimension by the special use of color. Kandinsky repeats this observation in the text of the Cologne lecture, citing *Composition II* as an example.[86] Discussing the compositional balance of the canvas and the way he wanted to achieve harmony out of "the collision and dramatic struggle of individual elements among themselves," he goes on to clarify:

Thus, e.g., in Composition 2 *I mitigated the tragic element in the composition and drawing by means of more indifferent and [totally] indifferent colors. Or I sought involuntarily to juxtapose the tragic [use of] color with sublimity of linear form For a time I concentrated all my efforts upon the linear element, for I knew internally that this element still requires my attention. The colors, which I employed later, lie as if upon one and the same plane, while their inner weights are different. Thus, the collaboration of different spheres entered into my pictures of its own accord. By this means I also avoided the element of flatness in painting, which can easily lead and has already so often led to the ornamental. This difference between the inner planes gave my pictures a depth that more than compensated for the earlier, perspective depth.*[87]

It is clear from this quotation that Kandinsky manipulates the physical attributes of painting while conscious of their psychological impact. He articulates the duality of matter and spirit, the object being only an expedient way of arriving at the spirit. He also knows, possibly as a result of his familiarity with the flat, decorative patterning of Jugendstil, that too great an emphasis on line might reduce the work to being purely ornamental, hence lacking spiritual meaning. In order to avoid the pitfalls of the ornamental, his compositional method relies on balancing the top and bottom of the picture through appropriate color combinations and by distributing the weight of dif-

ferent elements in such a way that it is possible to achieve the effects of depth and equilibrium.

The application of these principles is revealed in the final study for *Composition II*. Kandinsky intends the work to focus the viewer's attention on the inherent formal qualities—such as thickness of line, intensity of color, and their emotional impact—rather than on the subject matter. Yet, despite Kandinsky's statement to the contrary, the figurative elements present in *Composition II* imply a subject matter, the interpretation of which is complex.

Since *Composition II* is known only through its black-and-white reproductions, we can analyze its iconographic interpretation through its final study, in the collection of the Guggenheim Museum (pl. 11). While close to the painting, the study differs from it in a number of aspects.[88] The central white vertical form, which stops slightly below the upper edge of the picture in the study, extends beyond its boundaries in the painting. At lower left, a group of four closely huddled, shrouded figures in the study becomes an amorphous shape in the final version. There are also some less significant alterations of forms in the upper left and upper right sections; they are changes to either the proportions or the shapes of elements. A soft black crayon grid is visible under the paint layer along with some color notations—the use of such a device on canvas is extremely rare in Kandinsky's working process.[89]

Various hypotheses have been advanced as to the specific iconography of the work. Generally, it is accepted that the two sides of the painting depict two opposite themes, a catastrophe on the left and an arcadian scene on the right. These two conflicting moods are suggested by the disposition of forms, but especially by the color scheme, which is dark and ominous on the left, sunny and glowing on the right. It is probably because of the radiant right section that Grohmann initially interpreted the picture as a "festive scene in a hilly wooded landscape."[90] But this interpretation overlooks the stormy mood of the upper left section. There appear to be three focal points to the picture, each of equal importance: in the lower center, two horsemen are vigorously jumping in opposing directions over the white form of a tree trunk, a rock, or a road; at left a cataclysmic event occurs under ominous skies full of black clouds and lightning; and at the right is a lyrical, peaceful scene with two reclining figures in the foreground and several others in the background.

It was first suggested by Klaus Brisch that *Composition II* has the Deluge as its main theme and includes a Garden of Love motif on the right.[91] Following Brisch's interpretation of individual motifs, Washton Long sees the two sides as incorporating destruction and salvation, the two forces identified in the Revelation to John,[92] thus relating the painting to Rudolf Steiner's theosophical concepts and to ideas of Russian Symbolism. While Grohmann and Brisch suggest the central white form is a rock, Washton Long believes it to be a tree. She concurs with Grohmann as to a motif of children playing ball on the right, but suggests that the two horsemen are engaged in combat (as in *Composition IV*) rather than escaping from the flood, as suggested by Brisch. She sees the blue forms as rising waters that are consuming the figures at the lower left corner, while the green reclining figure has already drowned. At the top, the walled city of domed churches is crumbling under dark clouds and zigzagging lightning, and a yellow figure standing with outstretched arms in a violet boat is visible below the toppling mountain. All these images depict motifs found in Kandinsky's later painting *Deluge I* of 1912 (fig. 12).

The suggestion that the horsemen in the center are battling and represent the tragic conflict of individual material and spiritual forces is open to question, since on close study, the two horsemen do not seem so much engaged in combat as lurching forward or upward. This sense of motion, rather than conflict, can be gathered from a very generalized pen-and-ink drawing in Paris (pl. 7), where arrows indicate the directions of their movement, but which according to Vivian Barnett might have been executed much later. Another watercolor study for the lower central section, in Munich (pl. 9), shows two horsemen, one with outstretched arms, moving upward but not fighting. This upward motion is even more legible in the later woodcut for *Klänge* (pl. 13). An oil on cardboard study for the right side of the composition (pl. 10) conforms almost exactly in color and form to the pencil study for it and is only slightly changed in this part of the final work; it is an elaboration of the small Paris pencil sketch in which the figures are very clearly outlined and carry notations of colors (pl. 6). The color scheme of yellow, red, and black in the upper section is balanced by the white, blue, and green in the lower part, as if Kandinsky were applying the principles of interaction of colors and their psychological impact that he had laid out in *On the Spiritual in Art*.

Weiss emphasizes Kandinsky's Russian roots as the source of the imagery, relating them to the artist's ethnographic studies that date back to his 1889 trip to the Vologda region.[93] She convincingly argues that the iconography of *Composition II* embodies an example of *dvoeverie*, or "double faith," whereby Christian and pagan beliefs are fused into one symbol that carries the meaning of both—the very aspect of Zyrian beliefs that Kandinsky had addressed in his article. Weiss also relates the left side of *Composition II* to a great flood, and she thus identifies the recumbent green figure in the foreground as the Zyrian water spirit Vasa, always imagined in a green robe, who creates tempests by throwing himself into the water.[94] To Weiss, the golden figure in the boat with outstretched arms represents a son of Numi-Tõrem, the great god of the neighboring tribe, the Voguls. The son, Yanukh-Tõrem, the Golden Prince, was believed to wear such splendid clothing that he would shine like gold; he would descend to earth to command the atmospheric conditions and intervene in the affairs of man. Always represented with outstretched arms, here he can be compared to the figure of Christ calming the waters. Sometimes he is depicted on horseback (as in the small drawing for *Composition I*, pl. 1) or in a boat with two rowers. When shown on a white horse, he can be associated with Egori the Brave or Saint George, a patron saint of Russia and the figure with whom Kandinsky identified.

While to Weiss the left side depicts the flood, the right side would represent a sacred grove where a shaman is being buried in the background. According to the pagan custom, he is surrounded by drumming figures; the drum is an essential symbol of a shaman's ability to journey to other worlds.

When considered in the context of Kandinsky's profound interests in folk art—specifically the Finno-Ugric and Buriat legends—this interpretation seems quite plausible and adds an extra symbolic dimension to those based on Christian eschatological motifs. But Weiss suggests that there is also an autobiographical dimension to the picture, namely the fact that Kandinsky, having settled with Münter, was experiencing a stable period of creativity, thus identifying with idyllic Garden of Love and sacred grove subjects. In fact, this double theme would only be in keeping with Kandinsky's desire to draw the spectator into the picture on different spiritual levels.

Kandinsky's admiration of Gauguin and Matisse

is also apparent in such a combination of hieratic forms and arcadian symbolism. The top right section evokes the formal presentation of the figure of Christ in Gauguin's *Nativity* (1896)[95] or *Spirit of the Dead Watching* (1892),[96] paintings Kandinsky probably knew. The mood and formal aspects of the lower right seem to have a direct connection to Matisse's *Le Bonheur de vivre*, which Kandinsky had seen at the Salon des Indépendents in the spring of 1906 while living in Sèvres. Matisse was an artist whom Kandinsky especially appreciated and discussed in his writings. This motif of an arcadian paradise links Kandinsky's work in a broader sense to other presentations of the Garden of Love theme known in Western tradition.

When Kandinsky exhibited *Composition II* for the first time at the second exhibition of the Neue Künstler-Vereinigung at the Moderne Galerie Thannhauser, Munich, in September 1910, the painting was derided by the critics. One compared it to a design for a modern carpet or the creation of a madman.[97] Only two voices, Hugo von Tschudi, director of the Bayerische Staatsgemäldegalerie, and Kandinsky's close friend, the artist Franz Marc, spoke in favor of the painting.

Marc felt that it was regrettable that "Kandinsky's great Composition [II] cannot hang next to the Mohammeddan tapestries at the Exhibition Park."[98] He was referring to the exhibition of Muhammadan art held in Munich in summer 1910 that both Marc and Kandinsky found spectacular and which Matisse also visited. Kandinsky appreciated the technical virtuosity of the works, the great subtlety of line, the "primitive" quality of the color, and especially the way the figures were at the same time "modeled" and "on the plane," thus avoiding the pitfalls of the pictures being purely ornamental. Marc shared Kandinsky's enthusiasm for Islamic art but also greatly admired his work. Marc felt that only Kandinsky's Compositions could stand up in beauty to the Muhammadan art: "Let us try it with Kandinsky's compositions—they will stand this dangerous test, and not as tapestry, rather as 'Pictures.' What artistic insight hides in this unique painter! The grand consequence of his colors holds the balance of his graphic freedom—is that not at the same time a definition of painting?"[99]

Stylistically, *Composition II* is a major statement about the expressive power of broad fields of color whose structural role is reinforced by linear elements, thus creating compositional depth. Conceptually, it con-

tinues some of the preoccupations of *Composition I*, especially at the bottom register of the picture, where some of the features of the first Composition seem to recur. In both pictures there is a distinctive shared conception, an evolutionary quality of the stylistic and spatial solutions, and an emphasis on pictorial means as the primary vehicle of expression connecting the two pictures—indeed as if the two pictures represented the opening chapters of a large, ambitious work. In *Composition II*, pure pictorial attributes envelop the representational narrative to render, to use Marc's words, a "definition of painting."

III
Composition III

Unfortunately, only a black-and-white photograph and a few studies remain to provide clues into the interpretation of *Composition III* of November 1910 (pl. 20), also destroyed in World War II.[100] The existing studies include a pencil diagram that generally indicates the overall scheme of the final painting (pl. 14). Inscribed "Komp III" in the upper left corner, it focuses on the organization of the movement of different parts. This aspect is further developed in a pencil study (pl. 15), dated by Münter September 14, 1910 and taped to the back of a preparatory sketch for *Improvisation XIV*.[101] Here, even though some elements resemble those in the preceding drawing, certain lines are thicker, as if emphasizing the greater importance of the particular sections. A smaller pencil drawing (pl. 16) allows one to distinguish certain motifs of horsemen, waves, and elements of the landscape.

This drawing, *Study for Composition III (Improvisation XV)*, reveals motifs from Kandinsky's two earlier Compositions. There is possibly a reclining figure at lower left, reminiscent of the green-clad figure in *Composition II*, who is either drowned or, to adopt Weiss's interpretation of *Composition II*, might represent the Zyrian water spirit Vasa. The motif at lower right recalls the rider with outstretched arms found in the drawing for *Composition I* (pl. 1) and in the watercolor study for *Composition II* (pl. 9), although here his position is reversed. It could be the World-Watching Man or Yanukh-Tōrem from Zyrian beliefs.

There are color notations in German on the draw-

ing that indicate an expanse of violet in the right section; a large looming form in upper right—possibly a cloud—in black; three white sections at the top; different forms, possibly waves, in blue in the center; and a red shape in the lower right corner.[102]

Brisch and Washton Long suggest that *Composition III* is related to the theme of Deluge,[103] a hypothesis that seems quite credible. Similarly, Grohmann indicated that the mood of the painting was "threatening" and "catastrophic."[104] He also suggested that the center is occupied by what "looks like a single gigantic rock articulated into small blocks," the middle one being blue. But the blue forms could also represent waves. On the basis of that drawing, Grohmann surmised further that the "bright rocky forms" at the bottom grow upward, as figures.[105]

This suggestion might be confirmed by another double-sided drawing (pl. 17a–b) for *Composition III*, which adds some information to the interpretation of the theme.[106] The compositional scheme signals three figures in the lower register in motion to the left and a large tree in its right section (pl. 17a). It also indicates a color scheme: indigo and white at the upper right, green below it, then still lower, green and yellow, with an entire right border section marked "violet." On the verso (pl. 17b) the direction of the figures is reversed and there is a large tree-like form, strongly outlined in black, at left. A similar form can be found also in the large gestural pen-and-ink drawing (pl. 18).[107] The forms in the bottom register could be interpreted as human, but the two shapes in the left and right corners might indeed be waves. The final painting and all three drawings contain a tree-like shape in the very center of the composition; this connects to another tree form through a W shape and recalls the large white vertical central element in *Composition II*.

Two other unlocated studies are related to *Composition III*; one is *Sketch for Improvisation XV* (pl. 19), which incorporates almost identical pictorial motifs as *Composition III*, yet reverses the overall compositional arrangement.[108] Judging from the existing photographs of *Sketch for Improvisation XV* and *Composition III* (pl. 20), the mood conveyed by the picture was indeed that of impending doom or tragedy. *Composition III*, executed in 1910, must be viewed in the context of the preceding two Compositions, although stylistically, as far as one can judge from the black-and-white reproductions, it differs markedly from the first two. It incorporates fewer compositional elements; its forms are broader and rendered in larger expanses of color. In this work, linear definitions of forms create tensions and counterpoint the color structure. Kandinsky is moving in a more independent direction, decisively relying less on associating pictorial shapes with visible reality. The riders in a landscape become secondary, and the primary expressive force is conveyed through the arrangement of colored forms, creating a mood or an inner soul of the picture.

Toward Abstraction

IV

Composition IV

Composition IV (pl. 31), according to the Handlist by Gabriele Münter, was executed at the end of February 1911 and was given an alternative title, *Battle (Schlacht)*.[109] The painting, which is narrower in format than *Composition III*, undoubtedly belongs among Kandinsky's most visually compelling canvases. It incorporates several iconographic motifs already familiar from Kandinsky's earlier works, although here they have been abstracted and reduced to pictographic signs that require more attentive deciphering. These representational elements include the three foreground figures of Cossacks, a blue mountain in the center, a rainbow bridge to the left, the leaping or battling horsemen, boats, a fortress on the mountain, two reclining figures, and two standing robed figures.

Kandinsky essentially wants us to read the picture abstractly, yet he still retains some figurative element. What is, actually, the subject matter of this painting, and how should the viewer understand it? The collection of the Musée National d'Art Moderne, Paris, includes six drawings (pls. 21–26), a watercolor study for the painting (pl. 27), and a later woodblock (pl. 29) for the cover of a Russian monograph on the artist intended for publication by the Salon Izdebsky (in Odessa) in 1911. In addition, there is a handcolored line etching (pl. 28) in Munich that was to be inserted between pages 64 and 65 of the deluxe edition of the *Blaue Reiter Almanac*,[110] and finally, a painting at the Tate Gallery, called alternately *Cossacks* or *Section for Composition IV* (pl. 30).

The watercolor study and the drawings, some of which are dated 1911, provide insights into the development of an overall theme and specific motifs. In studying them, one is struck at first by their unhesitant, assured quality. They are well-thought-out studies of specific sections, but they lack the immediacy of a searching drawing. The work called *First Drawing for Composition IV* (pl. 21)[111] presents a well-defined initial idea, in which the upper left section of battling horsemen is juxtaposed with the reclining couple at lower right. The two forms the artist calls "lances" divide the composition into two parts, the agitated left and peaceful right. This drawing does not include, however, either the mountain or the rainbow bridge.[112]

A small charcoal drawing (pl. 22) indicates the general movement of pictorial masses and their positioning in a shorthand, though very assured manner; it retains the two vertical lines as the element dividing the composition into two sections. Three other drawings on sheets of identical size, hence probably done within a relatively short period of time, each develop themes that make up the right section of *Composition IV*: the reclining couple (pl. 23), the two figures on the hill above them (pl. 24), and the more general outline of a composite of both (pl. 25). A larger pen-and-ink and pencil drawing (pl. 26) defines the essential organizational scheme that is very close to the final arrangement on the canvas, although judging by the energetic and fairly uniform quality of line it might have been done later than the other drawings or even the painting. In the drawing of two figures standing on a hill (pl. 24), the placement of the figures and their relationship to the mountain are different, and there seem to be two additional figures at right—figures that are neither present in the final preparatory watercolor nor in the painting itself. The watercolor (pl. 27), which resembles the final painting closely in its formal and iconographical structure, shows an underlying grid, suggesting that it was squared up in preparation for the painting.

The most crucial work for understanding *Composition IV* is the painting known alternately as *Cossacks* and *Section for Composition IV*, at the Tate Gallery in London (pl. 30). Although signed and dated 1910 but recorded as having been painted on January 13, 1911, it probably preceded the many drawings for *Composition IV*.[113] Over half the size of *Composition IV*, this power-

ful canvas corresponds to its left side. It incorporates almost all of the iconographic elements of that half, though in a somewhat altered form: there are the two battling horsemen at center left, the castle on the mountain at right, the rainbow bridge near the center of the composition, and the three Cossacks, two carrying lances at the right foreground. It also includes the group of birds in flight in the upper register; this motif, defined by zigzag-like forms, was eliminated from the final composition and replaced by more painterly patches of blue, yellow, and green.

The title *Cossacks* seems to be almost incidental to this painting, even though two battling Cossacks, recognizable by their high red hats and lilac sabers, are portrayed at upper left and three standing Cossacks holding lances and a saber are at the lower right.[114] Despite all the identifiable motifs, the representational element emerges only on a secondary level. We see the work first as an "objective abstraction," in which colors and linear elements interact in an expressive, pictorial way. To be sure, as with the previous Compositions, in *Cossacks* a multilayered reading is expected of the viewer, a reading in which at least three levels of meaning gradually unfold: as an arrangement of color and form, as a depiction of a representational scene, and through the symbolism of the iconographical elements.

Composition IV (pl. 31) seems to be an elaboration of *Cossacks*. An entire right section has been added to counterbalance the left. The mountain with a castle is now in the center of the composition, splitting it in two, a division enhanced by the two black vertical lances held by the Cossacks, now in the center. As a result, the two battling horsemen occupy the upper left side of the composition, above the rainbow bridge and boat-like shapes. The right section of the painting includes a reclining couple and, above them, the two figures on the slope of a mountain.

Kandinsky provided certain clarification of iconographic motifs and pictorial intentions in an essay headed "Supplementary Definition" included in the appendix to the first monograph on his work, published in 1913 by Herwarth Walden, the owner of Der Sturm Gallery in Berlin.[115] The book appeared when the artist, besieged by incomprehension and doubt, felt compelled to enlighten the public and especially the critics about the creative premises of his work. Although this description clarifies certain motifs, it emphasizes primarily the formal aspect of the picture, implying that this is what Kandinsky considered fundamental to the appreciation of the work.[116]

In this "Supplementary Definition," Kandinsky highlights four elements critical to understanding the picture. These are: masses, contrasts, the running over of color beyond the outlines of forms, and the existence of two centers of the composition. He divides the distribution and balance of masses ("weights") into four sections: "lower center—blue (gives the whole picture a cold tone); upper right—divided blue, red, yellow; upper left—black lines of the entangled horses; lower right—extended lines of reclining figures."[117] His division emphasizes the balance between the coloristic and linear sections: lower center and upper right versus upper left and lower right. Such balance implies no structural hierarchy, rather that all elements are of equal pictorial value. The composition depends on contrasts—between mass and line, between elements precisely defined and those that are blurred, "between entangled line and entangled color, and principal contrast: between angular, sharp movement (battle) and light-cold-sweet colors."[118]

Thus Kandinsky wants the viewer to read the painting first as a composite of contrasting masses, colors, and lines, and only secondly to apply to it a more specific reading of the subject matter. He provides a clue to the subject by describing the angular, sharp movement of linear elements in the upper left as a battle. By extension, the "light-cold-sweet" colors, which he describes as an element under "contrasts," would refer to the lower right side of the picture, which is occupied by the reclining couple. This motif was often used in his works on the Garden of Love theme, and occurs in the lower right section of *Composition II*. In terms of content, then, there is a counterbalance between the forces of violence and those of peaceful harmony. In his discussion, Kandinsky compares this opposition to that in *Composition II* and writes: "It seems to me that this contrast is here, by comparison with *Composition 2*, more powerful, but at the same time harder (inwardly), clearer."[119] While such a statement might suggest analogous subject matter between the two paintings, it would certainly indicate comparable artistic purpose, that is, to achieve expression mainly through pictorial means. Elaborating on his identification of two centers in the painting, Kandinsky indicates that one of the formal centers is represented by the "entangled lines," the second by the "acute form modeled in blue." The two centers are then separated by "the two vertical black lines

(lances)." Hence the linear element creates one center, which is balanced by the painterly zone.

To follow Kandinsky's own description in the Der Sturm album, the elements characteristic of the painting are, among others, "passive movement principally to the right and upward" combined with "mainly acute movement to the left and upward"; these result in "counter-movements in both directions (the movement to the right is contradicted by smaller forms that move toward the left, and so on)."[120]

Thus, Kandinsky clearly tries to emphasize movement—the dynamism of forms, masses, lines, and colors within the work, the very issue that was then fundamental to artists such as the Futurists in Italy, Robert Delaunay and František Kupka in France, and Mikhail Larionov and Natalia Goncharova in Russia. However, by including references to the iconographic program of *Composition IV*—by pointing to the battle motif, the reclining couple, and the Cossacks—Kandinsky stimulates the viewer to search for a more profound meaning from such pictographic symbols.

A number of scholars have attempted to interpret this complex painting. Brisch discusses it in terms of a juxtaposition of battle and Garden of Love themes. Washton Long suggests that even though Kandinsky did not speak of this work in apocalyptic terms, there is a strong religious overtone in the picture, where images of upheaval and hope are integrated into the compositional scheme and enhanced by the presence of saints (the figures on the hill in the right section, above the reclining couple).[121] Although indeed the two sections of the picture represent the juxtaposition of violence (left) and peace (right), whether these concepts carry religious connotations is open to debate; the mood here, as with that of the earlier Compositions, is not really apocalyptic.

Peter Vergo, in his discussion of *Composition IV*,[122] mentions Kandinsky's letter to his friend Hans Hildebrandt, in which the artist, while discussing the lack of viewers' receptivity to his work in pre–World War I Munich, refers also to the subject matter of *Composition IV* as inspired by the charge of Cossacks that he witnessed in Moscow during the abortive Revolution of 1905.[123] However, according to the available biographical information on Kandinsky, the artist did not go to Moscow in 1905. In early October of that year he traveled to Odessa with his father and there he was caught up in the events of the revolution. Given how his profound love for Moscow often caused him to transpose

events into a Moscow-related vision, he might have simply fused a similar event he witnessed in Odessa with his treasured memories of Moscow.[124] Or, since Kandinsky was not always very accurate in his recollections, such an event might have occurred at a completely different time. In any case, *Composition IV* is not a rendering of a specific scene, rather it is a work that embodies Kandinsky's pictorial, philosophical, and spiritual concerns. While his dissolving the objects makes the viewer respond to the inner feeling conveyed by the relationships of its elements, the philosophical and spiritual aspects of *Composition IV* are much more difficult to chart. They reflect Kandinsky's complex interests in the philosophy of Schopenhauer; the music of Wagner; his preoccupation with theosophy, spiritualism, and Christianity; as well as his profound Russianness and knowledge of old Russian myth.

Vergo also compares Kandinsky's symbolism to Wagner's in *The Ring of the Nibelung*, specifically the first part of this tetralogy, *The Rhinegold*.[125] He compares the castle on top of the mountain to Valhalla, the castle of the gods and symbol of violence and deceit, and relates the rainbow bridge motif to the bridge on which the gods process in the final scene of *The Rhinegold*. At the time he painted *Composition IV*, Kandinsky was full of enthusiasm for Wagner, and in the Russian version of the "Reminiscences" he added a passage referring to his special appreciation of Wagner's *Ring*, which he emphasized, "still held my critical faculties in thrall for many a long year by their power and uniqueness of expression."[126] It is possible that Kandinsky, when seeing Wagner's production of the *Ring*, was struck by certain visual images that returned to him as he was painting *Composition IV*.

A reference to the spiritual meaning of some of Kandinsky's Compositions is provided by Gabriele Münter in a letter to Schönberg of 1912, in which Münter recommends to the composer a book she has been reading by Volker (Erich Gutkind) entitled *Sidereal Birth*.[127] In the postscript, responding to a letter from Schönberg where he speaks of his attempts to make the written word visible and audible, she comments: "And now I am completely sure that Volker is your man! At the bottom of page 31 he describes the elements of Kandinsky's *Composition II*, *IV* and *V* and so on. Naturally not in connection with Kandinsky, since he probably knew absolutely nothing of him and his work at that time. I think such men should get to know each other."[128]

Volker's book, which was subtitled *A Seraphic Quest from the Death of the World to the Baptism of the Deed*,[129] treated such subjects as spiritual regeneration and the destruction of materialism; certainly such concerns were akin to Kandinsky's own. The battling Cossacks might then represent the forces of materialism, while the right side of *Composition IV*—the standing and reclining figures—the symbols of the forthcoming spiritual epoch. But these messages can only be conjectural. In interpreting *Composition IV* we have to keep in mind the plurality and complexity of the artist's ideas as well as his intent expressed in the postscript to his "Autobiographical Note," written in 1912: "My aim is: to create by pictorial means, which I love above all other artistic means, pictures that as purely pictorial objects have their own independent, intense life."[130] *Composition IV* exemplifies this objective in the most comprehensive way; its emotional and pictorial impact exercises an expressive power over the viewer, independent of its iconographic program. The knowledge and understanding of the imagery engage the viewer on an intellectual level that intensifies the emotional response to the work, and it conveys the artist's "inner feeling" through color, form, and pictorial arrangement.

Composition V

One of the three largest of the extant Compositions, *Composition V* (pl. 34) was Kandinsky's most controversial painting of 1911.[131] Though at first glance the work is abstract, *Composition V* also embodies an extensive apocalyptic program. The artist explained the subject matter of *Composition V* in the text of his Cologne lecture of 1914:

I calmly chose the Resurrection as the theme of Composition 5 *and the Deluge for the sixth. One needs a certain daring if one is to take such outworn themes as the starting point for pure painting. It was for me a trial of strength, which in my opinion has turned out for the best.*[132]

Kandinsky points out the fact that presenting such a theme in a novel way required his experimentation with

the pictorial elements. He also states his ultimate goal: to create pure painting.

Only two small diagrams, drawn on the reverse of a letter, and one study exist as preparatory works for the final oil. The oil *Sketch for Composition V* (pl. 32)[133] is about half the size of the final canvas and resolves most of the problems of the finished picture. The two small diagrams (pl. 33) indicate the general movement of the masses (top) and define different parts of the compositional scheme inscribed with color notations in German (bottom). In the bottom diagram, despite its small scale, one can also distinguish quite clearly forms that appear in the final oil; for instance, the shape of an angel's head, wings, and trumpet in the upper right. Even the central oval from the little diagram seems to carry over into the final canvas, though in a more amorphous shape.

The theme, iconography, and genesis of *Composition V* present a complex issue.[134] It is important, however, to review them here in the context of all of the Compositions. In its overall conception, the painting relates to other works by Kandinsky created in Munich between 1910 and 1911, treating the theme of the Resurrection of the Dead. These are: *The Last Judgment* (fig. 7); *All Saints I* (1911)[135] and *All Saints II* (fig. 8); the four glass paintings *Resurrection*,[136] *All Saints Day I*,[137] *All Saints Day II* (fig. 9), and *Large Resurrection [Sound of Trumpets]* (1911);[138] and two watercolors, *Composition with Saints* (1911);[139] and *Sound of Trumpets (Large Resurrection)* (fig. 10). There is also a woodcut repeating the latter composition in the portfolio *Klänge*. Since these works all represent more literal depictions of the Last Judgment theme, they allow us to discover the abstracted motifs in *Composition V*.

By comparing the related oils and glass paintings, we can discern in *Composition V* several angels blowing trumpets. At the upper left an eye with schematic strands of hair and a wing behind, as well as the elongated shape of a trumpet outlined in black and highlighted in blue, indicate an angel. At upper right another angel blows a shorter trumpet that is highlighted in brownish red. There are three other trumpets, a large one at left and two in the center of the composition, which almost criss-cross each other. The hair of the angels is wind-blown behind the trumpets, and a thick black whiplash line crosses the canvas boldly from right to left and with a sweeping gesture turns toward the center, ending in a trumpet-like form. In the lower center there is a prominent double triangle; at lower left, below the curving line,

a boat with oars can be recognized. Above the black whiplash line, in the very top register, the towers of a walled-in city are clearly visible, and the red flickers of burning candles carried by the praying figures can be seen in the middle register at right. Each of these motifs has been used before, in varying configurations. Even the black whiplash line can be related not only to the linear devices derived from icons, *loubki,* or German medieval images used to represent sounding trumpets, but also to Kandinsky's glass painting with the archangel Gabriel, the prophet of birth and death. This emphasizes one of the important characteristics of Kandinsky's creative method, namely invoking extensive quotations from his previous work and revisions of motifs into new expressive forms.

Although the lower part of *Composition V* is painted rather broadly, one can distinguish the rising dead. The general impression, heightened by the overall grayish tone, is that of an event full of drama and confusion. This feeling is enhanced by the vaporous quality of the colors.

In his Cologne lecture, Kandinsky describes the unlimited possibilities within a color's changed intensity and density that his experiments with color allowed him to explore. He sees cool colors as expressive of tragic events: "To my way of thinking, which was at that time still completely unconscious, the highest tragedy clothed itself in the greatest coolness, that is to say, I saw that the greatest coolness is the highest tragedy. This is that cosmic tragedy in which the human element is only one sound, only a single voice, whose focus is transposed to within a sphere that approaches the divine."[140]

Kandinsky consciously painted a number of works in this spirit, among them *Compositions V* and *VI.* He adopted a different painting method to achieve this, explaining that he "abbreviated the expressive element by lack of expression" by eliminating the clarity of tone from his colors, "dampening them on the surface and allowing their purity and true nature to grow forth, as if through frosted glass."[141] Indeed, the application of paint of *Composition V,* in some parts rather thin, does produce that luminescent quality.

This transparent treatment of certain color zones essentially affects the space of the picture. Without volume, traditional definitions of foreground and background, nor light and atmosphere to create the illusion of perspective, the work conveys infinity. This unvoluminous, non-atmospheric quality is expressed through

7. Kandinsky, *The Last Judgment,* 1910, oil on canvas, 49¼ x 28¾" (125 x 73 cm), Collection Joseph H. Hazen.

the properties and application of color. In this way, abstract forms begin to dominate the canvas, suppressing the more representational ones. The veiling or stripping of the imagery, much more legible in Kandinsky's earlier works, plays a particular role in *Composition V.* It conveys a spiritual and symbolic meaning through the expressive means that Kandinsky considered compatible with the approaching age of the great spiritual. He saw this process of concealing as uniquely suitable for communicating the higher truths of a cosmological order. In spite of his inner tendency toward abstraction, however, Kandinsky still felt that the viewer is not prepared for such intangible language and so should be led by some recognizable motifs toward those spiritual ideas, hence

8. Kandinsky, *All Saints II*, 1911, oil on canvas, 33⅞ x 39" (86 x 99 cm), Städtische Galerie im Lenbachhaus, Munich.

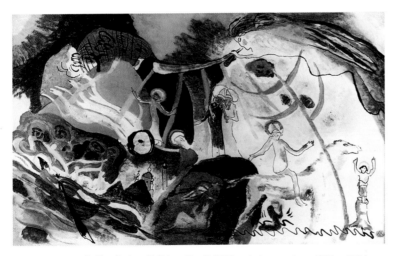

9. Kandinsky, *All Saints Day II*, 1911, painting on glass, 12⅜ x 18⅞" (31.3 x 48 cm), Städtische Galerie im Lenbachhaus, Munich.

the small remnants of representational images within the picture.

The rich spiritual and symbolic meaning of *Composition V* arises out of Kandinsky's immersion in the religious and spiritual ideas of his background: these incorporated the fundamental concepts of Symbolism, especially in its Russian version, and were tinged strongly with mysticism and strengthened by the theosophical

tenets of Rudolf Steiner and his pronouncements on the cleansing power of the Apocalypse and the ensuing spiritual rebirth. The Last Judgment ends an epoch with a cataclysmic event, and so carried the potential for the reconstruction of a new spiritual realm, the new Jerusalem.

Peg Weiss contends that some of the symbols within *Composition V*, such as the double triangle in the lower center of the composition, relate to imagery on the artifacts of the Finno-Ugric tribes of eastern Siberia, specifically a shamanic drum of the Lapp peoples, that Kandinsky would have known from the Museum für Völkerkunde in Munich and from the studies of his friend Nikolai N. Kharuzin.[142] The motif of a one-eyed head of a trumpeting angel with flying hair at the upper left of *Composition V* also has a counterpart among the images on the Lapp shamanic drum. Weiss further points out that the Zyrian imagery can be analyzed in Kandinsky's glass painting *All Saints Day II* (fig. 9), where such personages as Saint Elias, or Elijah ascending in his chariot, can also represent a pagan god of thunder, called Perun or Thor. In the lower left, the figure in a boat corresponds to that of the Zyrian shaman Pam, who encountered Saint Stephen, the Bishop of Perm, on the banks of the Vychegda River; Saint Stephen was responsible for converting the Zyrians to Christianity.

Another motif in the lower right suggested by the black zigzag shape is a horseman with outstretched arms, usually identified as Saint George, but in the Finno-Ugric belief known as the World-Watching Man. Often on a piebald horse, he is a recurring motif in many of Kandinsky's works, and we remember him in particular from *Compositions I, II,* and *III.* Thus he also has a double personality—as the Christian figure Saint George and as Yanukh-Tōrem, a god of northern shamanist tribes and a son of the highest god, for whom the World-Watching Man involves himself with the fate of man.

This kind of syncretism or "double faith," whereby the Christian and pagan motifs become interchangeable, seems to be a recurring feature of Kandinsky's iconography that looks back to his fascination with this phenomenon in his ethnographic paper of 1889 on the beliefs of the Zyrians. His curiosity and knowledge as an ethnographer, combined with his artistic creativity, resulted in his complex, polyvalent imagery that endowed the painting with such emotional charge. However, the final effect was hidden within the formal organization of the picture by way of color and line, and the whole dissolved into a seemingly abstract image. Thus even more

important than the purely artistic content and style is Kandinsky's mastery of "internal feeling which arises out of . . . 'inner necessity.'" *Composition V*, in its search for pure painting, went far beyond the abstracted image.

VI
Composition VI

In 1913, only two months after *Composition VI* (pl. 47)[143] was painted, Kandinsky published in the appendix of the Der Sturm album a text discussing the work, in which he clearly identified its subject as the Deluge.[144] He discusses the circumstances of its creation at the very beginning of this essay:

I carried this picture around in my mind for a year and a half, and often thought I would not be able to finish it. My starting point was the Deluge. My point of departure was a glass-painting that I had made more for my own satisfaction. Here are to be found various objective forms, which are in part amusing (I enjoyed mingling serious forms with amusing external expressions): nudes, the Ark, animals, palm trees, lightning, rain, etc. When the glass painting was finished, there arose in me the desire to treat this theme as the subject of a Composition, and I saw at that time fairly clearly how I should do it. But this feeling quickly vanished, and I lost myself amidst corporeal forms, which I had painted merely in order to heighten and clarify my image of the picture. I gained in confusion rather than in clarity.[145]

Kandinsky painted *Composition VI* almost sixteen months after he completed *Composition V*.[146] While the first five Compositions were executed within a relatively concentrated period of twenty-three months, between January 1910 and November 1911, Kandinsky explains this delay between *V* and *VI* in his essay, emphasizing the struggle between the concept and the process of execution: "In a number of sketches I dissolved the corporeal forms; in others I sought to achieve the impression by purely abstract means. But it didn't work. This happened because I was still obedient to the expression of the Deluge, instead of heeding the expression of the word 'Deluge.'"[147] This account of *Composition VI*, a

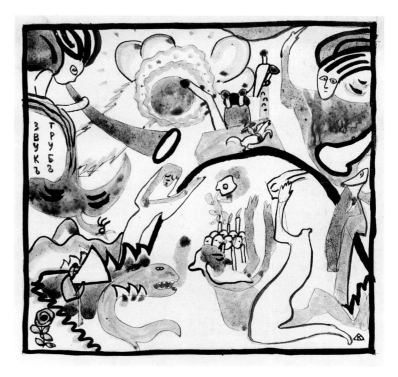

10. Kandinsky, *Sound of Trumpets (Large Resurrection)*, 1910–11, watercolor, india ink, and pencil on cardboard, 8½ x 8⅝" (21.7 x 21.8 cm), Städtische Galerie im Lenbachhaus, Munich.

painting still fresh in the artist's mind, is strikingly lucid and precise. It is clear that Kandinsky is fully conscious of every step in his creative process and of the feelings he experienced throughout its development.

Although the glass painting (fig. 11) on which *Composition VI* is based has been lost, a number of studies are preserved in Munich.[148] They present the evolution of certain motifs in *Composition VI*, and therefore must date to c. 1912. While based on Kandinsky's account of the process, one would expect he would have done many more studies than those extant. Two of the drawings, executed on sheets of the same size, are sketches of animals and figures. One depicts an elephant at left, two nudes in the central section, and a tree in upper left (pl. 35); the other contains human figures along with several studies of hands and legs (pl. 36).

While these two drawings are distinctly figurative and seem also to relate to the painting *Deluge I* (fig. 12), the subsequent studies depict a more general scheme of the work. They also relate to studies for *Deluge II*.[149] In the more gestural drawing (pl. 37) one can detect at

lower left a boat with oars and a standing figure with outstretched arms, above which a small angel blows a trumpet. The horizontal section of the lower register and the amorphous forms at right seem to represent the waves. Other sections contain more generalized forms. Another drawing (pl. 38) is more schematic, however it depicts more clearly such elements as the boat at the lower left or, recalling the first pencil drawing (pl. 35), the elephant at center right. It emphasizes some sections in a more decisive, thicker line and includes color inscriptions for various parts. The corporeal and abstract forms are interwoven. Besides these four process works, there are preserved in Munich five small diagrammatic sketches indicating the fundamental directions of the pictorial elements and the two compositional centers (pls. 39–43).

The first of these drawings (pl. 39) contains a description of the principal concepts and pictorial elements of the painting, graphically developed in the four remaining schematic drawings.[150] Additional drawings are in Paris (pls. 44, 45); one defines the general movement of the action within the painting, while the other represents a detail of a wave and boat at the lower left of the picture that is formally almost identical to this element in the final canvas. Another study in oil was destroyed in World War II.[151]

In an important preparatory oil study, *Improvisation Deluge (Large Study for Composition VI [Deluge])* (pl. 46), the objects are completely dissolved.[152] The painting is an allover composition with multiple amorphous areas of bright colors placed against other darker shapes. The only references to the Deluge are the sharp white diagonal lines in the upper center and the pink, almost vertical lines at upper right. In the lower register, across the composition, the irregular undulating shapes suggest violently crashing waves. This lower section is actually very close in its definition of forms to the corresponding part of the lost painting on glass (fig. 11). The painting is ambiguous spatially: there is no recession, no atmospheric quality. The black forms that fill the interstices of colored ones create a cosmic, infinite space, and the dark colors that modify the bright ones at center left evoke an apocalyptic mood. Several of the motifs that can be found in an earlier painting, *Deluge I* of 1912 (fig. 12), and the study for it at the Norton Simon Museum in Pasadena, reappear in a somewhat veiled configuration in *Composition VI*.

The final *Composition VI* (pl. 47) is a tumul-tuous array of forms interacting and colliding in multiple spatial spheres, creating the impression of a catastrophic event. Some forms are so dematerialized that one perceives only a vaporous mass of disembodied color. The monumental scale of the painting emphasizes further the effect of violent, crushing motion. Kandinsky calculated this effect, as he explains in his essay on *Composition VI*: "In this picture one can see two centers: 1. on the left the delicate, rosy, somewhat blurred center, with weak, indefinite lines in the middle; 2. on the right (somewhat higher than the left) the crude, red-blue, rather discordant area, with sharp, rather evil, strong, very precise lines. Between these two centers is a third (nearer to the left), which one only recognizes subsequently as being a center, but is, in the end, the principal center."[153]

Indeed, in reading the picture the three centers become apparent, and they capture the viewer's attention in a sequential order. First, the center at left is the focus, with its white and pink vortex almost connected to the diagonal, parallel, and multi-colored lines. The multiple lines, representing slashing streams of torrential rain, lead the eye to the right section, where darker forms, including black vertical lines of heavy rain, appear as if haphazardly arranged and create another turbulent focal point. The eye then slides to the lower center to a blue shape outlined in black, with a dark, wave-like form above it. In fact, the entire bottom section, with a boat and oars at lower left, gives the sensation of a misty atmosphere and crashing waves.

The whole composition projects a feeling of controlled chaos of juxtaposed, overlayed, and interrelated forms, interacting in a complex, deep, layered, infinite space. There is a conscious interplay between the two- and three-dimensional element, between surface and space that surrounds the viewer. The degree to which Kandinsky was conscious of these effects is clarified by the explanation he gives in the text on *Composition VI* referring to the centers of the work, as he described: "Here the pink and the white seethe in such a way that they seem to lie neither upon the surface of the canvas nor upon any ideal surface. Rather, they appear as if hovering in the air, as if surrounded by steam."[154] He further elaborates that this impression of the object hovering in an uncertain, undefined distance has the effect of the phenomenon that can be observed in Russian steam baths: "A man standing in the steam is neither close to nor far away; he is just somewhere. This feeling of 'somewhere'

about the principal center determines the inner sound of the whole picture."[155]

For Kandinsky, the "inner sound" of the picture is the crucial aspect of its success as a painting and the key to its understanding. Neither the descriptive quality of figures and objects nor the narrative aspect of the event is essential to him, rather the fact that idea of the event depicted and the sound of the word *Deluge* conjure a feeling in the viewer just as it had in the artist. Kandinsky's emphasis here on the correspondence of an image to the inner sound of the word connects him to Maeterlinck and his model of parallelism of words, sounds, and images. According to Maeterlinck, when a word is used it first evokes in the mind of the listener a dematerialized object. This results in a "vibration of the heart" and thus the word is understood on two levels, as a physical object and as a spiritual entity that evokes the abstract essence of the object, that is, a dematerialized object. This concept is also parallel to Steiner's "vibration of the soul" and the musical analogies of Wagner, Scriabin, and Schönberg. These were the guiding ideas in Kandinsky's creative process of *Composition VI*. He was not only conscious of the formal complexity of the picture, but especially of the conceptual and interpretative elements, a point he clearly states in his text for the Cologne lecture.[156] It is probably for that reason that he goes to considerable length to describe the process of balancing different parts of the picture in order to arrive at the most complete and dramatic expression. He consciously plays the opposite elements against each other:

To mitigate the dramatic effect of the lines, i.e., to distort the excessively importunate voice of the dramatic element (put a muzzle on it), I created a whole fugue out of flecks of different shades of pink, which plays itself out upon the canvas. Thus, the greatest disturbance becomes clothed in the greatest tranquility, the whole action becomes objectified. This solemn, tranquil character is, on the other hand, interrupted by the various patches of blue, which produce an internally warm effect. The warm effect produced by this (in itself) cold color thus heightens once more the dramatic element in a noble and objective manner. The very deep brown forms (particularly in the upper left) introduce a blunted, extremely abstract-sounding tone, which brings to mind an element of hopelessness. Green and yellow animate this state of mind, giving it the missing activity.[157]

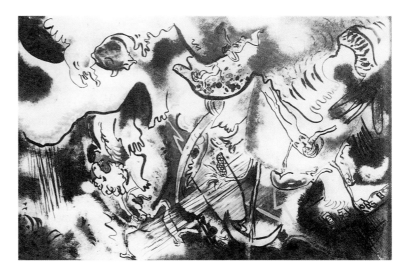

11. Kandinsky, *Deluge (for Composition VI)*, c. 1912, painting on glass, dimensions and location unknown.

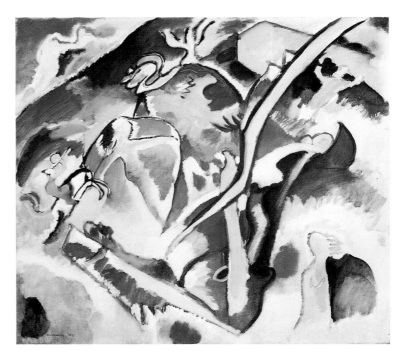

12. Kandinsky, *Deluge I*, 1912, oil on canvas, 39⅜ x 41⅜" (100 x 105 cm), Kaiser Wilhelm Museum, Krefeld.

This passage makes explicit Kandinsky's emphasis on the expressive quality of color over line. It illuminates the mood of the work, adding to our understanding of the iconography of the painting. Even though Kandinsky, beyond indicating very concisely the theme of the canvas, does not really provide any description of motifs in-

volved, his elaboration on the structure of the picture and the expressive qualities of colors explains his intentions better than any reference to the representational. Kandinsky is also conscious that the painting is perceived differently from a distance than when scrutinized from up close. In any event, the fundamental element is that of an equilibrium achieved by balancing different parts, often in an unusual or unexpected manner. As he explains, "So it is that all these elements, even those that contradict one another, inwardly attain total equilibrium, in such a way that no single element gains the upper hand, while the original motif out of which the picture came into being (the Deluge) is dissolved and transformed into an internal, purely pictorial, independent, and objective existence. Nothing could be more misleading than to dub this picture the representation of an event."[158]

Though he uses here some of the same formal devices as in earlier works—such as the vertical lines in *Composition IV*—he takes them a step further. The strong diagonals create an impression of violence and chaos. The underlying motifs are pushed to the limits of abstraction. When we compare *Compositions IV, V,* and *VI,* we can see the progressive dissolution of the object and representation being replaced by allusion, except for remnants of clues to lead the viewer into the picture. This is a premeditated device, as Kandinsky explains, "What thus appears a mighty collapse in objective terms is, when one isolates its sound, a living paean of praise, the hymn of that new creation that follows upon the destruction of the world."[159] This is especially significant since Kandinsky relates the iconography and theme of the Deluge to the notion of spiritual rebirth.

His statement also emphasizes the way he parallels dematerialized forms to musical sounds. His symphonic paintings, which he identifies as being in the idiom compatible with the advent of the epoch of the great spiritual, reveal once more his connection to Western mystical tradition and to the ideas of Western and Russian Symbolism.[160] Kandinsky's systematic dematerialization of forms, intended to convey the higher truths, connects him further to the theosophist notion that considers matter to be a denser version of spirit.

Composition VI reflects Kandinsky's spiritual vision of color and the process of dematerialization of form evolved into an intensely spiritual work conveyed through almost entirely abstract language. With its two centers that can create almost two separate pictures,

Composition VI looks formally back to *Composition II* and *Composition IV*. On both the conceptual level, through the use of eschatological themes, as well as stylistically, through his increasing abstraction, it relates very closely to *Composition V*.

Composition VII

The large oil *Composition VII* (pl. 81) is the most monumental and complex painting in Kandinsky's oeuvre of the pre-1914 period. It represents the culmination of Kandinsky's artistic development toward an abstract form that is disconnected from the depictive function. Although overtly abstract, it is known to contain a highly charged iconographic program based on apocalyptic subjects. According to Gabriele Münter, who photographed the process of its creation (fig. 15), *Composition VII* was painted in a remarkably short period of time, between November 25 and 28, 1913. It was preceded by over thirty drawings, watercolors, and oil studies, many of which are housed in the Städtische Galerie im Lenbachhaus, Munich.[161] These studies scrupulously document the process of creating the final oil.[162]

The preparatory drawings and watercolors in Munich fall into three distinct groups, although their exact chronology is difficult to establish.[163] It seems that for Kandinsky the process of creation was never linear; there is no certainty that one study results from another and leads to the next. His investigations might extend over a long period of time, and he seems to go back and forth between several motifs at the same time.

Particularly fascinating are two drawings from a sketchbook (pls. 48, 49) that show the unfolding of different variants of a compositional arrangement in the watercolor study for *Composition VII* (pl. 52) and *Watercolor (No. 13)* (pl. 53); these address motifs that are not necessarily present in the same form in the final work. Possibly contemporaneous are the analytical drawings that treat separate motifs, such as two drawings that study the three oval forms of reclining figures at the lower right of *Composition VII* (pls. 50, 51).

The most coherent group of studies consists of four pen-and-ink drawings and three watercolors, each inscribed on the mount by Kandinsky "Zu Komposition

7," and numbered 1 through 7. This group of studies develops several motifs incorporated into the overall scheme of *Composition VII*. The first one (pl. 54) shows general disposition of forms, many of which, in a somewhat modified version, remain in the final picture. The drawing is executed in a thin, rapid line, defining separate motifs in a firm, decisive way. The second drawing (pl. 55), according to Kandinsky's numeration, develops one of the motifs that seems related to the lower center and lower right section of the preceding drawing, although in the final painting that section is structured quite differently. There is a special calligraphic quality to the drawing and to the way the quick, thin line describing principal outlines interacts with shorter, closely grouped strokes, suggesting greater color activity. The third drawing (pl. 56) elaborates the central section of the painting. It essentially includes all the elements, such as the oval form intersected by an irregular rectangle in the center; the oval boat-like shape in lower right; another triangular boat-like form at left in the middle section; and a heavily delineated S-shaped form, possibly a mountain, shaded by cross-hatching, surrounding the central motif. The fourth and last pen-and-ink drawing (pl. 57) in this group reworks the lower right quarter of the overall composition. It marks the focal points of that section and experiments with the altered positioning of forms, for instance the central oval and the boat further below it. To a certain degree, it repeats some ideas from the second drawing (pl. 55).

The three watercolors in this group of seven works are all executed with vibrant patches of color combined with strong linear elements. Although they include pen and ink and pencil, the balance of expression is more in favor of color than line. The watercolor inscribed "5" (pl. 58), whose motif appears to relate to the glass painting *The Last Judgment* of 1912 (fig. 13), is of particular interest for decoding the iconography of the final oil that is disguised by the premeditated abstract form. We can recognize the head of an angel blowing a golden trumpet at upper right; the red patch of color crossed horizontally by undulating black lines symbolizing Elijah descending in his chariot; and a black boat-like shape floating in the lower right, recalling the boat with saints in the lower right register of the glass painting. Spatially, the work is loosely structured but has a clear and deliberate organization, although at first glance the brilliant colors seem to be distributed freely. This watercolor further points to a similarly structured *Sketch 14*

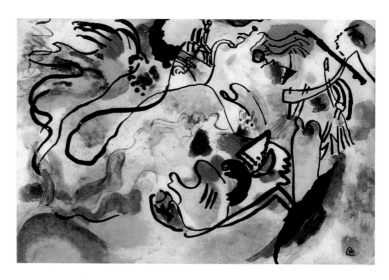

13. Kandinsky, *The Last Judgment*, 1912, painting on glass, 13⅜ x 17¾" (34 x 45 cm), Musée National d'Art Moderne, Centre Georges Pompidou, Paris; bequest of Nina Kandinsky, 1981.

(*Study for Composition VII*) (pl. 61) and an oil, *Study for Composition VII* (pl. 77), in which the Last Judgment motifs can easily be distinguished: for instance, the blue-faced angel blows the golden trumpet at the upper right; the red amorphous shape with three blue horizontal strokes symbolizes Elijah's chariot; the mountain with walled city topples over in the center; and the red trumpet is seen at center left.[164] The watercolor that forms the sixth study from the group (pl. 59) is similarly inscribed "6" following "Zu Komposition 7." Smaller than the previous study but equally vibrant, in its compositional scheme it recalls the first pen-and-ink drawing of the group (pl. 54), although some sections, such as the lower right, are noticeably changed. According to the catalogue raisonné of watercolors, it is a study for the oil *Sketch 1 for Composition VII* (pl. 65).[165] It is even closer to the pencil *Drawing Related to Sketch 1 for Composition VII* (pl. 62) and the pen-and-ink *Drawing Related to Sketch 1 for Composition VII* (pl. 63) as well as the watercolor *Study for Sketch 1 for Composition VII* (pl. 64). The arrangement of forms in all these works shows great similarity and points out Kandinsky's practice of alternating drawings and watercolors to resolve compositional issues, many of which carry over to the final painting. The last watercolor from the group, inscribed "7" (pl. 60), elaborates the motifs of the central section of *Composition VII* that are already sketched out

in the drawing inscribed "3" (pl. 56), modifying the shapes and their relationship to each other.

A further analysis of this central section can be found in a watercolor (pl. 66), another small schematic drawing (pl. 67), and an oil, *Section 1 for Composition VII (Center)* (pl. 68) where once more the proportions of the forms are different. It is elaborated in another preparatory oil, *Section 2 for Composition VII* (pl. 75).

Several diagrammatic drawings, with various inscriptions in Russian and German, especially illuminate Kandinsky's process of creating *Composition VII*. A schematic pen-and-ink drawing (pl. 69) highlights with quick, thin lines the basic outline of the general conception of the picture and more specifically identifies (in Russian) the individual colors and ideas.[166] Its inscriptions indicate that the artist is working out some basic details of *Composition VII* and places what he calls the "genesis"—depicted by a red and a blue line—in the lower left corner; "abyss" at lower right, below a semicircular section marked "yellow dirt"; in upper left, "discontinuity" (probably of forms and colors); at center top, "clear and divided" (or right and resolution), marked in warm red; the central motif, placed higher than in the final oil, specifies "on white exact" and is surrounded on the left by "red (hot)." Such notes attest to Kandinsky's extremely methodical process of creation, also emphasized by a few other drawings that analyze further the structure of the compositional scheme, in terms of movement and interaction of elements (pl. 70), color (pl. 71), and organization of masses (pl. 72).

Another pen-and-ink drawing, more specific in the definition of the compositional parts (pl. 73), shows in a linear fashion the direction and placement of the pictorial components and defines the central section contained within the upper and lower semicircular line as the main field of activity. Here, the oval form intersected by the rectilinear one is situated much higher and is closer to the top section of the pictorial field than it is in the final canvas. The inscriptions relate to the disposition of colors. There is also a small sketch of a detail with a double triangle as its center (pl. 74) that might have a connection to a central motif in the oil sketch *Study for Composition VII* (pl. 77). It seems to disappear in the final composition.

The most important group of works that are essential to understanding *Composition VII* are six oil studies for it, listed in the Handlist as numbers 179 to 185 (*Composition VII* follows in the Handlist as 186).

The first of these, *Sketch 1 for Composition VII* (pl. 65), is a very complete, fully developed preliminary work. It is approximately one-third the size of the canvas of *Composition VII* and is executed in bright colors of high intensity—it is in fact much brighter than the final painting. The greater contrast between the bright and the dark sections creates an almost ominously explosive and vibrant mood. Among some thirty preliminary studies on paper for *Composition VII*, four (pls. 59, 62, 63, 64) can be specifically related to this oil work.

There is really nothing preparatory about this sketch; all the relationships between the colors and forms are carefully worked out. The compositional center is in the very middle of the canvas. The balance of parts is extremely well thought out: as Kandinsky often emphasized in his writings, and particularly in his description of *Composition VI*, the bottom and the top of the pictorial construction are arranged in such a way as to arrive at a perfect equilibrium.[167] Here, the lower section is filled with swirling smaller forms, while the upper register is painted more broadly in brighter, vibrating hues of vivid yellows and reds. These two colors are repeated in the lower section to the left of center, below the semicircularly orchestrated darker central section. Thus the red and yellow produce a resounding effect and emphasize the tumultuous, darker central section. The composite forms are pressed toward the limits of abstraction and create a spatially complex painting of unusual strength and beauty.

A remarkably different treatment of color and mood is found in Kandinsky's *Sketch 2 for Composition VII* (pl. 76).[168] Half the size of the finished work, its bright colors vibrate sonorously throughout the canvas. There are certain differences from the earlier oil studies: it has a variant color scheme, several forms are altered and repositioned, and the entire lower section is painted quite loosely, emphasizing broad irregular areas of color rather than more defined shapes. But the principal characteristics evident in *Sketch 1 for Composition VII* are retained and evolve toward greater abstraction. The first impression is that of turbulent, chaotic explosion of colors and amorphous forms, anchored at the center by the small red oval, circled in blue, which was the focal point of the work from its very inception. However, in this oil study there is a great equilibrium between upper left and bottom right as well as between the horizontal sections at the top and bottom. The upper register is heavily packed with forms, while the bottom is almost

strangely empty, simply filled with color. Both parts horizontally and diagonally counterweigh each other and create a dynamic movement of forms in a tightly knit space.

The eschatological motifs that were at the origin of the seemingly abstract forms are hidden within, and the viewer immerses himself in the composition trying to decipher the many levels of veiled meaning. *Sketch 2 for Composition VII* is followed in the artist's Handlist by the *Study for Composition VII* (pl. 77), which might have been executed earlier, and which compared to *Sketch 2* shows more overtly figurative motifs related to the eschatological themes that formed the conceptual departure for *Composition VII*. As indicated in the discussion of the watercolors *Study for Composition VII* (pl. 58) and *Sketch 14* (pl. 61), the angels blowing trumpets, Elijah in his chariot, the tumbling towers of a walled city, the large mountain in the center of the composition, and the human figures at right center are all clearly visible. They relate the work to the Resurrection paintings (figs. 7, 10) and the Last Judgment glass painting (fig. 13) and help to decode the underlying iconography of *Composition VII*.

The fourth canvas among the oil studies, *Study for Composition VII* is also somewhat different in general scheme. Forms are more concentrated toward the outer perimeter of the canvas, leaving the emptier center to be occupied by the large mountain. The central oval motif is here placed much lower and to the left, ceding its central position to a blue rhomboid form or overlaid triangles with a red center. The overall color scheme is golden yellow, with darker forms floating throughout the outer sections of the pictorial field. The central motif of the mountain with the onion-domed towers is reminiscent of that same motif in several other works.[169] The mood of the work seems less ominous than that conveyed by other studies, for instance the final *Sketch 3 for Composition VII* (pl. 80) in Munich.[170]

The exceptionally large *Sketch 3 for Composition VII* might have been preceded by two other studies. *Watercolor with Red Spot* (pl. 78) relates to the central section of *Composition VII* and emphasizes the area above the main focal motif. Broadly defined abstract shapes, among which one can still distinguish a triangular hull of a boat (at center left), two reclining figures (at lower left), and a second boat (at lower center), all add up to a brilliant whole.[171] Although dated 1911 in the Handlist, on stylistic grounds it definitely belongs among the works of 1913. The brightly colored work sums up Kandinsky's

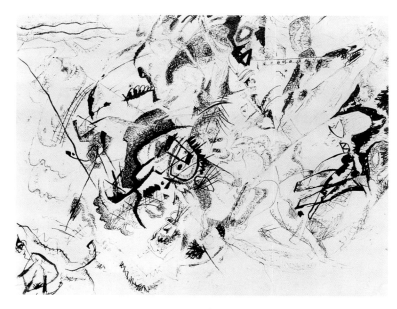

14. Kandinsky, *Drawing for Composition VII*, 1913, pen and ink on paper, dimensions and location unknown.

philosophy of greater expressive strength through color than through form.

The last work on paper related to *Composition VII* is a watercolor in Paris, *Untitled (Study for Composition VII)* (pl. 79) that gained notoriety as "the first abstract watercolor" and was for years considered by scholars to have been done in 1910, owing to the artist's inscription.[172] In 1978, a Japanese scholar, Hideho Nishida, first proposed that the work actually represents the eighth study for *Composition VII*, and thus dates to 1913.[173] The work is unusually large among the studies, its size approaching only that of *Watercolor with Red Spot,* and presents a very loose structure of multiple amorphous forms found in the final oil. Certain elements are clearly identifiable: the central motif of an oval intersected by an irregular rectangular form, the blue form to the left of it, the boat with oars below it, the three oval forms reworked in two other drawings (pls. 50, 51) at center right, the two parallel strokes (reclining figures) at lower left, and the red trumpet at upper left, to name only a few. The fresh colors are very sparsely distributed through the compositional field and project strongly against the neutral background. This lets the white paper play an important part as the light makes the colored forms stand out and hover in an infinite space. The overall airy impression is contrary to that of the final composition, where the forms are very tightly organized and violently collide with each other.

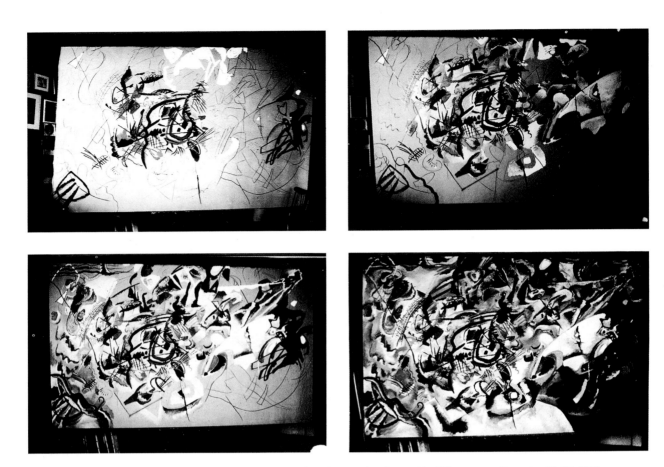

15. Four photographs taken by Gabriele Münter in the span of 3½ days documenting *Composition VII* in progress, November 25–28, 1913.

The final extant study for *Composition VII*, entitled *Sketch 3 for Composition VII* (pl. 80), is the last of the six preparatory oils. It is a riotous arrangement of, at first sight, abstract forms that clash in a circular motion towards the center of the composition, which contains a red circle outlined in blue and overlayed by a cross-like form of black lines. The red and blue are echoed by the adjacent semicircular form to the left of the central motif, which gives a sense of creating a vortex within the clashing dynamic forms. To a large degree, the elements of the central, bottom left, and bottom right sections remain the same in the final work. The mimetic pictorial motifs guiding the viewer to the complex iconography of the final painting are here much more dissolved and hidden among the abstract shapes, but the overall composition has a similar mood to that of the final picture. A lost drawing, known only in reproduction (fig. 14), depicted almost exactly the final scheme of *Composition VII*. Although the finished painting shows modifications of certain areas, the drawing represents the fully developed conception of the work in minute detail.

The process of executing the painting, documented by Münter in four photographs (fig. 15), sheds light on the completion of the work. From the photographs, we can ascertain that the full composition was drawn out on canvas, then the artist began painting the central section and that at the extreme right. He elaborated the parts above and below the central motif, expanding the arrangement of forms toward the center right and creating a profusion of forms in circular motion around the central motif. Next, he developed the entire left side and, finally, the lower right.

The final *Composition VII* (pl. 81) represents the conceptual and stylistic pinnacle of Kandinsky's Munich period and embodies his philosophical and pictorial ideas of that time.[174] Further, it marks a turning point in Kandinsky's development toward an increasingly abstract idiom. The complex iconography of *Composition VII*, as has been pointed out by several scholars, combines the themes of the Resurrection, the Last Judg-

ment, the Deluge, and the Garden of Love.[175] The motifs relating to all of these subjects are recognizable among the turbulent abstract and semi-abstract shapes, and can be identified on the basis of those present in the numerous preliminary studies.

Formally, *Composition VII* is focused around the motif of an oval outlined in green and black and criss-crossed by two horizontal black lines and an irregular black rectangle. This central motif is placed more toward center left in all of the preliminary sketches, thus creating a diagonal motion from lower left to upper right. It is closely surrounded by the vestiges of the blue mountain, a boat with three oars outlined in black at the lower left, a smaller triangular hull of a boat at middle left, and another boat shape with a figure and two oars below the central motif at the bottom of the canvas. The elongated blue shapes at upper right bring to mind the trumpets and their resounding music as in depictions from the Russian folk *loubki* (fig. 3) or German fifteenth-century bibles, where the sound is symbolized by straight lines spilling out of a trumpet and crossing the pictorial field. Here it is represented as the outer edges of an extended blue conical form. Another source of this motif could have been the fresco by the Nazarene painter Peter von Cornelius above the main altar of Saint Ludwig's Church in Munich (fig. 16), which was certainly familiar to Kandinsky. Vestiges of other trumpets are visible in the top register, defined in yellow, and an extended orange arm of a blue angel appears to hold one of the yellow trumpets. The shapes of a horse and rider, initially placed in the right section, are now barely evident. At the right mid-section, two purple oval shapes are placed diagonally, close to each other. This is Kandinsky's abstracted, universalized form of a couple, formerly seen in a similar configuration in *Composition IV* (pl. 31) and easily recognizable from Kandinsky's Garden of Love paintings and watercolors. These shapes lead the spectator to discover a comprehensive apocalyptic iconography that symbolizes Kandinsky's viewpoint of the world's condition and its future, as well as his conviction that art leads to a spiritual renewal.

Kandinsky thus strove to evolve imagery evocative of the ideas and the themes of the Deluge, the Last Judgment, and the Resurrection—fitting subjects for finding the universal language that would imply the change of focus from the external and representational to the internal, spiritual, and abstract. But just as destruction and catastrophe had to bring the hope of re-

16. Peter von Cornelius, *The Last Judgment*, 1836–39, fresco, St. Ludwig's Church, Munich.

newal and the spiritual, so to balance his catastrophic imagery, Kandinsky introduced the motif of an Eden or the Garden of Love, represented in *Composition VII* in the lower right corner of the pictorial field, where we see the oval shapes placed diagonally as if intertwined, symbolizing the reclining couple. This device of balancing the left and right sides of the composition with contradictory events is similar to his solutions in *Compositions II* and *IV* (pls. 12, 31). The introduction of the Garden of Love motif universalizes the concept of the reclining couple, recalling the late–nineteenth-century Symbolist notion of transcendent love and the idyllic state of the world.[176]

In depicting such a traditional paradisiacal scene, Kandinsky veils the image, stripping it of the subjective element, and retains the general connection between the representational and the abstract through pictorial means: form, color, movement, and balance—the inner sound of the picture. *Composition VII* in its conceptual, iconographic, and stylistic complexity embodies Kandinsky's artistic aspirations. It expresses his apprehension about the materialistic epoch and his hope for the imminent arrival of the new spiritual epoch. Finally, it situates art as the means of salvation in this process.

Late Compositions

VIII

Composition VIII

The last three Compositions indeed took a very different stylistic course. Having painted seven Compositions within a fairly compressed period of time, from January 1910 to November 1913, an entire decade passed before Kandinsky executed another painting he would call *Composition*. However, extant works on paper point to an earlier conception of *Composition VIII*, for an untitled watercolor on tracing paper of 1918, once known as *Lyrical Invention* (fig. 17),[177] is very close in composition and identical in size to an ink drawing of 1918 in the Tretyakov Gallery, Moscow.[178] Stylistically, these works are dramatically different from the cool geometric *Composition VIII* of 1923 (pl. 85). The first conception was based on more organic forms that appear related to naturalistic, perhaps landscape-inspired content. Because he later renamed the final oil *Pointed Suspension*, it would seem that he decided it did not correspond to the concept of Composition. It was only in July 1923, while Kandinsky was again in Germany teaching at the Bauhaus in Weimar, that he painted *Composition VIII*.

Already during a period he spent in Russia from 1915 to 1921, Kandinsky began to rely increasingly on geometric form in combination with the freer forms characteristic of his earlier years. He continued to explore this style in the first years after his return to Germany. As time went on, his style grew away from the expressionistic elements of his pre-war Compositions toward a more universal, objective idiom influenced by Suprematism and Constructivism. Yet philosophically, he still retained some aspects of his thought from before the war. For instance, in his foreword written in Berlin in April 1922 for the catalogue of the First International Art Exhibition that took place in Düsseldorf in May of that year, he wrote: "The irreconcilable is reconciled. Two opposing paths lead to one goal—analysis, synthesis. Analysis + synthesis = the Great Synthesis. In this way the art that is termed 'new' comes about, which apparently has nothing in common with the 'old' but which shows clearly to every living eye the continuing thread. That thread which is called Inner Necessity. Thus the Epoch of the Great Spiritual has begun."[179]

When Kandinsky joined the Bauhaus in June 1922, it became for him the beginning of the "Great Synthesis." Among the Bauhaus faculty members were his old friend Paul Klee and other artists: Johannes Itten, Oskar Schlemmer, Lyonel Feininger, Georg Muche, Lászlò Moholy-Nagy, and Joseph Albers. Among them, it was particularly Itten's method of elaborate geometric analysis and reductive schematization that appears to have influenced Kandinsky's own teaching system of analytical drawing. His style underwent a significant change. During his Bauhaus years in Weimar (1922–25) Kandinsky continued both his writing and his art. He wrote three essays: "The Basic Elements of Form," "Color Course and Seminar," and "Abstract Synthesis on the Stage." They resumed, to a certain degree, the line of ideas expressed in his pre-war essay "On the Question of Form" and his seminal treatise *On the Spiritual in Art*.

In the Bauhaus writings, there is a major shift in his theory: now form is emphasized over color as the primary expressive pictorial element, a reversal of the ideas of the artist's early Munich period (1896–1914). In a 1936 letter to Alfred H. Barr, Jr., Kandinsky commented about the work of this period: "After the 'dramatic' period before the War (called 'lyric period' in France), I slowly developed into a *great calmness* which was, of course, already foreshadowed before the War. This period received no less criticism than the first: it was said that I worked in a 'cool' or 'cold' manner, that my pictures had lost all life . . . Good examples of both periods can be seen in the collection of S. R. Guggenheim (for instance the 'dramatic' 'Black Lines' and the 'cool' 'Composition 8.')"[180] Will Grohmann reported that in later years Kandinsky considered *Composition VIII* as "the high point of his post-war achievement."[181]

There are only a few preparatory studies for

Composition VIII. They are a pencil and india ink drawing in Paris (pl. 82); a watercolor, *Study for Composition VIII*, in a private collection in Europe (pl. 83); and a study in pencil, india ink, and watercolor on paper, also in Paris (pl. 84).

The latter drawing (pl. 84), executed—as was the painting—in July 1923, shows a compositional scheme approximating the final work.[182] Certain areas have been changed in their configuration, for instance the lines with the semicircular motifs that cut diagonally through the blue mountain have become a single thin line overlayed with a snake-like motif; the amorphous shapes in the same section and the diagonal line forming the bottom of the acute triangle in center right of the first drawing (pl. 82) have been eliminated; and the motifs at the base of that triangle are more geometric, adjacent semicircles in the final composition. Additionally, the linear structure within the right acute triangle has been significantly altered. But the work is squared up as though in preparation for its transposition onto a canvas and also includes inscriptions in German referring to the color scheme. The visible grid suggests that the work was probably a final study for the oil.

The watercolor (pl. 83) is a preliminary study for the right section of the composition. Its color scheme points closely to that of the final work. The other drawing (pl. 82) addresses the section of the canvas just to the right of the center, experimenting with many more circular forms and linear rhythms than are present in the final painting. It is more an alternate resolution of the motif used in the right section of the composition than an actual study for it. These are motifs that reappear in several works unrelated to *Composition VIII*. As with the preliminary sketches for the other Compositions, one is struck by the premeditated, unhesitant aspect of the formal arrangement of the studies for *Composition VIII*. Kandinsky has worked out conceptually what is to be depicted before confining it to paper.

Formally, the pictorial vocabulary in *Composition VIII* (pl. 85) is reduced to a relatively small number of geometric forms: circles, semicircles, open-ended acute angles, blocks of squares and rectangles in diverse irregular configurations, and other linear elements. The focal point of the picture is the large multicolored circle at upper left, adjacent to a smaller red circle; the compositional balance is reached through their juxtaposition with the linear configuration in the right section of the canvas. In fact, the general impression is that of a linear

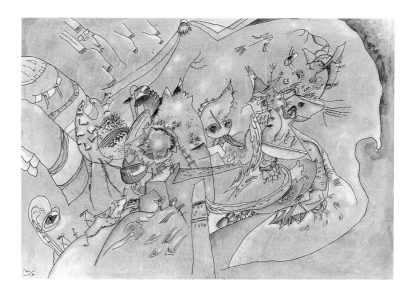

17. Kandinsky, *Untitled (Related to Composition VIII [Sketch])*, 1918, watercolor, opaque white and india ink on tracing paper, mounted on cardboard, 10⅛ x 13½" (25.7 x 34.4 cm), Solomon R. Guggenheim Museum, New York; gift, Solomon R. Guggenheim, 1941.

structure placed against an empty, light-colored background. The formal arrangement of the elements seems to be inspired by a landscape. The black and purple circle outlined with the pink aureole is positioned like the sun above the mountain-like shapes, with a lower, broader, blue one and a higher, steeper mountainous form depicted as a pinkish acute angle. The geometric forms are organized horizontally within the pictorial field, yet despite their placement on the surface, we read the composition as taking place in a layered, undefined space, the hidden imagery no longer taking on as important a role as in the pre-1914 Compositions. There is a great ambiguity in the spatial structure of the picture that results from the use of the light background colors—white in the middle section, pale yellow toward the top, and light blue toward the bottom. This ambiguous quality is further emphasized by the other circular elements, surrounded with an aureole of a complementary color, making it difficult to judge whether the elements recede or advance.

This type of undefined, infinite space brings to mind the work of Kasimir Malevich who, beginning with his early Suprematist canvases, used the white background as a foil for the multi- or single-colored geometric shapes arranged into various configurations (fig. 18). For Malevich, such works were to convey a sense of forms floating in an indefinite space, symbolic of the

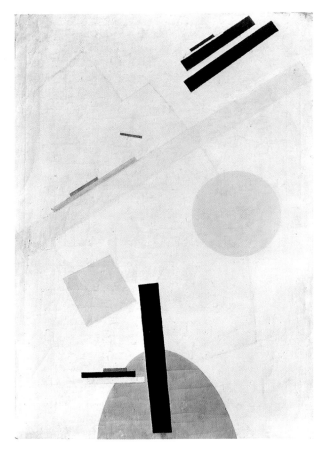

18. Kasimir Malevich, *Suprematist Composition*, 1916–17, oil on canvas, 38½ x 26⅛" (97.8 x 66.4 cm), The Museum of Modern Art, New York.

ten over ten years earlier, those writings seem especially pertinent to *Composition VIII*, even though here form dominates over color as an expressive medium:

Form itself, even if completely abstract, resembling geometrical form, has its own inner sound, is a spiritual being possessing qualities that are identical with that form. A triangle (without more detailed description as to whether it is acute, or obtuse, or equilateral) is one such being, with its own particular spiritual perfume. . . . Here the interaction of form and color becomes clear. A triangle filled with yellow, a circle with blue, a square with green, then again a triangle with green, a circle with yellow, a square with blue, etc. . . . The effect of deeper colors is emphasized by rounded forms (e.g., blue in a circle). Of course, it is clear on the one hand that the incompatibility of certain forms and certain colors should be regarded not as something "disharmonious," but conversely, as offering new possibilities—i.e., also [a form of] harmony.[184]

In *Composition VIII* Kandinsky explores these multiple possibilities of confining different colors within different shapes, as with the blue right angle and the pink acute angle, or the blue circle outlined in pink and yellow counterpoised by the yellow circle haloed in blue. The very careful balance between the circular and the linear elements within the composition is played out by the colored circles of varying sizes that are distributed throughout the pictorial field, enlivening the surface and contrasting with the sharp linear forms that include diagonals moving toward the upper right.

It is revealing that in 1929 Kandinsky explained in an answer to a psychologist's questionnaire that he felt the same love for the circle motif as he had felt for the horse motif during his early pre–World War I years.[185] Kandinsky began to use the circle motif in his works in 1921, but by 1923 it assumed a much more prominent position within his pictorial vocabulary.

The circle, which came to play such a strong role in *Composition VIII*, had certainly gained importance among the artists of the avant-garde in the several years preceding this work. Aleksandr Rodchenko in Russia and Laszlò Moholy-Nagy at the Bauhaus had each, in different ways, used the circle as an almost iconic image (figs. 19, 20). Like the form of the square, which for Malevich was replete with possibilities, so did the form

absolute, the cosmic, and the higher spiritual plane. Kandinsky, who had spent seven years in Russia at the height of the development of Malevich's Suprematism, probably absorbed that influence into his own art, translating it into his personal expression. Malevich's concept of the art that reached a higher spiritual plane through the formal non-objective language of pure geometric forms would have in many respects corresponded to Kandinsky's own aspirations, expressed earlier in his theoretical writings. Furthermore, Kandinsky's concept of balancing top and bottom of the canvas, the idea he had emphasized in his discussion of *Composition VI* a decade earlier, is particularly clear in terms of such powerful color combinations as blue and yellow. This recalls closely his ideas about the effects of color that go back to 1910, expounded in the chapters "Effects of Color" and "The Language of Forms and Colors" in *On the Spiritual in Art*.[183] Despite the fact that they were writ-

of the circle represent for Kandinsky a symbol of great inner force. He stresses this aspect in a letter of 1930 to his early biographer Grohmann:

You mention the circle, and I agree with your definition. It is a link with the cosmic. But I use it above all formally... Why does the circle fascinate me? It is
(1) the most modest form, but asserts itself unconditionally,
(2) a precise but inexhaustible variable,
(3) simultaneously stable and unstable
(4) simultaneously loud and soft
(5) a single tension that carries countless tensions within it. The circle is the synthesis of the greatest oppositions. It combines the concentric and the excentric in a single form, and in balance. Of the three primary forms [triangle, square, circle], it points most clearly to the fourth dimension.[186]

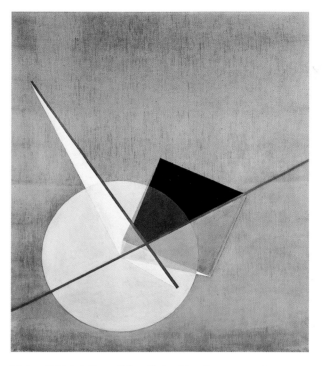

20. Laszlò Moholy-Nagy, *Yellow Circle*, 1921, oil on canvas, 53⅛ x 45¼" (135 x 115 cm), The Museum of Modern Art, New York; the Riklis Collection of McCrory Corporation.

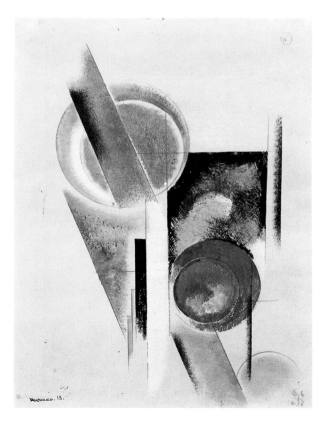

19. Aleksandr Rodchenko, *Composition*, 1919, gouache on paper, 12¼ x 9" (31.1 x 22.9 cm), The Museum of Modern Art, New York; gift of the artist.

Kandinsky's reference to the fourth dimension is analogous to aspects of the Suprematism of Malevich, who through the formal constructions of his paintings—composed of non-objective geometric forms floating against an unstructured white background—tried to achieve the space-time continuum and the spiritual dimension.

In *Composition VIII*, through Kandinsky's orchestration of the smaller circle motif and its interaction with the triangle, he explores all of the tensions and variable possibilities—simultaneous stability and instability, concentric and excentric forces—and the powerful impressions they convey to the viewer. These polarities are analogous to those created by the contrast of two primary colors, such as blue and yellow. The powerful interaction of vibrant forms and color in *Composition VIII* creates a dynamic, pulsating whole.

Composition VII and *Composition VIII* lie at opposite ends of the spectrum. Where the earlier work was apocalyptic, agitated in the emotion conveyed through the chaotic expressive arrangement of forms cut off by the picture edge, *Composition VIII* presents a reflective, introspective, and peacefully orchestrated

mood. Although dynamic in their interaction, the forms of *Composition VIII* show great clarity of organization within the pictorial field.

It has been suggested that *Composition VIII* was essentially conceived by Kandinsky as being constructed on an "ideal plane" that comes into existence in the process of moving toward abstraction, eliminating modeling and thus the third dimension, and anchoring the picture to the surface.[187] But Kandinsky felt that the flat depiction on a picture plane had serious constraints and that the picture must exist on that ideal plane, which would be situated somewhere in front of the physical plane. In this respect, we are reminded of the preoccupations of his Russian contemporaries at the beginning of the second decade of the century. They very strongly emphasized the importance of the "surface plane" and *faktura* as active components of pictorial expression.[188]

Even in his geometric abstract works, Kandinsky does not abandon his goal of achieving harmony and the inner expression of the soul. His definition of pictorial composition, given twelve years earlier in *On the Spiritual in Art*, still rings true with *Composition VIII*: "Clashing discords . . . opposites and contradictions— this is our harmony. Composition on the basis of this harmony is the juxtaposition of coloristic and linear forms that have an independent existence as such, derived from internal necessity, which create within the common life arising from this source a whole that is called a picture."[189]

Composition IX

In late December 1933, Kandinsky and his wife arrived in Paris and settled in the suburb Neuilly-sur-Seine; this move marked for him an important personal and stylistic transition. The process of adjusting to a new country and a foreign artistic atmosphere was for Kandinsky a discomforting exile. In 1933 he was sixty-seven years old, and for almost half his life he had lived in Germany, which had become his second home. Kandinsky did not paint for the period of about six months surrounding his move to Paris. This inactivity, understandably due to the whole circumstances of his uprooting, was followed, however, by a richly prolific period: over the eleven years

that he spent in Paris, Kandinsky executed a large number of works in different mediums, including one hundred and forty-four paintings, two hundred and fifty watercolors and gouaches, as well as several hundred drawings.[190]

In France, his art again underwent transformations and his style changed noticeably. When he resumed painting in the early months of 1934, the artist introduced a new vocabulary of biomorphic and amorphous shapes, imagery that seems to reflect his exposure to Surrealism. Although he violently opposed the notion that these forms were influenced by the styles of Arp and Miró, it is hard not to see the affinities. Yet his new formal language might also stem from biological interests, as proposed by Barnett.[191]

Kandinsky painted his two final Compositions while in France: *Composition IX* in 1936 (pl. 86) and *Composition X* in 1939 (pl. 88). Although monumental in format, with the exception of *Composition I* they are the smallest of the ten canvases. Despite the extraordinary number of drawings executed within these last years, there exist only one preparatory drawing for *Composition IX* (pl. 87), and none for *Composition X*. While it is possible that Kandinsky discarded some drawings, a statement by Nina Kandinsky illuminates his drawing habits and working process: "He had the rare ability to visualize the world in his paintings in his head, with their colors and their shapes, exactly as he carried them out on canvas later."[192] This exceptional gift would account for the relatively small number of preparatory drawings for most of the Compositions.

Composition IX of 1936 (pl. 86) combines Kandinsky's geometric tendencies with his newfound interest in biomorphic imagery.[193] It embodies his theories regarding the relationship between art, nature, and technology, a concept that had been already introduced during the Bauhaus period.

In analyzing the work, the important question we must ask is why Kandinsky chose to call this work a Composition. Unquestionably, the picture shows a complex organization, and certainly it is unique in its use of the wide diagonal stripes as a background against which are superimposed shapes that are both geometric and amorphous, biological and abstract. The diagonal stripes bring to mind symbols of the successive chords in a musical piece. Some of the floating geometric forms—the squares, rectangles, and narrow parallel planes—recall the configurations of Suprematism, but the rigid geo-

metric structure is counteracted by the floating amorphous elements that create a compositional tension. An almost pastel color scheme adds to the work a sense of playfulness, making a special universe of forms in flux.

The complexity of spatial organization in *Composition IX* is quite different than that of *Composition VIII*, where the pale, almost white background creates a sense of infinite space. Here the space is blocked off by the solid diagonal stripes of color and diverse overlapping shapes that float in front of the pictorial plane, creating a horizontally layered and ambiguous space. Forms and colors play equal roles in ambiguities of tension and space. The precision, clear graphic form, and the light hues of color contribute to the controlled expressive energy of *Composition IX*. But there is something soft and ornamental about this canvas, which, no matter how attractive its formal arrangement and stylistic change, does not equal the explosive strength of the early pre-war Compositions.

The picture seems to respond to Kandinsky's ideas about the merits of abstract painting, expressed in his "Reflections on Abstract Art," published in *Cahiers d'Art* in Paris in 1931 and written while he was at the Bauhaus in Dessau (1925–33): "Abstract painting can, of course, in addition to the so-called strict geometrical forms, make use of an unlimited number of so-called free forms, and besides primary colors can make use of an unlimited quantity of inexhaustible tonalities—each time in harmony with the aim of the given image."[194]

For Kandinsky, the ultimate goal of the artist is, through this harmonious arrangement of colors and forms, to arouse emotions and to bring out the inner sound and the long-developing feeling. These are the indispensable elements of the works that he called "Compositions."

Composition X

Between December 1938 and January 1939 Kandinsky painted *Composition X* (pl. 88), closing this important series of works.[195] In its markedly changed style it created a coda to the nine most ambitious works of his career and proved once more his vital and original creative spirit, even returning somewhat to an earlier emotional

21. Joan Miró, *The Escape Ladder* from the Constellation series, 1940, gouache, watercolor, and ink on paper, 15¾ x 18¾" (40 x 47.6 cm), The Museum of Modern Art, New York; Helen Acheson Bequest.

intensity. It was painted at the time when Kandinsky experimented with the effects of the new vocabulary of free forms, and when he was especially preoccupied with the phenomenon of positive-negative form, that is, of the black form against white background and its counterpart, the white against black.[196] *Composition X* looks back to a device first known to him from his woodcut experience and with which Kandinsky had often experimented since his very early Munich years, namely the black background against which particularly in the early period he had created romantic, fairy-tale images, some in a mosaic-like style.

Composition X is a large polychrome canvas where the multicolored, free forms—some quite simple, others rather complex—interact dynamically. The bright forms appear to be almost paper cut-outs in the tradition of Russian folk art decorations, but they float in a cosmic and infinite space. The orchestration of forms could be compared to a polyphonic musical piece, recalling Kandinsky's interests in musical metaphors at the time of his correspondence with Schönberg from 1911 to 1914.

Although at first glance *Composition X* seems to be freely organized, it is balanced symmetrically according to the rules expounded more than twenty-five years earlier in *On the Spiritual in Art:* a vertical axis cuts through the open book shape in the upper center; the

right section evokes associations with a floating balloon where small, colorful figures are placed on top of a rainbow-like form. The movement of forms in this section occurs along the diagonal axis and toward the upper right. The left section, also full of forms reminiscent of children's motifs or folk cut-outs, includes a looming brown balloon shape, recalling images identified in *Composition V* that probably owe to the shamanic drums of the Lapp tribes—a comparison that is strengthened by the use of pictographic symbols on the drum shape.[197] To a certain degree, *Composition X* looks back to an earlier canvas, Kandinsky's *Multiple Forms*, painted in February 1936 and thus contemporary with *Composition IX*. Though of a grander scale, in the mood and formal structure it bears affinities to Miró's Constellations, such as *The Escape Ladder* of 1940 (fig. 21).

The black background of *Composition X* is its striking element; it makes colors and forms vibrate, emphasizes their continuous flux, and gives special brilliance to the colors. Although Kandinsky spoke of his dislike of black as a color in a work of art in *On the Spiritual in Art* (1911) and "Reminiscences" (1913), in *Composition X* he uses the black background to create a mood—to give physical and psychological relief to the multicolored forms placed against it. His discussion of the properties of black from *On the Spiritual in Art* provides penetrating insight into this work:

Black has an inner sound of nothingness bereft of possibilities, a dead nothingness as if the sun had become extinct, an eternal silence without future, without hope. Musically, it is represented by a general pause, after which any continuation seems like the beginning of another world, for that part which was brought to a close by this pause remains finished, complete for all time: the wheel has come full circle. Black is something extinguished, like a spent funeral-pyre, something motionless, like a corpse, which is dead to all sensations, which lets everything simply pass it by. It is like the silence of the body after death, the close of life. Black is externally the most toneless color, against which all other colors, even the weakest, sound stronger and more precise.[198]

In spite of the light, almost whimsical character of *Composition X*, we can find in it all of the aspects mentioned in this quote—the extinguished sun, the pause and silence, and possibly his premonition of war as well as his musings about the past and the approaching end of his life.

Composition X is Kandinsky's last major statement. It brings his creative life full circle, embodying his longing for the past and his preoccupations and ambitions of the present.

Notes

1. Kandinsky, "Reminiscences," in Kenneth C. Lindsay and Peter Vergo, eds., *Kandinsky: Complete Writings on Art* (Boston, 1982; rev. ed. New York: Da Capo Press, 1994), p. 373.

2. "Reminiscences," Lindsay & Vergo, p. 890 n. 40.

3. While the first edition of the *Über das Geistige in der Kunst* coincided with the first Blaue Reiter exhibition organized by Kandinsky in December 1911, some notes of the typescript of the German version are actually dated Murnau, August 3, 1909. Excerpts of the text in Russian were read by Nikolai Kulbin, a member of the Russian avant-garde, at the All-Russian Congress of Artists held in Saint Petersburg in December 1911. For details of the various editions of this important text, see John E. Bowlt and Rose-Carol Washton Long, eds., *The Life of Vasilii Kandinsky in Russian Art* (Newtonville, Mass.: Oriental Research Partners, 1980).

The text of *On the Spiritual in Art* referred to throughout this essay is the second German edition, trans. and rpt. in Lindsay & Vergo, pp. 114–219.

4. Kandinsky, *On the Spiritual in Art*, Lindsay & Vergo, p. 218.

5. Kandinsky had already raised this point in his Foreword to the catalogue of the First Exhibition of the Neue Künstler-Vereinigung, Munich, which took place on December 1–15, 1909 at the Moderne Galerie Thannhauser; that coincides with the time he probably began his first Compositions. See Hans Roethel, *Kandinsky: Das graphische Werk* (Cologne, M. DuMont Schauberg, 1970), pp. 438–39.

6. Kandinsky, "Content and Form," Lindsay & Vergo, p. 87.

7. *On the Spiritual in Art*, Lindsay & Vergo, p. 218.

8. For "Painting as Pure Art," published in the periodical *Der Sturm* by Herwarth Walden at the time of his Erster Deutscher Herbstsalon (First German Salon d'Automne) in September 1913, see Lindsay & Vergo, pp. 348–54.

9. "Painting as Pure Art," Lindsay & Vergo, p. 353.

10. A thorough discussion of the cultural atmosphere in Munich around the turn of the century and of Kandinsky's early development can be found in Peg Weiss, *Kandinsky in Munich: The Formative Jugendstil Years* (Princeton: Princeton University Press, 1979).

11. It was Münter who scrupulously helped Kandinsky during their years together to record most of his works in his Hauskatalog, or Handlists, important primary sources of information. In 1957 Münter donated her extensive archive and a collection of paintings by Kandinsky, which remained in her possession, to the Städtische Galerie im Lenbachhaus, Munich. The archival materials constitute the holdings of the Gabriele Münter–Johannes Eichner Stiftung there.

12. Kandinsky describes this in detail in "Reminiscences"; see Lindsay & Vergo, p. 359.

13. Kandinsky discusses Maeterlinck on several occasions in his writings, for example in his article "Whither the 'New' Art," published in *Odesskie Novosti* (Odessa News) in 1911. For Eng. trans., see Lindsay & Vergo, pp. 96–104; see also *On the Spiritual in Art*, Lindsay & Vergo, pp. 146–47.

14. For a discussion of Kandinsky's Paris years, see Jonathan Fineberg, *Kandinsky in Paris 1906–07* (diss. Harvard; Ann Arbor, Mich.: UMI Research Press, 1975).

15. Mir Iskusstva (World of Art) was an artistic group founded in Saint Petersburg around the turn of the century. It published a monthly artistic and literary journal there from November 1898 to 1904, under the editorship of Sergei Diaghilev. Among the main contributors to the journal were artists Alexander Benois, Konstantin Somov, Evgenii Lanceré, Leon Bakst, Mstislav Dobouzhinski, and Igor Grabar; literary contributors included Dmitrii Filosofov and various Symbolist writers. The publication of this journal in 1898 is considered a symbolic opening of a new period in Russian art: the journal also sponsored annual modern art exhibitions. In 1902 Kandinsky contributed articles to it; his painting *Old City* was reproduced in 1904. See Janet E. Kennedy, *The Mir Iskusstva Group and Russian Art 1898–1912* (diss. Columbia, 1976; New York: Garland, 1977).

16. Will Grohmann, *Wassily Kandinsky: Life and Work* (New York: Harry N. Abrams, 1958), p.158.

17. *Apollon* was a Symbolist literary monthly published between October 1909 and 1917. Edited by Sergei Makovsky, it contained three sections: general material, an art chronicle, and a literary almanac. Many former contributors to *Mir Iskusstva* were also published there. Kandinsky contributed five letters from Munich in 1909–10.

18. An example was the second Blaue Reiter exhibition in February 1912. See Donald Gordon, *Modern Art Exhibitions 1900–1916* (Munich: Prestel, 1974), vol. II, pp. 548–50.

19. Sixten Ringbom, *The Sounding Cosmos: A Study in the Spiritualism of Kandinsky and the Genesis of Abstract Painting* (Abo: Abo Akademi, 1970), p. 41.

20. The interest in folk art and the pure qualities of "primitive" art began in Russia in the 1870s with the creation of art colonies founded by wealthy patrons, notably Savva Mamontov (1841–1918) at his estate Abramstevo near Moscow, and Princess Maria Tenisheva (1864–1928) at Talashkino near Smolensk. These two centers, encouraged in the 1880s and 1890s by the similar spirit of the English Arts and Crafts movement, set as their goal saving the national heritage from the oblivion and decline apparent in contemporary easel painting. This trend continued among the artists of the avant-garde such as Goncharova, Larionov, and Malevich, who emphasized their interest in *lovbki* (primitive folk prints), icons, and children's drawings, much as the German Expressionists of Die Brücke group or painters in France had done.

For extensive discussion of the folk art revivalism in Russia see John E. Bowlt, "Two Russian Maecenases: Savva Mamontov and Princess Tenisheva," *Apollo* (December 1973), pp. 444–53; also *Talashkino: L'Art décoratif des ateliers de la Princesse Tenichef*, (Saint Petersburg: Sodrougestvo, 1906).

21. This photograph is reproduced in Rose-Carol Washton Long, *Kandinsky: The Development of an Abstract Style* (Oxford: Clarendon Press, 1980), fig. 38.

22. The article was published in Moscow's *Etnografieskoe obozrenie* (Ethnographic Review), 1889.

23. "Reminiscences," Lindsay & Vergo, pp. 368–69.

24. The subject of the internal spectator is discussed at length by Richard Wollheim in *Painting as an Art* (Princeton: Princeton University Press, 1987), chap. III, pp. 101–86.

25. "Reminiscences," Lindsay & Vergo, p. 369.

26. Kandinsky's explorations of just such imagery are discussed at length by Peg Weiss in "Kandinsky and 'Old Russia': An Ethnograph-

ic Exploration," in Gabriel Weisberg and Laurinda S. Dixon, eds., *The Documented Image: Visions in Art History* (Syracuse: Syracuse University Press, 1987), pp. 187–222. See also Peg Weiss, "Kandinsky: The Artist as Ethnographer," in *Münchner Beiträge zur Völkerkunde* 3 (1990), pp. 285–329. These concepts will be further elaborated in Weiss's forthcoming book *Kandinsky and "Old Russia": The Artist as Ethnographer and Shaman* (New Haven: Yale University Press, forthcoming 1995).

27. "Reminiscences," Lindsay & Vergo, p. 379.

28. Kandinsky's interest in theosophy and his relationship to Steiner, Madame Blavatsky (whom he mentions in the third chapter of *On the Spiritual in Art*), Annie Besant, Charles W. Leadbeater, Edward Schuré, and the Theosophical Society have been extensively treated by Ringbom; see *The Sounding Cosmos*.

29. *On the Spiritual in Art*, Lindsay & Vergo, pp. 143–45.

30. He also refers the reader to Steiner's *Theosophy* and his articles on the paths of knowledge in *Lucifer-Gnosis* (1904–08); see Lindsay & Vergo, p. 145 and p. 876 n. 28.

31. See *Pan*, March 21, 1912 and Lindsay & Vergo, p. 874 n. 8. Schönberg, in his essay on "The Relationship to the Text," included at Kandinsky's urging in the *Blaue Reiter Almanac*, also quotes from Schopenhauer's treatise *The World as Will and Idea*. According to Schopenhauer, the composer reveals the innermost essence of the world; he pronounces the most profound wisdom in the language into which it is difficult to translate the concepts of reality and that reason cannot fully comprehend.

32. For Kandinsky's associations between color and spirituality, see *On the Spiritual in Art* and "Reminiscences," Lindsay & Vergo, pp. 156–60, 376–79.

33. *On the Spiritual in Art*, Lindsay & Vergo, pp. 156–60.

34. *On the Spiritual in Art*, Lindsay & Vergo, p. 159.

35. *On the Spiritual in Art*, Lindsay & Vergo, p. 161 ff.

36. Blue, for instance, can convey an "inner sound" when used as a circle; white, yellow, or red, through a different geometric form, convey the mood produced by various musical instruments.

37. "On Stage Composition" and *Yellow Sound*, published in the Blaue Reiter Almanac in 1912, are trans. and rpt. in Lindsay & Vergo, pp. 257–83. The music for *Yellow Sound* was to be composed by Thomas von Hartmann.

38. *On the Spiritual in Art*, Lindsay & Vergo, p. 219.

39. See Kandinsky, "Reminiscences," Lindsay & Vergo, p. 364.

40. This theory, according to Kandinsky's own footnote, was informed by the experiments of a Russian music teacher, Madame A. Zakharin-Unkovskaya, at the Saint Petersburg Conservatory. Kandinsky was fascinated with her method, which he considered special and precise, since it allowed for "translating the colors of nature into music, of painting the sounds of nature, of seeing sounds in color and hearing colors musically." *On the Spiritual in Art*, Lindsay & Vergo, p. 159.

41. After attending a concert of the composer's music in Munich on January 1, 1911, the artist began a long-lasting correspondence with him that was only interrupted by the outbreak of World War I. What particularly captured Kandinsky's attention were Schönberg's theories of music, even though in a letter of January 13, 1912, Kandinsky freely admits that his knowledge of music and musical theory is rather rudimentary and that he awaits the visit of his friend the Russian composer Thomas von Hartmann, who will explain to him the nuances of Schön-

berg's theory as expounded in his book *Theory of Harmony* (1911). Kandinsky insisted that excerpts from Schönberg's article "On Parallel Octaves and Fifths," from his *Theory of Harmony*, should be published in Kandinsky's personally footnoted Russian translation in the catalogue to the second salon organized by the sculptor Vladimir Izdebsky in Odessa, December 1910.

42. For discussion of Schönberg's work, see R. P. Morgan, *XXc. Music* (New York and London: W. W. Norton, 1991), pp. 62–77. On the relationship between Kandinsky and Schönberg, see Peter Vergo, "Music and Abstract Painting: Kandinsky, Goethe and Schönberg," in *Towards a New Art: Essays on the Background to Abstract Art 1910–20* (London: Tate Gallery, 1980), pp. 41–63.

43. *On the Spiritual in Art*, Lindsay & Vergo, p. 215.

44. *On the Spiritual in Art*, Lindsay & Vergo, p. 217.

45. Peg Weiss discusses in detail Kandinsky's admiration for Hodler and his tendency toward the use of melodic and rhythmic elements in his work; see her article "Kandinsky and the Symbolist Heritage," *Art Journal* 45 (Summer 1985), pp. 137–45.

46. *On the Spiritual in Art*, Lindsay & Vergo, p. 217.

47. *On the Spiritual in Art*, Lindsay & Vergo, p. 217.

48. The connection to music is not the only analogy Kandinsky brings up in this context. The tranquil, elevated style of Gothic architecture, which shows a poised rhythmic composition of well-balanced structural parts, creates for him a spiritual mood as in painting. See *On the Spiritual in Art*, Lindsay & Vergo, p. 218.

49. During this decade, Kandinsky did not abandon his notion of making a Composition; he attempted to paint a *Composition VIII* around 1918 (as a dated study is entitled *Study for Composition VIII*).

50. A new institution, called the People's Commissariat for Enlightenment (Narkompros), was assigned the task of coordinating the cultural affairs of the newly born Soviet Union. Its head, Anatolii Lunacharsky, invited such avant-garde artists as Vladimir Tatlin and Aleksandr Rodchenko to join the Department of Visual Arts (IZO). In January 1918 they invited Kandinsky to join IZO, where he was later appointed editor of *Visual Art*, a periodical published by IZO Narkompros.

In October 1918 Kandinsky established contact with German artists and the architect Walter Gropius, who would be the founder of the Bauhaus in 1919. For detailed discussion of the period see Clark Poling, *Kandinsky: Russian and Bauhaus Years, 1915–1933* (New York: Solomon R. Guggenheim Foundation, 1983), chaps. 1 and 2, pp. 12–56.

51. However, since the beginning of the Weimar Republic in Germany, following the November Revolution in 1918, an art society called the November Gruppe, the Arbeitsrat für Kunst (Work Council for Art), and the Bauhaus all postulated the goal of creating art that would respond to the needs of a new, more egalitarian society. For a detailed discussion of this period, see Poling, *Kandinsky: Russian and Bauhaus Years*, chaps. 1 and 2, pp. 12–56.

52. In 1920–21 Kandinsky had been involved with the Russian School Vkhutemas (Higher Art Technical Studios); the Bauhaus was structured according to the same system of studios as the Vkhutemas and also propagated the synthesis of the fine and applied arts.

53. In its importance regarding Kandinsky's pictorial theories of the post–World War I period, *Point and Line to Plane* is comparable to *On the Spiritual in Art* of the pre–World War I years. The book was first published in 1926 in volume 9 of the Bauhaus Books. According to Kandinsky's introduction, the ideas presented in the book were the re-

sult of his pictorial investigations and ideas developed over the period beginning in 1914. See Lindsay & Vergo, pp. 524–699.

54. For example, a 1936 exhibition at the Galerie Jeanne Bucher, which showed his works of a geometric abstract idiom, was not well received. An in-depth discussion of Kandinsky's move and his reception in France can be found in Christian Derouet, "Kandinsky in Paris 1934–1944," in Vivian Barnett et al., *Kandinsky in Paris, 1934–1944* (New York: Solomon R. Guggenheim Foundation, 1985), pp. 16–60.

55. André Breton published the second Surrealist Manifesto in 1929 in the last issue of *La Revolution Surréaliste*, beginning the second phase of Surrealism.

56. *On the Spiritual in Art*, Lindsay & Vergo, p. 218.

57. *On the Spiritual in Art*, Lindsay & Vergo, p. 219. Kandinsky's anxiety about the creation of a new spiritual realm and his desire to evolve a new idiom in painting that would express this new reality brings to mind the pursuits of such artists as Piet Mondrian in Holland and Kasimir Malevich in Russia.

58. "Painting as Pure Art," Lindsay & Vergo, pp. 348–54.

59. "Painting as Pure Art," Lindsay & Vergo, p. 354.

60. Also subtitled *Painting with Riders*, it is listed under no. 92 in Kandinsky's Handlist as the first painting completed in 1910. It was acquired by Otto Ralfs of Braunschweig, Germany in 1924, and destroyed by World War II, on October 14, 1944. See Hans K. Roethel and Jean K. Benjamin, *Kandinsky: Catalogue Raisonné of the Oil Paintings* (Ithaca: Cornell University Press, 1982), vol. I, no. 327, p. 306. Handlists are Kandinsky's own handwritten lists of his works (called by him *Hauskatalog* and sometimes translated as "house catalogue"), which constitute the primary source of documentation on the artist's oeuvre. Handlist I, written in German, records paintings executed between 1900 and mid 1909, all numbered consecutively from 1 to 73; Handlist II covers paintings 62 (1909) to 243 (1922), recorded in Russian, and 244 (1922) to 370 (1926), recorded in German.
 Handlist III, written by Münter in German, lists paintings 62 (1909) to 204 (1916). It preceded Handlist II, which partly consists of her list copied by Kandinsky during their stay in Stockholm in 1916. The entries are often accompanied by small schematic sketches executed by Münter; sometimes they also carry descriptive subtitles. Handlist IV includes the paintings begun in Dessau in 1927 and covers 371 to 738 (1944). Not all of Kandinsky's works are recorded in Handlists.

61. As conveyed to Peg Weiss in her 1982 interview with Käte Ralfs, the owner, and confirmed in discussions with the author. See also Peg Weiss, "Books in Review," *Art Journal* 44 (Spring 1984), pp. 93–94; n. 3, where she reviews Washton Long, *Kandinsky*; see response in *Art Journal* 44 (Fall 1984), p. 299. In his monograph, Will Grohmann, who knew the artist, conveys a similar impression of the mood of the painting, of a feeling of hovering forms and lightness within loosely applied expressive colors. Grohmann, *Wassily Kandinsky: Life and Work* (New York: Harry N. Abrams, 1958).

62. Klaus Brisch, "Wassily Kandinsky (1866–1944): Untersuchungen zur Entstehung der gegenstandslosen Malerei an seinem Werk von 1900–1921," diss. University of Bonn, 1955, pp. 231–33.

63. Grohmann, p. 120.

64. Washton Long, *Kandinsky*, pp. 108–110.

65. Washton Long, pp. 108–10. She further cites different sources for the linear or horizontal arrangement of the riders rather than the usual vertical format: for instance, fifteenth-century German printed bibles, popular German glass paintings, and such specific sources as a watercolor by Gerhard Munthe published in *Dekorative Kunst* in 1906.

66. In her recent articles and forthcoming book on Kandinsky, Weiss argues convincingly that the imagery in certain of the Compositions relates to the Nordic myths and legends of Siberia. See Peg Weiss, "Kandinsky's Shamanic Emigrations," *Künstlerischer Austausch*, Akten des XXVIII. Internationalen Kongresses für Kunstgeschichte, July 15–20, 1992, (Berlin: Akademie Verlag, 1992), pp. 187–202 ; "Kandinsky: The Artist as Ethnographer," in *Münchner Beitrage zur Völkerkunde* 3 (1990), pp. 285–329; and *Kandinsky and "Old Russia": The Artist as Ethnographer and Shaman* (New Haven: Yale University Press, forthcoming 1995).

67. *On the Spiritual in Art*, Lindsay & Vergo, p. 218.

68. Städtische Galerie im Lenbachhaus, Munich; Roethel & Benjamin, cat. no. 423.

69. Städtische Galerie im Lenbachhaus, Munich; Roethel & Benjamin, cat. no. 507.

70. The subject of three riders in a mountainous landscape with other figures present in the lower register of the composition has already appeared earlier, for example in the *Blue Mountain* (1908, Solomon R. Guggenheim Museum), a vibrant, coloristically rich painting that initiated Kandinsky's individualistic style.

71. Weiss, *Kandinsky and "Old Russia"* (1995), introduction and chap. 3.

72. Originally published as "Rückblicke" in *Kandinsky, 1901–1913*, (Berlin: Der Sturm, 1913) pp. III–XXIX; Lindsay & Vergo, pp. 355–82. In their commentary, the authors discuss the different versions of the German and Russian texts. The most significant Russian translation was by the artist himself, published in Moscow by IZO Narkompros Department of Visual Arts, (People's Commissariat for Enlightenment) in 1918.

73. "Reminiscences," Lindsay & Vergo, pp. 358–59.

74. In July 1910 it was included in the exhibition of the Allied Artists Association at the Royal Albert Hall in London. Later that year he also presented it in his native Russia at the Second International Art Exhibition, Salon Izdebsky, January 1911, Odessa. A year later the painting was again exhibited at his first one-man show, organized by Herwarth Walden at his Der Sturm Gallery in Berlin in October 1912, which toured various European cities until September 1916.

75. The Russian edition of 1918, translated by Kandinsky, differs noticeably from the 1913 German text. It was published as *Stupeni* by IZO Narkompros. Differences between the two versions are discussed by Lindsay & Vergo, p. 357, and Jean-Paul Bouillon, ed., *Wassily Kandinsky: "Regards sur le passé" et autres textes 1912–1922* (Paris: Collection Savoir Hermann, 1974), pp. 41 ff.

76. "Reminiscences," Lindsay & Vergo, p. 890 n. 40.

77. *Composition II* was in the Botho von Gamp collection in Berlin and was listed in Kandinsky's Handlist II under no. 98 and dated 1909–10. Münter gave it the subtitle Cliffs (*Felsen*) in her Handlist II and dated it winter 1909–10. Roethel and Benjamin suggest the winter of 1909–10 as the date of its execution.

78. Only six entries separate the two compositions in the Hauskatalog: *Improvisation*; *Improvisations 4a, V, VI, VII*, and *Study for VIII*.

79. Discussions with Vivian Barnett, who is preparing a catalogue raisonné of Kandinsky's drawings, lead to the conclusion that these and other drawings related to *Compositions III* and *IV* were probably "afterthoughts."

80. Reproduced in Erika Hanfstaengl, ed., *Wassily Kandinsky: Zeichnungen und Aquarelle. Katalog der Sammlung in der Städtischen Galerie*

im Lenbachhaus, München (Munich: Prestel, 1974 and 1981), cat. no. 54.

81. The lecture "Kandinsky über seine Entwicklung" was scheduled to be delivered in Cologne at the invitation of the society Kreis für Kunst Köln to celebrate the opening of their Kandinsky exhibition. Lindsay & Vergo, pp. 392–400.

82. "Kandinsky über seine Entwicklung" (the Cologne Lecture), Lindsay & Vergo, p. 399.

83. In spite of their Russian themes, the *Arrival of the Merchants* was executed in Munich, and *Motley Life* in Sèvres.

84. Lindsay & Vergo, p. 395.

85. *On the Spiritual in Art*, Lindsay & Vergo, pp. 194–95.

86. "Kandinsky über seine Entwicklung" (the Cologne Lecture), Lindsay & Vergo, pp. 395–96.

87. "Kandinsky über seine Entwicklung" (the Cologne Lecture), Lindsay & Vergo, p. 397.

88. For a thorough discussion of the Guggenheim painting, see Angelica Rudenstine, *The Guggenheim Museum Collection of Paintings 1880–1945* (New York: Solomon R. Guggenheim Museum, 1976), vol. I, pp. 228–36 and Vivian Endicott Barnett, *Kandinsky at the Guggenheim* (New York, Solomon R. Guggenheim Museum and Abbeville, 1983), cat. no. 22, pp. 80–81.

89. Rudenstine, p. 228, refers to only two other examples of grid notations, as opposed to Kandinsky's frequent practice of making color notations on preparatory studies such as in the drawings for *Compositions I* and *II*. The use of such grid notations appears only in a watercolor sketch for *Composition IV* (Musée National d'Art Moderne, Paris) and on a sketchbook page of anatomical studies.

90. Grohmann, p. 120.

91. Brisch, pp. 233–34.

92. Washton Long, *Kandinsky*, pp. 110–112.

93. Weiss, "Artist as Ethnographer," pp. 310–16 and *Kandinsky and "Old Russia"* (1995), chap. 3.

94. Vasa was not only a spirit responsible for the drowned, he sometimes stole horses when they went too close to the water. Thus, the two rushing horsemen would be Florus and Laurus, patron saints of horses who were venerated by the Vologda peasants and to whom they prayed for miraculous cures. See Weiss, *Kandinsky and "Old Russia"* (1995), chap. 3.

95. Bayerische Staatsgemäldegalerie, Munich.

96. Albright-Knox Art Gallery, Buffalo.

97. See E. J. Wolf, in *Die Kunst für Alle* (November 1, 1910), pp. 68 ff.

98. Klaus Lankheit, ed., *Franz Marc Schriften* (Cologne: Du Mont, 1978), p. 126; Eng. trans. quoted in Weiss, "Kandinsky in Munich: Encounters and Transformations" in Weiss, *Kandinsky in Munich*, p. 66.

99. Lankheit, p. 127. Eng. trans. Weiss, "Kandinsky in Munich," p. 66.

100. *Composition III*, like *Composition II*, was in the Botho von Gamp collection in Berlin. It is signed in the lower left "Kandinsky/1910" and, according to its record in Handlists II and III (no. 112), it was executed on November 15, 1910.

101. The study is inscribed in the upper left in Münter's hand "14.IX.10" and in the lower left "zu Comp. III."

102. The placement of forms in the drawing resembles the schematic depiction of the picture in Handlist III under no. 112.

103. Brisch, pp. 239–40; Washton Long, *Kandinsky: The Development of an Abstract Style*, p. 112.

104. Grohmann, pp. 120–21.

105. Grohmann, p. 121.

106. Executed in pencil with additions of black and blue crayon, the drawing is also inscribed on the recto in pencil by Münter "14.IX.10" at the upper left and "Zu Komp. 3" at lower left; it includes some color notes: "Indigo and W" (i.e., white in the upper right), green below it, then still lower, it notes "green and yellow," with an entire right border section marked "violet."

107. This work in pen and ink, which although initialed and dated 1910 in the lower left corner as well as inscribed on the verso "Zeichnung zur Komposition 3, 1910," might actually have been done later, since the quality of line is quite different from that in the other drawings.

108. Roethel & Benjamin, cat. nos. 357 and 358.

109. The work is listed under no. 125 in Handlists II and III.

110. Vivian Endicott Barnett, *Kandinsky Watercolors, Catalogue Raisonné* (Ithaca: Cornell University Press, 1992–94), no. 267.

111. It is inscribed: "iste Zeichnung zu Komposition 4, 1911"; for details, see Christian Derouet and Jessica Boissel, *Kandinsky: Oeuvres de Vassily Kandinsky (1866–1944)* (Paris: Collections du Musée National d'Art Moderne, Centre Georges Pompidou, 1984), p. 109.

112. The same composition is repeated in a (possibly later) larger pen-and-ink drawing, pl. 11 in the appendix to Kandinsky's text *Point and Line to Plane*; see Lindsay & Vergo, p. 684.

113. Roethel & Benjamin, no. 367. The work is dated on the canvas "Kandinsky 1910," although Handlists II and III date it January 13, 1911. Peter Vergo, *Kandinsky: Cossacks* (London: Tate Gallery, 1986), p. 13, n. 14 and 15. In fact, it is inscribed on the back in Kandinsky's hand: "Zu Komposition 4 (Fragment) 1911." See Vergo, *Cossacks*, p. 7; also R. Alley, *Catalogue of the Tate Gallery's Collection of Modern Art, Other Than Works by British Artists* (London: Tate Gallery, 1981), pp. 380–381. It appears in Handlist III—written by Münter—under no. 119 and carries alternative titles of *Improvisation 17 (Battle) 13 January* and *Zu Komp. 4 (Fragment)* with the title *Improvisation 17*, later crossed out by Münter.

114. The title *Cossacks* is based on such sources as Kandinsky's letter of January 13, 1939, to his American dealer Galka Scheyer, referring to the Tate acquisition of the painting *Cosaques*, and an old label attached to the back of the picture. For details see Alley, p. 381.

115. Entitled *Kandinsky, 1901–1913*, the album-format book included a large section illustrating Kandinsky's works of the years followed by his autobiographical essay "Reminiscences." Besides the text on *Composition IV*, it included those on *Composition VI* and *Painting with White Border*. Curiously, *Composition IV* was the only one of these three works not illustrated. It has been suggested that the text, written in March 1911, was published at the time when Kandinsky's work was very strongly attacked by German and various European critics as being incomprehensible, foreign, and unskilled.

116. Kandinsky, "Komposition 4" *Kandinsky 1901–1913*, pp. XXXII–XXXIV; Lindsay & Vergo, pp. 383–84.

117. "Composition 4," Lindsay & Vergo, p. 383.

118. "Composition 4," Lindsay & Vergo, p. 383.

119. "Composition 4," Lindsay & Vergo, p. 384.

120. "Composition 4," Lindsay & Vergo, p. 384.

121. Brisch, pp. 234–36. Washton Long, *Kandinsky: The Development of an Abstract Style*, pp. 112–13.

122. Vergo, *Cossacks*, pp. 12–26.

123. For the letter, dated 25 March 1927, see Hans Hildebrandt, "Drei Briefe von Kandinsky," *Werk* 42 (October 1955), p. 328.

124. Kandinsky talks about such transposition of events in "Reminiscences." See Lindsay & Vergo, pp. 359–60 and 367.

125. Vergo, *Cossacks*, p. 22 ff.

126. "Reminiscences," Lindsay & Vergo, p. 889 n. 24.

127. For the letter, dated Murnau, August 20, 1912, see Jelena Hahl-Koch, ed. *Arnold Schönberg—Wassily Kandinsky. Letters, Pictures, and Documents*, trans. John Crawford (London and Boston: Faber and Faber, 1984), pp. 55–56.

128. Hahl-Koch, *Schönberg—Kandinsky*, pp. 55–56.

129. Vergo, *Cossacks*, p. 26.

130. The "Autobiographical Note and Postscript" appeared in the second edition of the catalogue for *Kandinsky: Kollektiv-Ausstellung, 1902–1912*, published by Hans Goltz in Munich in early 1913. For the English text, see Lindsay & Vergo, p. 345.

131. According to the Handlists II and III, it was executed on November 17, 1911 and is listed as no. 144. In Handlist III Münter gave it the subtitle *Jüngstes Gericht* (The Last Judgment). Because of its seemingly abstract idiom and complex conceptual program, the work became an immediate subject of controversy when the jury of the Neue Künstler-Vereinigung, a group of which Kandinsky was one of the organizers, questioned the inclusion of the work in the group's forthcoming exhibition. As a result, Kandinsky, Münter, Marc, and Kubin resigned from the Neue Künstler-Vereinigung and organized the first Blaue Reiter exhibition at the Moderne Galerie Thannhauser in 1911, where *Composition V* was hung.

132. "Kandinsky über seine Entwicklung" (the Cologne Lecture), Lindsay & Vergo, p. 399.

133. Recorded in the Handlists II and III as no. 142, it was shown once in Moscow at the *Jack of Diamonds* exhibition in 1912. The work disappeared from view until about twenty-five years ago, when it resurfaced in a private collection in Saint Petersburg and was acquired for the collection of the Hermitage. The work is dedicated on the front "to O. and T. Hartmann. Kandinsky 1911," and inscribed on the back "Entwurf Zu Komposition V." Thomas von Hartmann, a Russian composer, and his wife Olga were close friends of the artist between 1908 and 1911–12, when Kandinsky and von Hartmann experimented with the *Bühnengesamtkunstwerk* (total work of art for the stage). Von Hartmann composed the music for Kandinsky's stage work *Der Gelbe Klang* (The Yellow Sound), first published in the *Blaue Reiter Almanac* (1912), but never produced during Kandinsky's lifetime.

134. Brisch, pp. 244–46; Johannes Eichner, *Kandinsky und Gabriele Münter: Von Ursprüngen moderner Kunst* (Munich: F. Bruckmann, 1957), pp. 114–15; Grohmann, p. 124; Hans K. Roethel, *Kandinsky* (New York: Hudson Hills, 1979), no. 15, pp. 86–87. Washton Long, *Kandinsky*, pp. 113–16; Weiss, "Artist as Ethnographer," p. 316 ff.; "Kandinsky in Munich," pp. 66–77; Weiss, "Kandinsky's Shamanic Emigrations," pp. 189–90.

135. Roethel & Benjamin, cat. no. 408.

136. Roethel & Benjamin, cat. no. 422.

137. Roethel & Benjamin, cat. no. 412.

138. Roethel & Benjamin, cat. no. 420.

139. Barnett, *Watercolors*, cat. no. 275.

140. "Kandinsky über seine Entwicklung," (the Cologne Lecture), Lindsay & Vergo, p. 398.

141. "Kandinsky über seine Entwicklung," (the Cologne Lecture), Lindsay & Vergo, p. 398.

142. While this motif in the painting can be related to the theosophist symbol of the spiritual triangle, or the eye of God, it can also, as in the Munich drum, symbolize the house of the highest Lapp god, Radien. See Weiss, "Artist as Ethnographer," p. 314.

143. *Composition VI* is dated in the lower right "1913" and according to both Handlists, where the painting is recorded as no. 172, the work was painted on March 5, 1913; see Roethel & Benjamin, no. 464.

144. *Composition VI* was reproduced as the first plate in the album; see *Kandinsky, 1901–1913*, pp. xxxv–xxxviii; Lindsay & Vergo, pp. 385–388.

145. "Composition 6," Lindsay & Vergo, p. 385.

146. *Composition V* was completed November 17, 1911; *Composition VI* on March 5, 1913.

147. "Composition 6," Lindsay & Vergo, p. 385.

148. All of the drawings are discussed and illustrated in Hanfstaengl, pp. 85–87.

149. Barnett, *Watercolors*, cat. no. 319. See also Barnett, *Watercolors*, cat. no. 331.

150. The following are speculative interpretations of the drawings for *Composition VI*, which have previously not been discussed in detail. The description in German on the first drawing (pl. 39) possibly reads "Austragung des Bildes" ["laying out of the picture"]; it includes three main points:
 1) aus Wr-Kl. ["ausgehend Wirrnis-Klarheit" or "from chaos to clarity"]
 2) Zusammenstoss mit R[uhe]. ["collision with calmness"]
 3) Deutung des Sieges [possibly an interpretation of the victor]
These three points are accompanied by an arrow indicating movement from lower left toward upper right, along a stepped-up trajectory. This corresponds to Kandinsky's description of the painting in the Der Sturm album that reflects movement from the left center toward the upper right.
 The second part of the inscription on pl. 39 continues as: "Austragung des G." "G" might represent "Gedankens" (thought or idea), or perhaps "Geburt" (birth). These notes are inscribed above the small circle crossed with an arrow that points from lower right to upper left. Thus the two parts of the description might define two basic axes of the movement of forms, which can be found in the final oil. This second part of the description might present "laying out of the idea" and consists of three points:
 1) W.—["Wirrnis" (chaos) or "Weiss" (white)]
 2) W. überspringt Schw [possibly "Wirrnis überspringt Schwere," or "chaos overcomes gravity" or "Weiss überspringt Schwartz" ("white overcomes black")]
 3) W. wird G ["Wirrnis wird Gedanken," that is, "confusion or chaos, becomes idea"].
In view of Kandinsky's text on *Composition VI*, these diagrams might have been done in a moment of reflection, when after numerous attempts at developing the layout of the work and its pictorial form,

Kandinsky felt the need to conceptualize the objectives he wanted to achieve in the painting and therefore spelled them out for himself.

How this conception evolved is further diagrammed in another drawing that indicates the directions the elements move (pl. 40). Two intersecting diagonals with the third stepped up here (related to the same configuration in the first drawing) are possibly marked with abbreviations for "Bewegung des Bildes," or the "movement of the picture" from lower left to upper right and notes that might read "Bewegung des Gedankens," which would describe the "movement of the idea" developing from lower right to upper left; from *Schwere* (gravity) to *Wirrnis* (chaos). Here we can follow Kandinsky's description of the process of creation with the definition of the two centers, each representing a focal point of the compositional arrangement and apparent in the final painting. The third of the five diagrams (pl. 41), like the preceding one, might either refer to the color scheme or to the conceptual direction of the theme, for instance along the axis that runs from left to upper right—it could be read as "bildliche Wirrnis—bildliche Katastrophe—bildliches Heim," or "pictorial chaos—pictorial catastrophe—pictorial home." This would be the resolution of the composite elements that build up the content of the painting. Applying this logic to the structural scheme of *Composition VI*, it is likely that Kandinsky conceived of the picture in such terms.

The next drawing (pl. 42) appears to define the two centers that Kandinsky refers to in his essay on *Composition VI* and shows the trajectories of their movement with arrows pointing to "B" ("Bild") and "G" ("Gedanke"), or "picture and idea," at upper right and upper left. While *Bild* could be equated with *Heim* ("home") and *Gedanke* with *Wandlung* ("transformation"). It might signify that he felt he resolved pictorially the upper right while the upper left was still in process of being developed.

The last of the five diagrams (pl. 43) is just as puzzling. It essentially points out the axes that divide the picture into different segments and indicates with arrows the movement of different elements. The abbreviation "Sch." ("Schwarz") corresponds to the black area at left, slightly below the middle of the canvas. These five diagrams for *Composition VI* would then in a very systematic way present the evolution of this complex idea and the final picture.

151. This oil study, which was exhibited in Berlin at the Galerie Der Sturm in the Erster Deutscher Herbstsalon (First German Salon d'Automne) in 1913 as no. 186, was in the Koehler collection in Berlin and was destroyed in 1945.

152. This work is inscribed on the verso in the artist's hand: "Kandinsky 1913 Sintflut Improvisation." For a brief discussion, see Armin Zweite, *The Blue Rider in the Lenbachhaus Munich* (Munich: Prestel, 1989), no. 45.

153. "Composition 6," Lindsay & Vergo, p. 387.

154. "Composition 6," Lindsay & Vergo, p. 387.

155. "Composition 6," Lindsay & Vergo, p. 387.

156. "Kandinsky über seine Entwicklung" (the Cologne Lecture), Lindsay & Vergo, p. 399. For the iconography and interpretation of *Composition VI* see Brisch, *Wassily Kandinsky*; Washton Long, *Kandinsky*; and Felix Thürlemann, *Kandinsky über Kandinsky: Der Künstler als Interpret eigener Werke* (Bern, 1986).

157. "Composition 6," Lindsay & Vergo, p. 388.

158. "Composition 6," Lindsay & Vergo, p. 388.

159. "Composition 6," Lindsay & Vergo, p. 388.

160. As Sixten Ringbom rightly points out, Kandinsky's dislike of overt corporeal imagery recalls that of such mystical legends as the vision of Saint Bernard's transcending fantastic images. Ringbom, "Transcending

the Visible: The Generation of the Abstract Pioneers," in *The Spiritual in Art: Abstract Painting 1890–1985* (Los Angeles: Los Angeles County Museum of Art, 1986), pp. 144–53.

161. For detailed information on these holdings see Hanfstaengl, nos. 241–57; 199, 160, 267–71; Rosel Gollek, *Der Blaue Reiter im Lenbachhaus München. Katalog der Sammlung in der Städtischen Galerie* (Munich: Prestel, 1982), nos. 144–46, pp. 334–35; Zweite, no. 46.

162. *Composition VII* is listed in the artist's Handlist under no. 186, where among several preceding listings there are six preparatory oils (nos. 179–185).

163. I am grateful to Vivian Barnett for her willingness to help establish the chronology of the studies.

164. In fact, as Washton Long points out in her analysis of the painting in its iconographic scheme, it looks back to Kandinsky's 1911 watercolor *Sound of Trumpets (Large Resurrection)* (fig. 10), also at the Städtische Galerie, Munich.

165. The oil was formerly in the collection of Paul Klee, then his son Felix. Barnett, *Watercolors,* no. 359; Washton Long, *Kandinsky;* Hanfstaengl, *Wassily Kandinsky,* no. 246; pp. 118–22.

166. Jelena Hahl-Koch in her *Kandinsky* (New York: Rizzoli, 1993) reproduces the drawing with her translations of the Russian inscriptions. See p. 210.

167. "Reminiscences," Lindsay & Vergo, p. 386.

168. Recorded in the Handlist as no. 182, it is inscribed on the back "Kandinsky—Zu Komposition 7 (Entwurf 2), 1913, No. 182"; Roethel & Benjamin, no. 472.

169. This oil and tempera on canvas is recorded in Handlist II as no. 183; Barnett, *Watercolors,* no. 27. The mountain topped with the onion-domed towers recurs in the oil *Small Pleasures* (summer 1913, Solomon R. Guggenheim Museum) and *Improvisation 21a* (1911, Städtische Galerie, Munich), to mention only the works closest in chronology incorporating that motif.

170. Included in the Handlists as no. 185 and inscribed on the reverse "Kandinsky—Zu Komposition 7 (Entwurf 3) 1913. No 185"; Roethel & Benjamin, no. 473.

171. Barnett places it chronologically between *Sketch 2 for Composition VII* (pl. 76) and *Sketch 3* (pl. 80) both in Munich, thus establishing its date as 1913. On the other hand, the work is included in the Handlist under the date 1911 and follows the famous "abstract watercolor," discussed below. See Barnett, *Watercolors,* no. 364.

172. The work is inscribed by the artist on the verso: "Acquarelle 1910 (abstraite)." However, in the context of the 1910 works, this watercolor, in its abstract construction, is rather unusual. Several scholars have questioned its dating to 1910 on stylistic grounds, and as Derouet and Boissel report, Kandinsky himself stated in 1921 that he painted his first abstract work in 1911. For a detailed analysis of the watercolor, see Derouet & Boissel, no. 99. See also Barnett, *Watercolors,* no. 365.

173. Hideho Nishida, "Genèse de la première aquarelle abstraite de Kandinsky," *Art History* 1 (1978), pp. 1–20.

174. *Composition VII* is registered in the Handlist as no. 186; see also Roethel & Benjamin, no. 476.

175. Ringbom, *Sounding Cosmos*, pp. 162–169; Washton Long, *Kandinsky*, pp. 118–22; Brisch, pp. 252–55 and 281; Roethel, 1979, no. 21, pp. 104–08.

176. Kandinsky uses the same generalized motif in several other works, *Improvisations 25* and *27* as well as *Improvisation 28* and a study for

it (both in the Solomon R. Guggenheim Museum). The motif of the Garden of Love is discussed extensively in Rose-Carol Washton Long, "Kandinsky's Vision of Utopia as a Garden of Love," *Art Journal* (Spring 1983), pp. 50–60. In her article she calls attention to diverse sources of this conception, such as the Russian Symbolist philosophies of Vladimir Soloviev and Dmitri Merezhkovsky, Wagner's idealistic view of transcendent love, and Edvard Munch's depictions of love in the cycle-of-life paintings. These sources also encompass Nietzsche's admiration of the Dionysian concept, the contemporary Dionysian attitude that sexual love in its fulfillment leads to a transcendental state, and, particularly, the notion of the transcendent power of sex propounded by the Polish writer Stanislaw Przybyszewski, who was living in Berlin and once in the intimate circle of Munch. Many of Kandinsky's close friends, among them the poet Stefan George, Karl Wolfskehl, and Alfred Kubin, were involved with the Dionysian celebrations popular among the Munich bohemian and intellectual circles. Kandinsky was an active member of the intellectual and bohemian life in Munich and photographic evidence indicates that he and Münter were both interested in Dionysian celebrations. Furthermore, his liaison with Münter from 1902–16 (well before his failing marriage to his cousin ended in 1911) personalized the motif of the couple as a symbol of transcendence. He thus used it as a symbol of redemption to counter the destructive forces in the painting.

177. The study is signed and dated on the recto "K/18" and inscribed in Cyrillic on the verso, "Eskiz Kompozitsii No8. (III 1918)"(Sketch for Composition No. 8 [III 1918]).

178. The Tretyakov drawing is the original work of which the Guggenheim piece is the tracing. It is also known as Untitled *(Related to Composition VIII) (Sketch)*. As Barnett indicates, the tracing paper support is mounted to cardboard inscribed on the reverse with the date of execution and identifying the watercolor as a study for the 1920 oil sketch for *Composition VIII*, renamed by the artist *Spitzes Schweben* (Pointed Suspension). It is recorded in the Handlist of oil paintings for the year 1920 under no. 228. See Barnett, *Watercolors*, cat. no. 494 and her *Kandinsky at the Guggenheim*, no. 60, p. 130; also Roethel & Benjamin, cat. no. 669, for the artist's renaming of the work.

179. "Foreword to the Catalogue of the First International Art Exhibition, Düsseldorf," Lindsay & Vergo, p. 479.

180. The Alfred H. Barr, Jr., Papers, Museum of Modern Art Archives, Museum of Modern Art, New York, letter of Kandinsky to Barr, July 16, 1936.

181. Grohmann, p. 188.

182. According to the Handlist (no. 260), *Composition VIII* was painted in July 1923. The work is inscribed on the recto in lower left "K/23" and on the reverse "K/N260/1923" in the artist's hand; it is also marked "Komposition 8" on the stretcher. Barnett, *Kandinsky at the Guggenheim*, no. 83, pp. 160–61.

183. *On the Spiritual in Art*, Lindsay & Vergo, pp. 156 ff.

184. *On the Spiritual in Art*, Lindsay & Vergo, p. 163.

185. Grohmann, p. 188.

186. The letter is dated October 12, 1930. Grohmann, pp. 187–88.

187. Paul Overy, *Kandinsky: The Language of the Eye* (London: Elek, 1969), p. 121. This concept relates closely to the famous statement of Maurice Denis who, as a spokesman for the Nabis in the 1890s, stated that "a picture before being a battle horse, a nude woman, or some anecdote—is essentially a plane surface covered with colors assembled in a certain order." See M. Denis, *Theories: 1870–1910* (Paris, 1930), p. 3.

188. For a discussion of the "surface plane" and *faktura*, see Magdalena Dabrowski, *The Russian Contribution to Modernism: "Construction" as Realization of Innovative Aesthetic Concepts of the Russian Avant-garde*, diss. New York University, Institute of Fine Arts; Ann Arbor, Mich.: (UMI Research Press, 1990), pp. 22–34.

189. *On the Spiritual in Art*, Lindsay & Vergo, p. 193.

190. Derouet, "Kandinsky in Paris," p. 26.

191. Vivian Barnett postulates that Kandinsky's new vocabulary of amorphous, ameboid, and embryonic forms, characteristic of his Parisian paintings, has its origin in biological sources and results from his vivid although never explicit interest in embryology and zoology. She further suggests a connection between the biological and philosophical concepts that would appeal to Kandinsky's preoccupations with the ideas that had been the focus of his work and theories since the early Munich period, namely a "spiritual meaning of beginning, regeneration and a common origin of life." See "Kandinsky and Science: The Introduction of Biological Images in the Paris Period," in Barnett et al., *Kandinsky in Paris*, pp. 61–87.

192. Nina Kandinsky, *Kandinsky et moi*, trans. J. M. Gaillard-Pacquet (Paris, 1978), p. 191, quoted in Derouet, "Kandinsky in Paris," p. 32.

193. Executed in February 1936, and no. 626 in the Handlist; it is alternatively titled *L'Un et l'autre*. Roethel & Benjamin, no. 1064.

194. "Reflections on Abstract Art," Lindsay & Vergo, p. 760.

195. Recorded on Handlist IV as no. 655.

196. For a more extensive discussion of this period see Derouet, "Kandinsky in Paris," pp. 33 ff.

197. Weiss classifies this work as one of his "communication paintings" filled with innumerable symbolic messages and exploring pictographic writing. Weiss, *Kandinsky and "Old Russia"* (1995) chap. 6.

198. *On the Spiritual in Art*, Lindsay & Vergo, p. 185.

Plates

1. Untitled (*Study for Composition I*) 1910
Pencil on paper, 4½ x 7⅛" (11.3 x 18 cm), Musée National d'Art Moderne, Centre Georges Pompidou, Paris; bequest of Nina Kandinsky, 1981.

2. *Study for Composition I* 1910
Pencil on paper, 6½ x 4⅛" (16.3 x 10.4 cm), Städtische Galerie im Lenbachhaus, Munich.

Opposite:
3. *Composition I* 1910
Oil on canvas, 47¼ x 55⅛" (120 x 140 cm), no longer extant.

4. Untitled (*Study for a Woodcut on the Theme of Composition I*)
1910
Charcoal, blue pencil, and ink on cardboard, 4⅝ x 7⅛" (11.8 x 18.2 cm), Musée National d'Art Moderne, Centre Georges Pompidou, Paris; bequest of Nina Kandinsky, 1981.

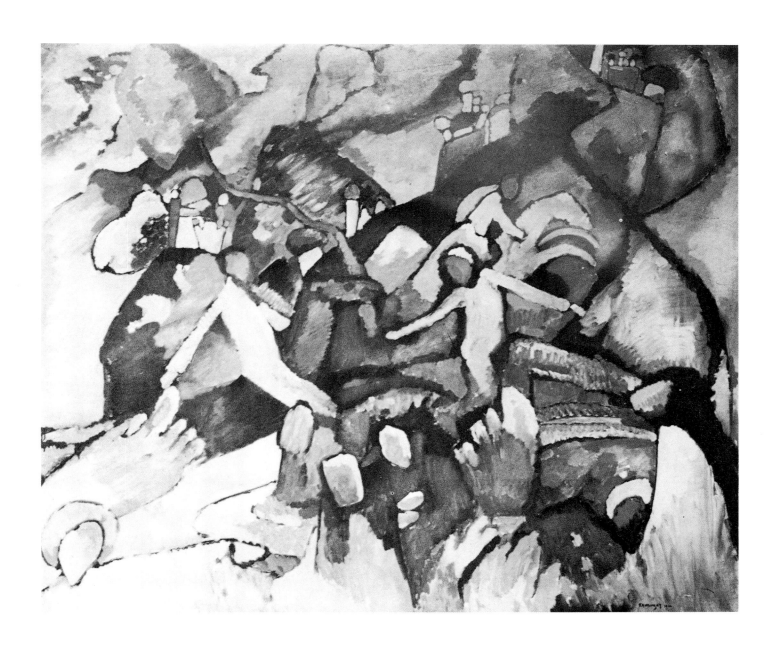

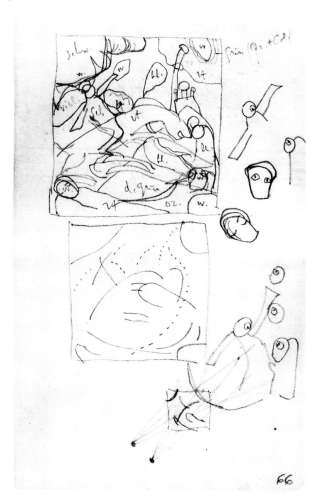

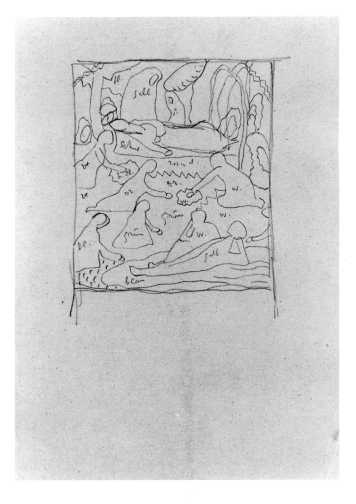

5. *Sketch for Watercolor Study for Composition II* 1909
Page 66 of notebook; pencil on paper, 5¼ x 3⅛" (13.2 x 7.9 cm), Städtische
Galerie im Lenbachhaus, Munich.

6. Untitled (*Study for Section of Composition II*) 1910
Pencil on paper, 5⅞ x 3⅞" (14.8 x 10 cm), Musée National d'Art Moderne,
Centre Georges Pompidou, Paris; bequest of Nina Kandinsky, 1981.

7. *Study for Composition II* 1910
India ink on paper, 9⅜ x 11⅞" (23.8 x 30.2 cm), Musée National d'Art
Moderne, Centre Georges Pompidou, Paris; bequest of Nina Kandinsky, 1981.

8. *Diagram for Composition II* 1910
Pencil on paper, 8½ x 12" (21.7 x 30.3 cm), Musée National d'Art Moderne,
Centre Georges Pompidou, Paris; bequest of Nina Kandinsky, 1981.

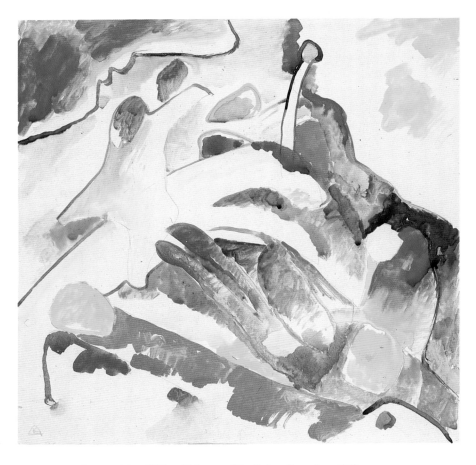

9. *Study for Composition II (Two Riders and Reclining Figure)* c. 1910
Watercolor and pencil on cardboard, 12⅞ x 12⅞" (32.9 x 32.9 cm), Städtische
Galerie im Lenbachhaus, Munich.

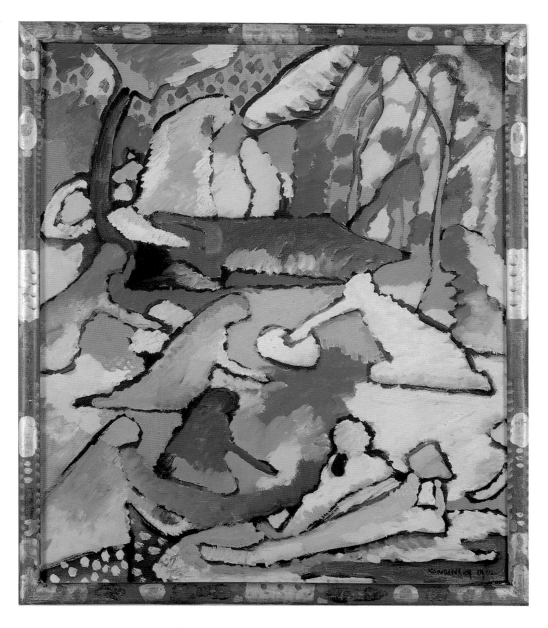

10. *Study for Section of Composition II* 1910
Oil on cardboard, 22⅞ x 18⅞" (58 x 48 cm), Private collection, Switzerland.

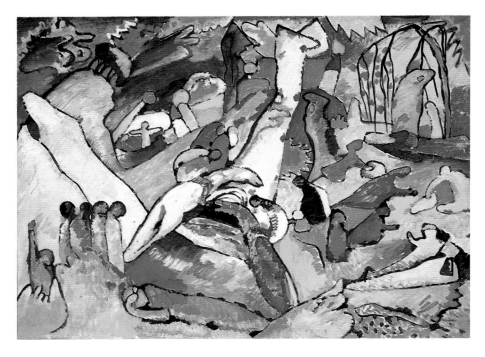

11. *Sketch for Composition II* 1909–10
Oil on canvas, 38⅜ x 51⅝" (97.5 x 131.2 cm), Solomon R. Guggenheim
Museum, New York.

Opposite:
12. *Composition II* 1910
Oil on canvas, 78¾ x 108¼" (200 x 275 cm), no longer extant.

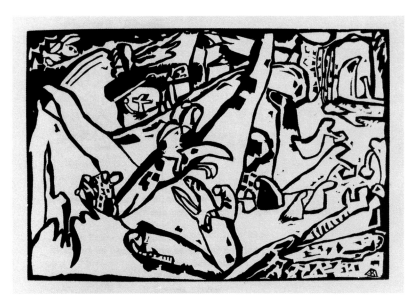

13. *Composition II* (plate, folio 7) from *Klänge*, (Munich,1911)
Woodcut, printed in black, composition: 5⅞ x 8¼" (14.9 x 21 cm), page:
11¹⁄₁₆ x 10⅞" (28.1 x 27.7 cm), The Museum of Modern Art, New York; the
Louis E. Stern Collection.

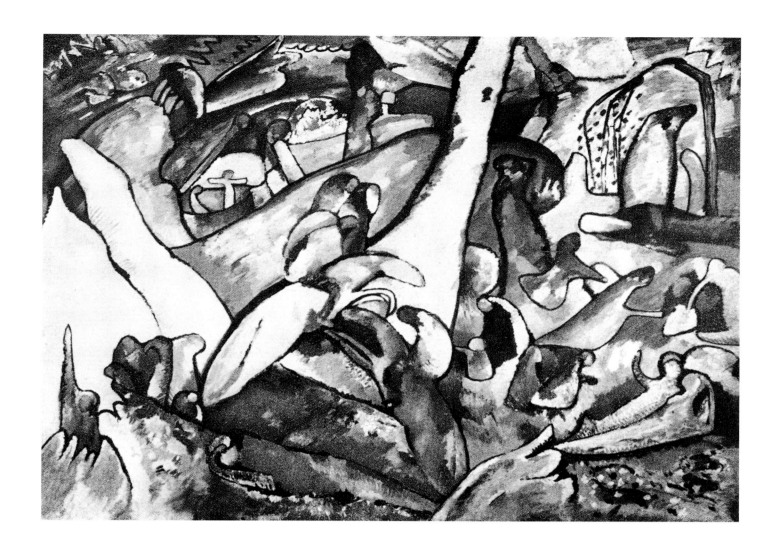

14. *Diagram for Composition III* 1910
Pencil on paper, 9¾ x 11⅝" (24.8 x 29.7 cm), Musée National d'Art Moderne,
Centre Georges Pompidou, Paris; bequest of Nina Kandinsky, 1981.

15. Untitled (*Diagram for Composition III*) 1910
Pencil on notebook page, 6⅜ x 8¼" (16.2 x 20.9 cm), Musée National d'Art
Moderne, Centre Georges Pompidou, Paris; bequest of Nina Kandinsky, 1981.

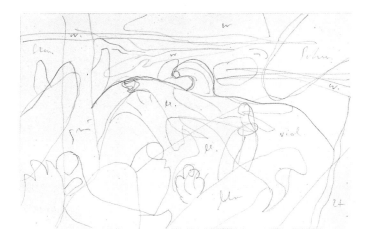

16. Untitled (*Study for Composition III [Improvisation XV]*) 1910
Pencil on paper, 3⅞ x 5⅞" (10 x 14.8 cm), Musée National d'Art Moderne,
Centre Georges Pompidou, Paris; bequest of Nina Kandinsky, 1981.

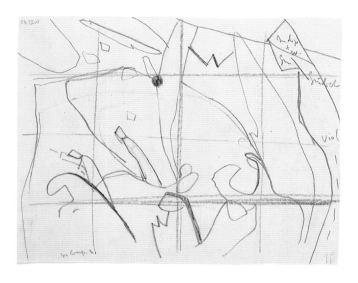 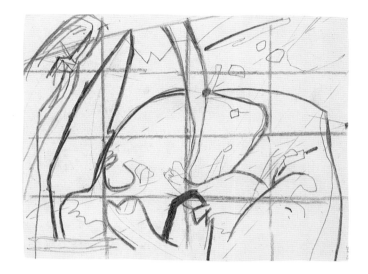

17a–b. Untitled (*Studies for Composition III,* recto and verso) 1910
Black and blue pencil on paper, 6½ x 8¼" (16.5 x 20.9 cm), Musée National
d'Art Moderne, Centre Georges Pompidou, Paris; bequest of Nina Kandinsky,
1981.

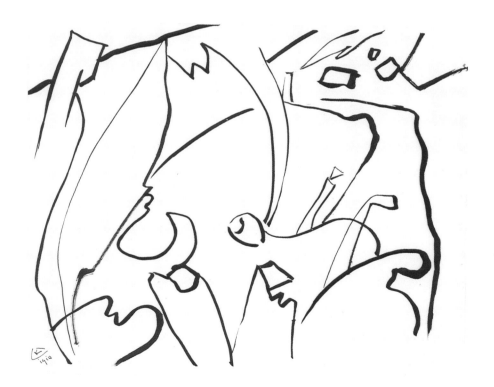

18. *Drawing for Composition III* 1910
India ink on paper, 9⅞ x 12" (25 x 30.4 cm), Musée National d'Art Moderne,
Centre Georges Pompidou, Paris; bequest of Nina Kandinsky, 1981.

19. *Sketch for Improvisation XV (Study for Composition III)* 1910
Oil on cardboard, dimensions and location unknown.

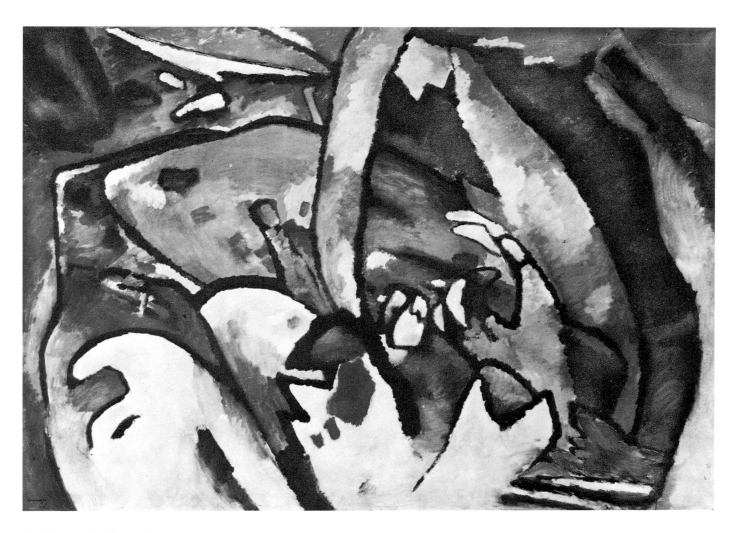

20. *Composition III* 1910
Oil on canvas, 74¾ x 98⅜" (190 x 250 cm), no longer extant.

21. *First Drawing for Composition IV* 1911
Pencil, charcoal, and india ink on paper, 4 x 7⅞" (10.2 x 20 cm), Musée
National d'Art Moderne, Centre Georges Pompidou, Paris; bequest of Nina
Kandinsky, 1981.

22. Untitled (*Diagram for Composition IV*) 1911
Charcoal on paper, 3⅞ x 5⅞" (10 x 14.9 cm), Musée National d'Art Moderne,
Centre Georges Pompidou, Paris; bequest of Nina Kandinsky, 1981.

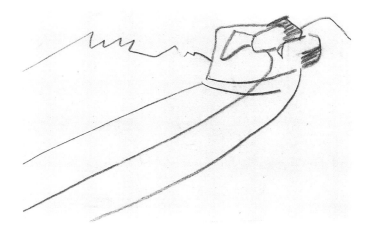

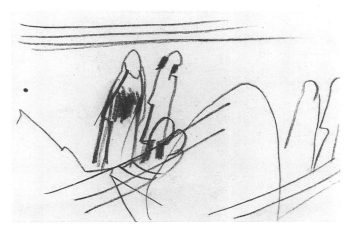

23. Untitled (*Study for Detail of Composition IV*) 1911
Charcoal on paper, 3⅞ x 5⅞" (10 x 14.9 cm), Musée National d'Art Moderne,
Centre Georges Pompidou, Paris; bequest of Nina Kandinsky, 1981.

24. Untitled (*Study for Detail of Composition IV*) 1911
Charcoal on paper, 3⅞ x 5⅞" (10 x 14.9 cm), Musée National d'Art Moderne,
Centre Georges Pompidou, Paris; bequest of Nina Kandinsky, 1981.

25. Untitled (*Study for Detail of Composition IV*) 1911
Pencil on paper, 3⅞ x 5⅞" (10 x 14.9 cm), Musée National d'Art Moderne,
Centre Georges Pompidou, Paris; bequest of Nina Kandinsky, 1981.

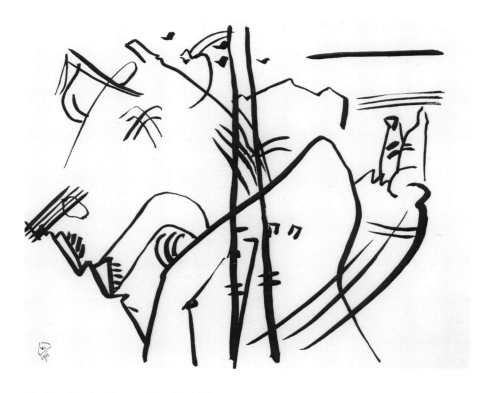

26. *Drawing for Composition IV* 1911
Pencil and india ink on paper, 9⅞ x 12" (24.9 x 30.5 cm), Musée National d'Art
Moderne, Centre Georges Pompidou, Paris; bequest of Nina Kandinsky, 1981.

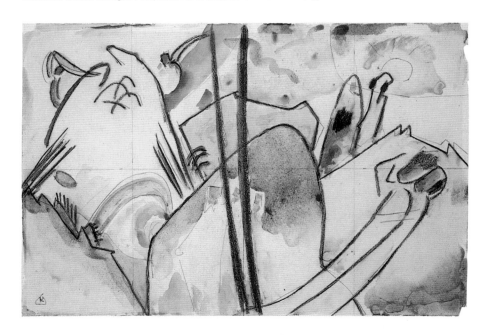

27. Untitled (*Study for Composition IV*) 1911
Pencil, charcoal, and watercolor on paper, 7⅜ x 10⅝" (18.5 x 27.1 cm),
Musée National d'Art Moderne, Centre Georges Pompidou, Paris; bequest of
Nina Kandinsky, 1981.

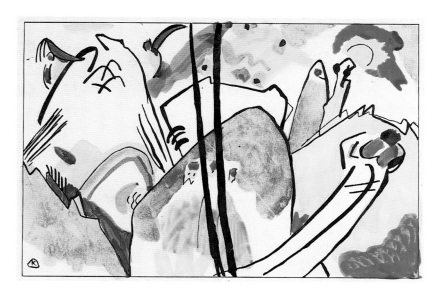

28. *Study for Composition IV* 1911
Etching with watercolor and india ink on paper, 7½ x 10⅜" (19 x 26.3 cm),
Städtische Galerie im Lenbachhaus, Munich.

**29. *Cover Design for the Edition Salon Izdebsky,* (motif taken
from *Composition IV*)** 1911
Woodblock, 11⅛ x 11 x 1" (28.2 x 27.9 x 2.5 cm), Musée National d'Art
Moderne, Centre Georges Pompidou, Paris; bequest of Nina Kandinsky, 1981.

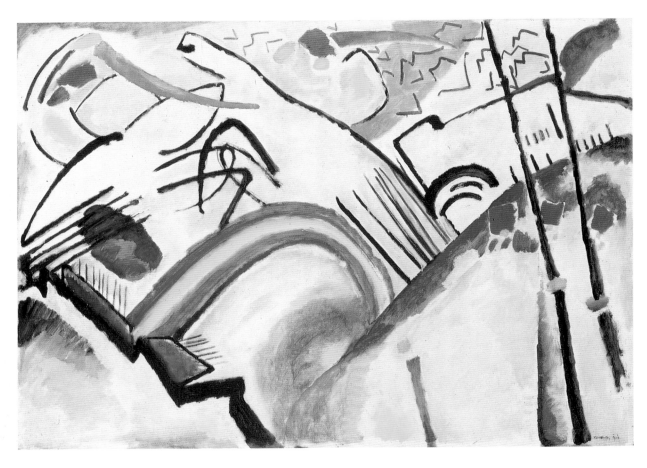

30. *Cossacks* 1910–11
Oil on canvas, 37 x 51⅛" (94 x 129.9 cm), Tate Gallery, London; presented by
Mrs. Hazel McKinley, 1938.

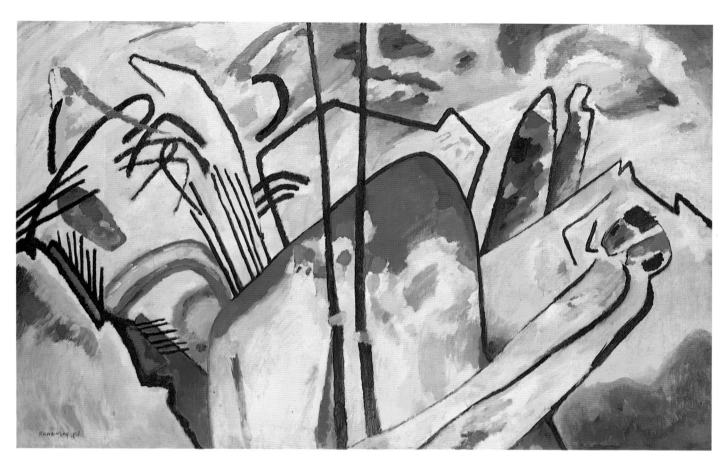

31. *Composition IV* 1911
Oil on canvas, 62⅞ x 98⅝" (159.5 x 250.5 cm), Kunstsammlung Nordrhein-
Westfalen, Düsseldorf.

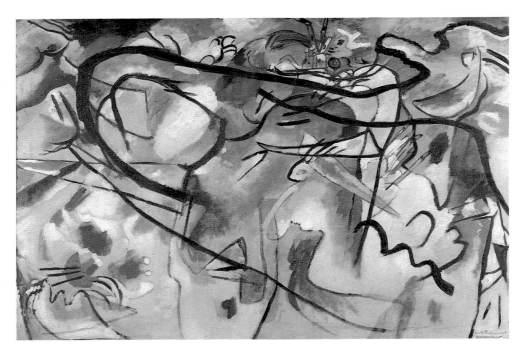

32. *Sketch for Composition V* 1911
Oil on canvas, 37¼ x 54¾" (94.5 x 139 cm), Hermitage Museum, Saint Petersburg.

33. Untitled (*Two Diagrams for Composition V*) 1911
Ink on paper (on reverse of a letter), 8¾ x 11" (22.1 x 28 cm), Musée National d'Art
Moderne, Centre Georges Pompidou, Paris; bequest of Nina Kandinsky, 1981.

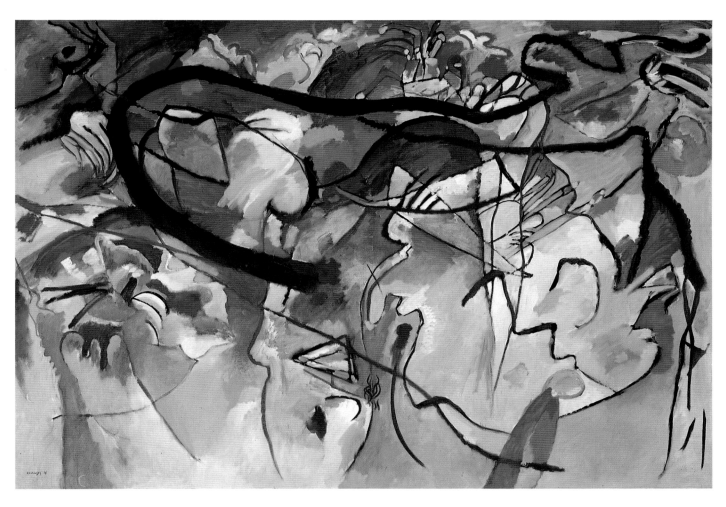

34. *Composition V* 1911
Oil on canvas, 6' 3⅞" x 9'¼" (190 x 275 cm), Private collection.

35. *Animals and People (Study for Deluge for Composition VI)*,
c. 1912
Pencil on paper, 13⅜ x 17¼" (33.8 x 43.8 cm), Städtische Galerie im
Lenbachhaus, Munich.

36. *Figure and Hand Studies*
(*Study for Deluge for Composition VI*) c. 1912
Pencil on paper, 13⅜ x 17¼" (33.8 x 43.8 cm), Städtische Galerie im
Lenbachhaus, Munich.

37. *Study for Composition VI* 1912–13
Pencil on paper, 13¼ x 17¼" (33.6 x 43.8 cm), Städtische Galerie im
Lenbachhaus, Munich.

38. *Study for Composition VI* 1912–13
Pencil on paper, 8⅜ x 13" (21.1 x 33.2 cm), Städtische Galerie im
Lenbachhaus, Munich.

39. *Diagram for Composition VI* 1912–13
Pencil on notepaper, 4⅛ x 6⅛" (10.3 x 15.3 cm), Städtische Galerie im
Lenbachhaus, Munich.

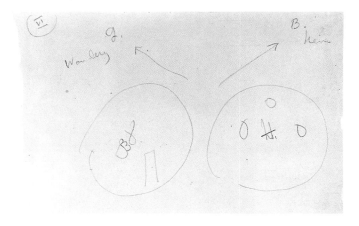

40. *Diagram for Composition VI* 1912–13
Pencil on notepaper, 4⅛ x 5⅞" (10.3 x 14.9 cm), Städtische Galerie im
Lenbachhaus, Munich.

41. *Diagram for Composition VI* 1912–13
Pencil on notepaper, 4⅛ x 6⅛" (10.3 x 15.6 cm), Städtische Galerie im
Lenbachhaus, Munich.

42. *Diagram for Composition VI* 1912–13
Pencil on notepaper, 4⅛ x 6⅛" (10.3 x 15.3 cm), Städtische Galerie im
Lenbachhaus, Munich.

43. *Diagram for Composition VI* 1912–13
Pencil on notepaper, 4⅛ x 6¾" (10.3 x 17 cm), Städtische Galerie im
Lenbachhaus, Munich.

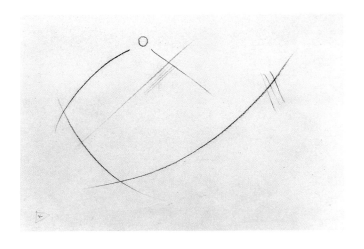

44. Principal Lines of Composition VI 1913
Pencil on paper, 7½ x 10⅝" (19 x 26.9 cm), Musée National d'Art Moderne,
Centre Georges Pompidou, Paris; bequest of Nina Kandinsky, 1981.

45. Study for Detail of Composition VI 1913
Charcoal on paper, 6½ x 8½" (16.4 x 21.5 cm), Musée National d'Art Moderne,
Centre Georges Pompidou, Paris; bequest of Nina Kandinsky, 1981.

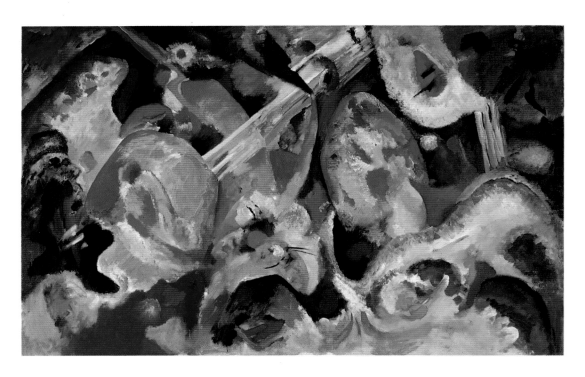

46. Improvisation Deluge (Large Study for Composition VI [Deluge]) 1913
Oil on canvas, 37⅜ x 59⅛" (95 x 150 cm), Städtische Galerie im Lenbachhaus, Munich.

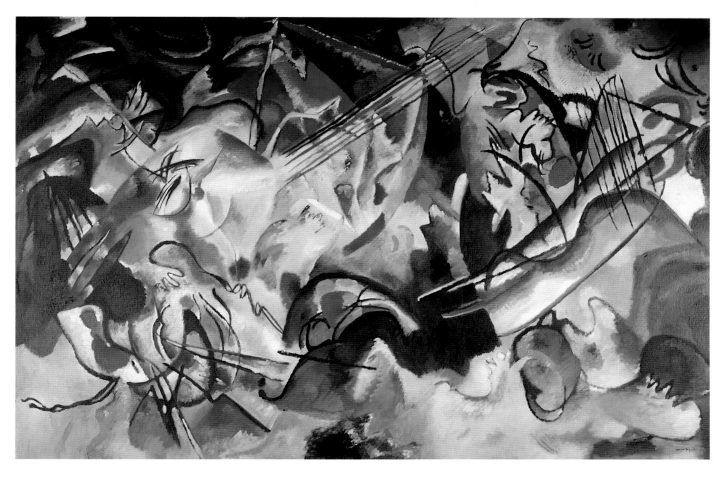

47. *Composition VI* 1913
Oil on canvas, 6' 4¾" x 10' (195 x 300 cm), Hermitage Museum, Saint Petersburg.

48. Untitled *Drawing Related to Composition VII* 1913
Ink on paper, 9³⁄₈ x 12" (23.9 x 30.3 cm), Städtische Galerie im Lenbachhaus, Munich.

49. *Two Sketches on the Theme of Composition VII (Section)*
c. 1913
Pencil on paper, 12 x 9¼" (30.3 x 23.8 cm), Städtische Galerie im Lenbachhaus, Munich.

50. *Study for Composition VII* 1913
Pen and ink on paper, 8¼ x 13" (21 x 33.1 cm), Städtische Galerie im Lenbachhaus, Munich.

51. *Study for Composition VII* 1913
Watercolor on paper, 9³⁄₈ x 12½" (23.9 x 31.6 cm), Städtische Galerie im Lenbachhaus, Munich.

52. *Study for Composition VII* (Fragment) 1913
Watercolor and india ink on paper mounted on cardboard, 9³⁄₈ x 12³⁄₈" (23.9 x 31.5 cm),
Städtische Galerie im Lenbachhaus, Munich.

53. *Watercolor (No. 13)* (Related to Composition VII) 1913
Watercolor on paper, 12½ x 16" (31.8 x 40.5 cm), The Museum of Modern Art,
New York; Katherine S. Dreier Bequest.

54. *Study for Composition VII* 1913
Ink on paper, 8¼ x 13" (21 x 33 cm), Städtische Galerie im Lenbachhaus, Munich.

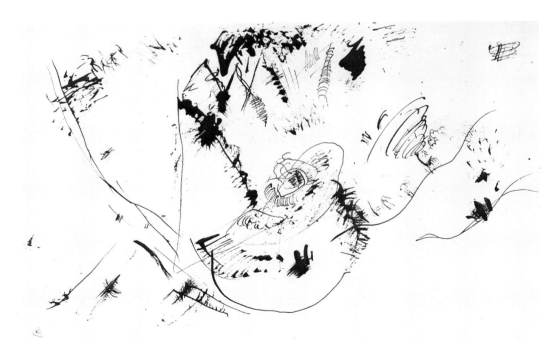

55. *Study for Composition VII* 1913
Ink on paper, 8¼ x 13⅛" (21 x 33.2 cm), Städtische Galerie im Lenbachhaus, Munich.

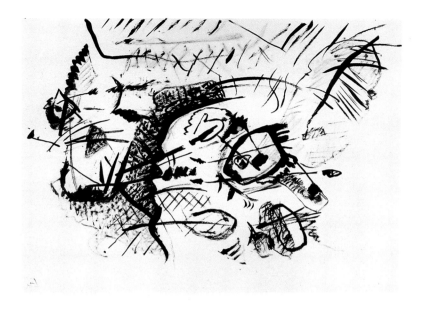

56. *Study for the Center of Composition VII* 1913
Ink on paper, 10 x 13⅛" (25.2 x 33.3 cm), Städtische Galerie im Lenbachhaus, Munich.

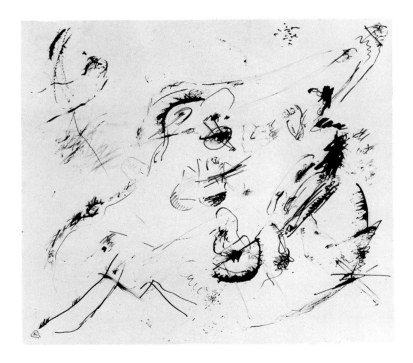

57. *Study for Composition VII* 1913
Pen and ink on paper, 14¼ x 15¾" (36 x 40 cm), Städtische Galerie im
Lenbachhaus, Munich.

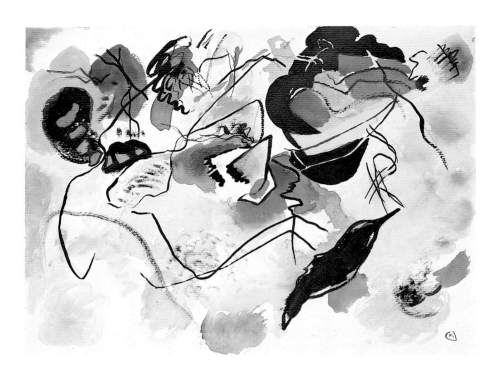

58. *Study for Composition VII* 1913
Watercolor, india ink, and pencil on paper mounted on gray paper, 9⅜ x 12½"
(23.9 x 31.6 cm), Städtische Galerie im Lenbachhaus, Munich.

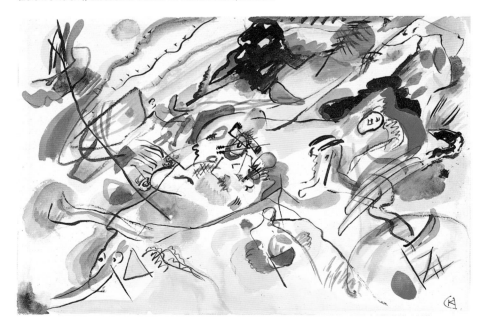

59. *Study for Sketch 1 for Composition VII* 1913
Watercolor, india ink, and pencil on paper mounted on gray paper, 7¼ x 10⅝"
(18.4 x 27.1 cm), Städtische Galerie im Lenbachhaus, Munich.

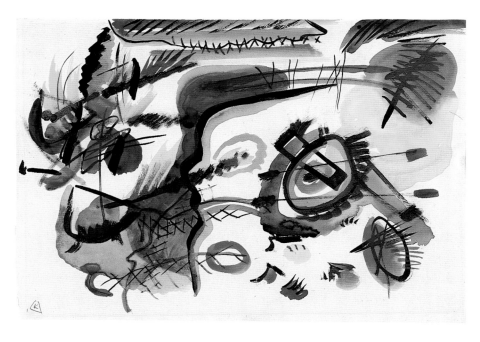

60. *Study for Composition VII* 1913
Watercolor and india ink on paper mounted on gray paper, 9⅞ x 13⅞" (24.9 x 35.2 cm),
Städtische Galerie im Lenbachhaus, Munich.

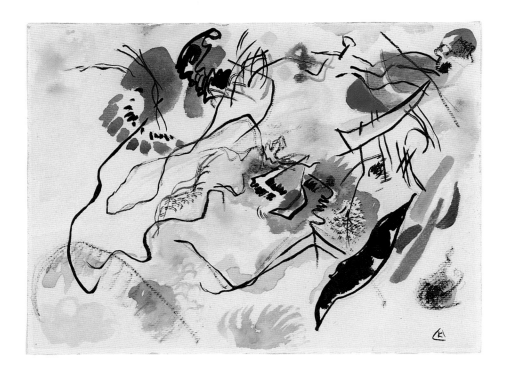

61. *Sketch 14 (Study for Composition VII)* 1913
Watercolor and india ink on paper, 9½ x 12½" (24.1 x 31.7 cm), The Museum
of Modern Art, New York; Katherine S. Dreier Bequest.

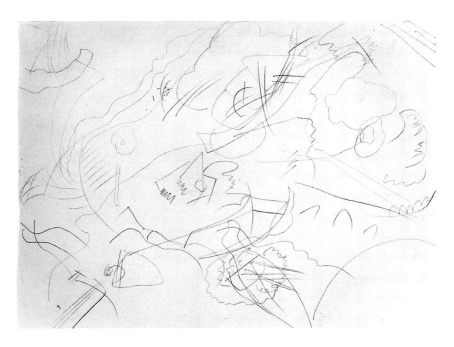

62. *Drawing Related to Sketch 1 for Composition VII* 1913
Pencil on paper, 8¼ x 10⅞" (21 x 27.5 cm), Städtische Galerie im
Lenbachhaus, Munich.

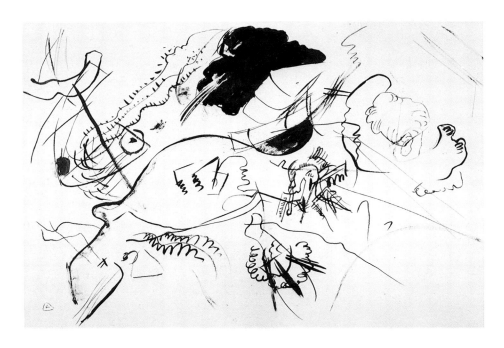

63. *Drawing Related to Sketch 1 for Composition VII* 1913
Ink on paper, 13½ x 19¾" (34.2 x 50 cm), Städtische Galerie im Lenbachhaus, Munich.

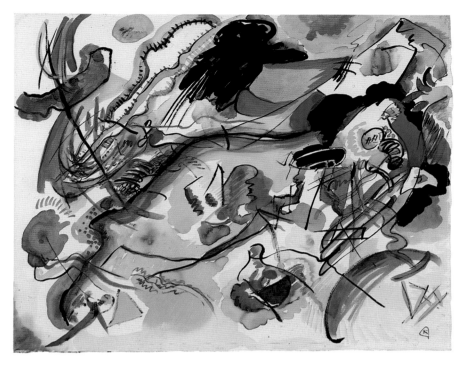

64. *Study for Sketch 1 for Composition VII* 1913
Watercolor and india ink on paper mounted on cardboard, 12 x 15"
(30.4 x 38 cm), Kunstmuseum Bern: Stiftung Othmar Huber.

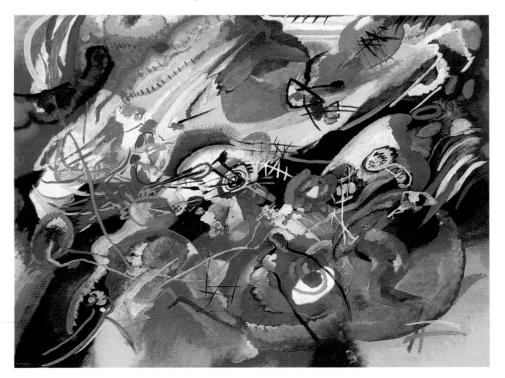

65. *Sketch 1 for Composition VII* 1913
Oil on canvas, 30¾ x 39⅜" (78 x 100 cm), Private collection.

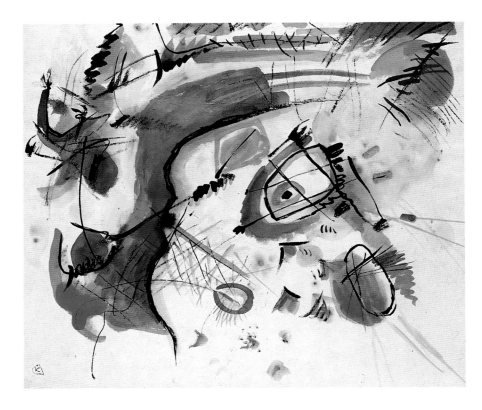

66. *Study for Composition VII* 1913
Watercolor and india ink on paper, 15³⁄₈ x 18¹⁄₈" (39.2 x 46 cm), Private collection.

67. *Study for Composition VII* 1913
Pen and ink on paper, 8¼ x 13" (21 x 33.1 cm), Städtische Galerie im
Lenbachhaus, Munich.

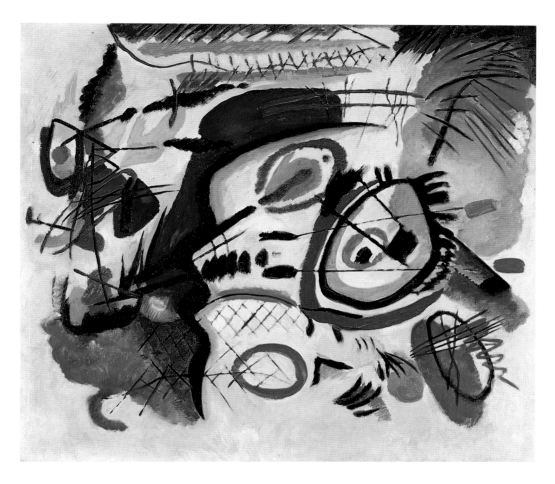

68. *Section 1 for Composition VII* **(Center)** 1913
Oil on canvas, 34½ x 38⅝" (87.5 x 98 cm), Milwaukee Art Museum; gift of
Mrs. Harry Lynde Bradley.

69. Drawing for Composition VII 1913
Pen and ink on paper, 8¼ x 13" (21 x 33.1 cm), Städtische Galerie im
Lenbachhaus, Munich.

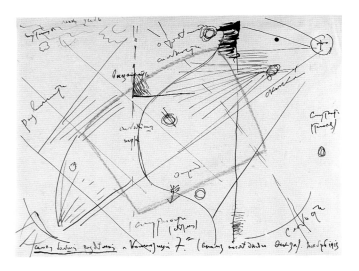

70. Study for Composition VII 1913
Pen and ink and red crayon on paper, 8¼ x 10⅞" (21 x 27.5 cm), Städtische
Galerie im Lenbachhaus, Munich.

71. Study for Composition VII 1913
Pencil on paper, 4⅝ x 6⅞" (11.8 x 17.3 cm), Städtische Galerie im
Lenbachhaus, Munich.

72. Study for Composition VII 1913
Pencil on paper, 9⅜ x 12" (23.8 x 30.4 cm), Städtische Galerie im
Lenbachhaus, Munich.

73. *Study for Composition VII* 1913
Pen and ink on paper, 8¼ x 13" (21 x 33 cm), Städtische Galerie im
Lenbachhaus, Munich.

74. *Study for the Center of Composition VII* 1913
Ink on paper, 8¼ x 13" (20.9 x 33.1 cm), Städtische Galerie im Lenbachhaus,
Munich.

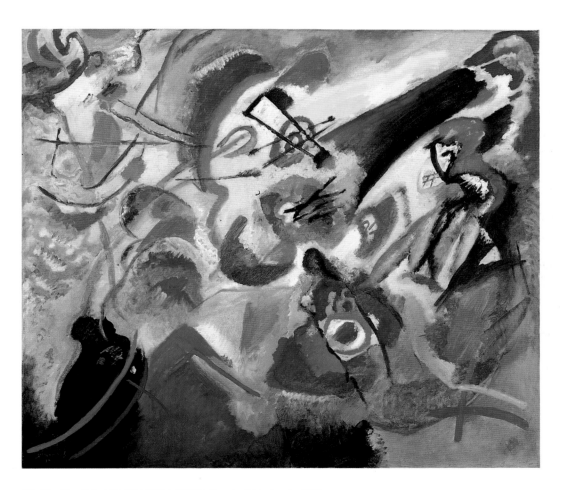

75. *Section 2 for Composition VII* (Center and corners) 1913
Oil on canvas, 34½ x 39¼" (87.5 x 99.5 cm), Albright-Knox Art Gallery, Buffalo,
New York; Room of Contemporary Art Fund, 1947.

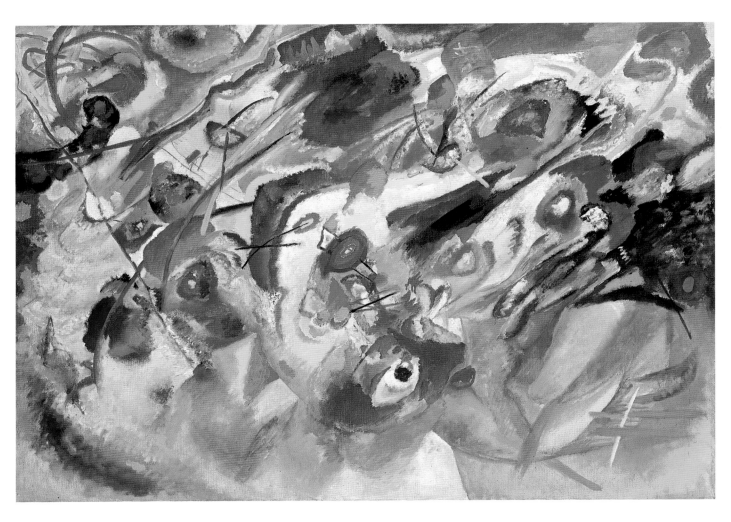

76. *Sketch 2 for Composition VII* 1913
Oil on canvas, 39⅜ x 55⅛" (100 x 140 cm), Städtische Galerie im
Lenbachhaus, Munich.

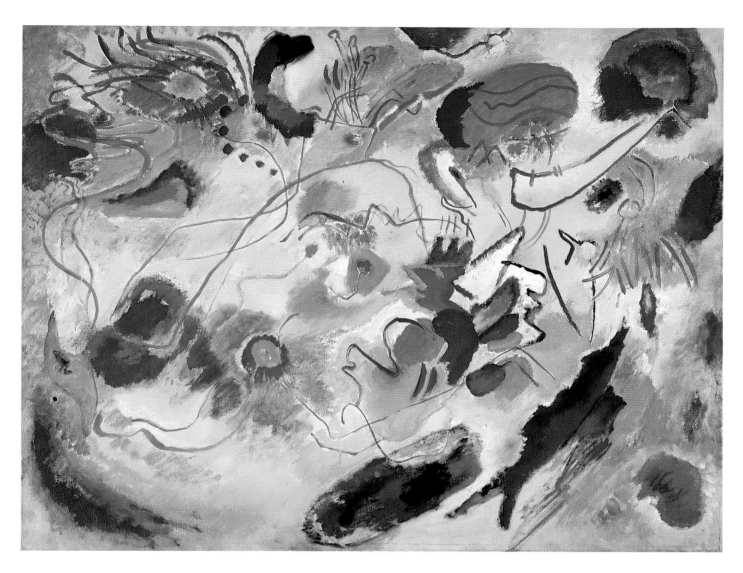

77. Study for Composition VII 1913
Oil and tempera on canvas, 30⅝ x 39⅝" (78.5 x 100.5 cm), Städtische Galerie
im Lenbachhaus, Munich.

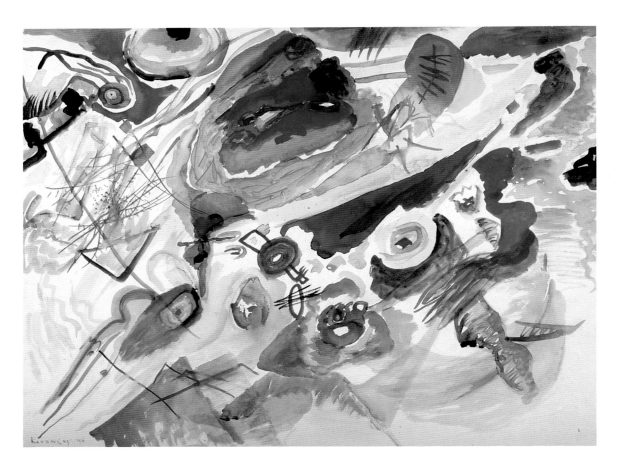

78. *Watercolor with Red Spot (Related to Composition VII)* 1913
Watercolor on paper, 19 x 24⅞" (48.3 x 63.3 cm), Deutsche Bank AG.

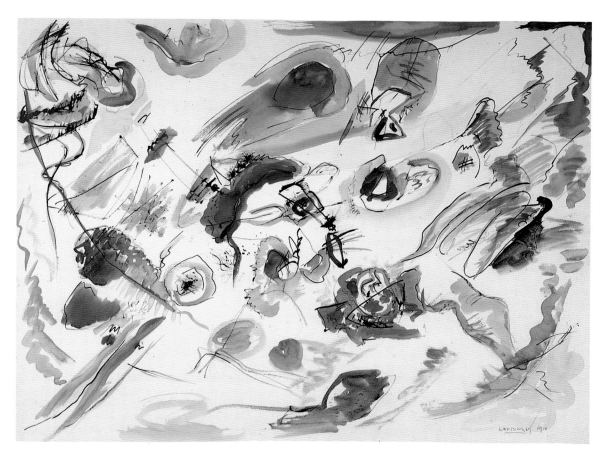

79. Untitled (*Study for Composition VII*) 1913
Watercolor, india ink, and pencil on paper mounted on cardboard, 19⅝ x 25⅝"
(49.8 x 65.1 cm), Musée National d'Art Moderne, Centre Georges Pompidou,
Paris; gift of Nina Kandinsky, 1976.

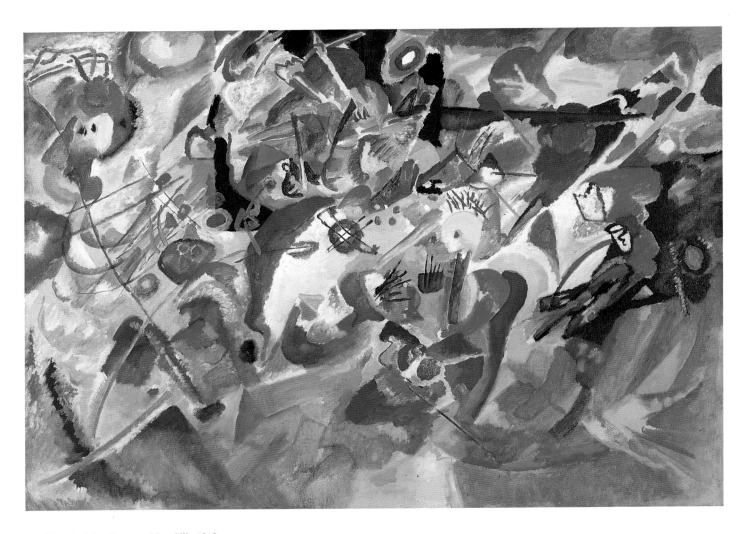

80. *Sketch 3 for Composition VII* 1913
Oil on canvas, 35¼ x 49¼" (89.5 x 125 cm), Städtische Galerie im
Lenbachhaus, Munich.

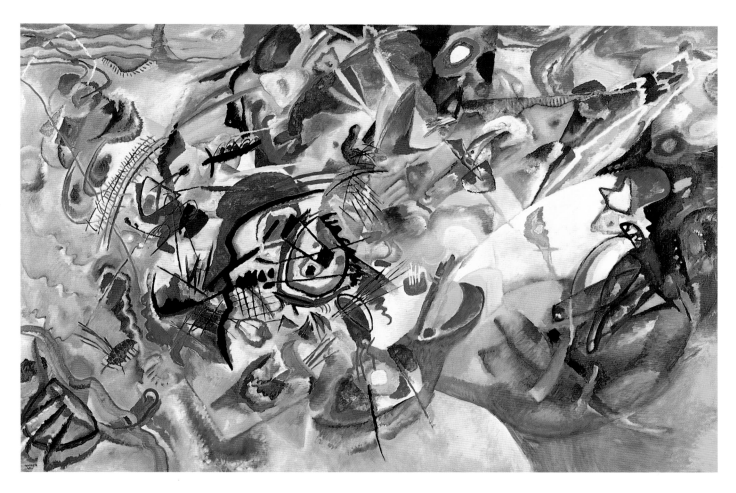

81. *Composition VII* 1913
Oil on canvas, 6' 6¾" x 9' 11⅛" (200 x 300 cm), Tretyakov Gallery, Moscow.

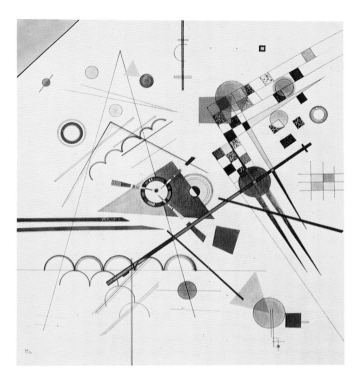

82. Untitled (*Related to Composition VIII*) 1923
Pencil and india ink on paper, 14⅞ x 14½" (37.6 x 36.7 cm), Musée National d'Art Moderne, Centre Georges Pompidou, Paris; bequest of Nina Kandinsky, 1981.

83. *Study for Composition VIII* 1923
Watercolor on paper, 18½ x 16¾" (47 x 42.5 cm), Private collection.

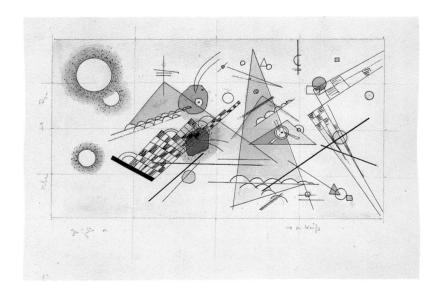

84. Untitled (*Study for Composition VIII*) 1923
Pencil, india ink, and watercolor on paper, 11 x 14⅞" (27.8 x 37.7 cm), Musée National d'Art Moderne, Centre Georges Pompidou, Paris; bequest of Nina Kandinsky, 1981.

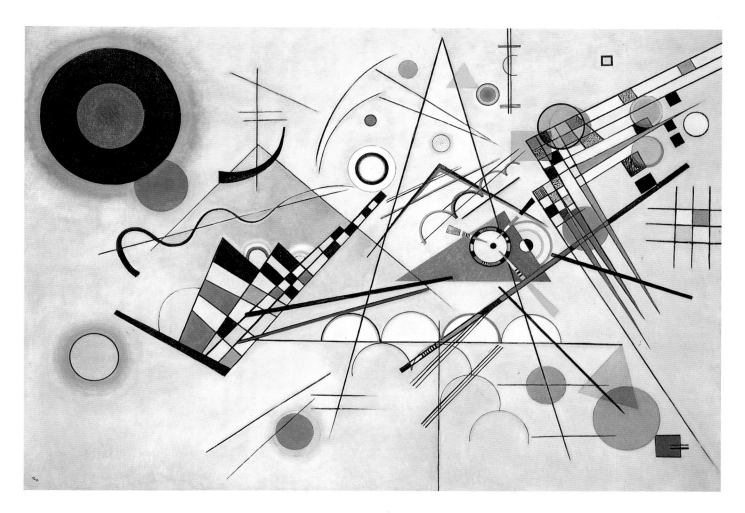

85. *Composition VIII* 1923
Oil on canvas, 55⅛ x 79⅛" (140 x 201 cm), Solomon R. Guggenheim
Museum, New York; gift, Solomon R. Guggenheim, 1937.

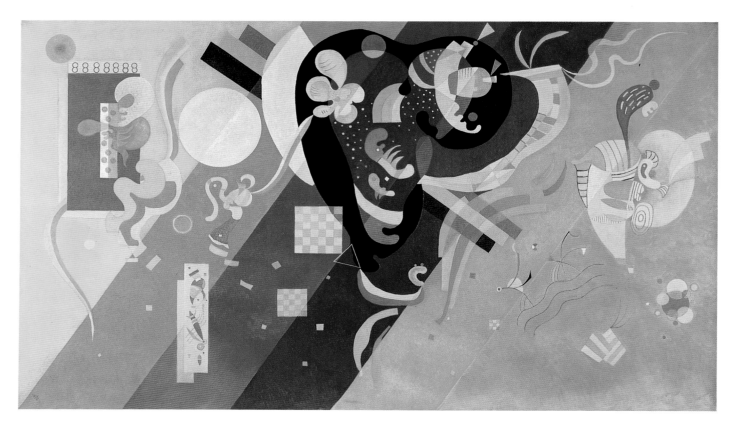

86. *Composition IX* 1936
Oil on canvas, 44⅝ x 76¾" (113.5 x 195 cm), Musée National d'Art Moderne,
Centre Georges Pompidou, Paris; Attribution de l'Etat.

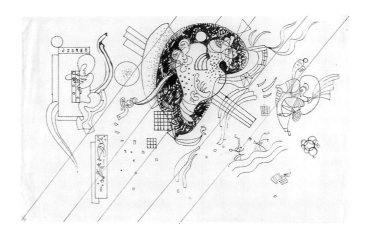

87. Untitled (*Study Related to Composition IX*) n.d.
India ink and pencil on paper, 12⅞ x 19⅞" (32.5 x 50.6 cm), Musée National
d'Art Moderne, Centre Georges Pompidou, Paris; bequest of Nina Kandinsky,
1981.

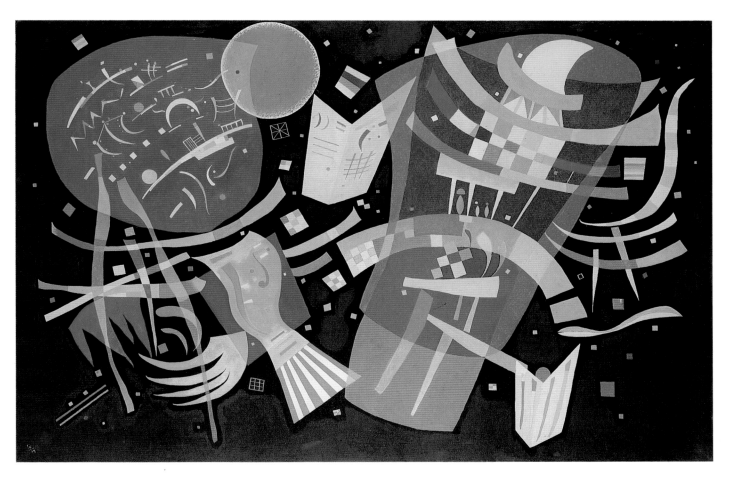

88. *Composition X* 1939
Oil on canvas, 51⅛ x 76¾" (130 x 195 cm), Kunstsammlung Nordrhein-
Westfalen, Düsseldorf.

Chronology

1866
December 4: Born Vasily Vasilievich Kandinsky in Moscow.

1871–85
Family moves to Odessa, where he attends high school and learns to play the piano and cello. Beginning in 1879, makes yearly trips to Moscow with his father.

1886–92
Studies economics, law, and ethnography at the University of Moscow.

1889
May 28–July 30: Commissioned by the Russian Imperial Society of Friends of Natural History, Anthropology, and Ethnography, embarks on solo expedition to the remote Vologda province and is impressed by native folk art. Subsequently publishes essay on the pagan religion of the Zyrians, an East Finnish tribe.

1892
Marries his second cousin, Ania Chimiakin.

1896
Summer: Sees a Monet Haystack at the French Industrial and Art Exhibition in Moscow. Is deeply moved by the picture, without at first recognizing the object portrayed.
December: Moves to Munich in order to study painting.

1897
For two years, studies at the private art school of Anton Ažbè.

1900
Studies under Franz von Stuck at the Academy of Art in Munich.

1901
May: Cofounder and, later in the year, president of the Phalanx exhibition society; teaches painting and drawing at the Phalanx school.
August–November: Participates in the first Phalanx exhibition.

1902
Meets Gabriele Münter, his student at the Phalanx school.

1904–05
Begins writing a theory of colors.
Separates from wife.
After dissolution of Phalanx association, travels with Münter to the Netherlands, Tunisia, and Italy.

1906–08
Kandinsky and Münter live in Sèvres, near Paris, also in Berlin, Munich, and Murnau.

1907
June: Begins *Klänge* woodcuts.

1908
Attends lecture in Berlin given by the German theosophist Rudolf Steiner.

1909
January: Cofounder and president of Neue Künstlervereinigung (New Artists' Society) of Munich (NKVM).
October: Is Munich correspondant, through November 1910, to the Russian art journal *Apollon*.
Winter: Begins *Composition I* and *Composition II*, completed respectively in January and March of the following year.

1910
Meets Franz Marc and August Macke.
September 15: Completes *Composition III*.
Finishes manuscript of *Uber das Geistige in der Kunst (On the Spiritual in Art)*.

1911
January: Attends Schönberg concert in Munich; begins correspondence with the composer that would continue regularly through the summer of 1914.
February: Completes *Composition IV*.
Mid-September: Meets Schönberg.
Fall: Cofounder, with Franz Marc, of Der Blaue Reiter (The Blue Rider).
Meets Paul Klee.
Divorce from Ania Chimiakin becomes final.
November 17: Completes *Composition V*.
December 2: *Composition V* rejected by NKVM jury, causing Kandinsky, Marc, Münter, and Alfred Kubin to resign from the society.
December 18–January 3, 1912: The first Blaue Reiter exhibition opens.
December: Publishes first edition of *On the Spiritual in Art*.
December 29–31: Excerpts from the text of *On the Spiritual in Art* are read by Nikolai Kulbin at the Second All-Russian Congress of Artists in Saint Petersburg.

1912
April: Second edition of *On the Spiritual in Art* is published.
May: Publication of *Der Blaue Reiter Almanach*.
Fall: Publication of *Klänge (Sounds)*, collection of prose poems and woodcuts.
Third edition of *On the Spiritual in Art* is published.
October 2–28: First one-man exhibition opens at Galerie Der Sturm, Berlin and tours in varying forms in Germany, the Netherlands, Switzerland, and Sweden through September 1916.

1913
March 5: Completes *Composition VI*.
September: Publishes essay, "Malerei als reine Kunst" ("Painting as Pure Art") in *Der Sturm*, Berlin.
September 20–December 13: Erster Deutscher Herbstsalon (First German Salon d'Automne) is held in Berlin, organized by Der Sturm.
October: The album *Kandinsky 1901–1913*, containing the artist's "Reminiscences" ("Rückblicke"), as well as his descriptions of *Compositions IV*, *VI*, and *Painting with White Border*,

is published by Der Sturm, Berlin.
November 25–28: Paints *Composition VII*.

1914
Composition VII is included in the Munich venue of the 1912 solo exhibition, held at the Moderne Galerie Thannhauser.
January 30–February 15: One-man exhibition held at the Kreis für Kunst Köln im Deutschen Theater (Cologne). Traveled to Barmen (Wuppertal) and Aachen through late March.
April 23: English translation of *On the Spiritual in Art* published in London and Boston.
August: Outbreak of World War I, leaves Munich with Münter and travels to Switzerland.
December: Returns to Moscow.

1915
December 23–March 16, 1916: In Stockholm; last meeting with Münter.

1916
February 1: *Composition VI* included in *Kandinsky: Oljemålninger och Grafik*, the Stockholm venue of the one-man exhibition organized by Der Sturm in 1912.
March 17–April 16: *Composition II* exhibited at the Hague in *Zweite Ausstellung Den Haag/Holland: Expressionisten, Kubisten.*
March 19: Returns to Russia.

1917
February 11: Marries Nina Andreevskaya.
September: Birth of son, Vsevolod Vasilievich (1917–20).

1918
January: At invitation of Vladimir Tatlin, joins Department of Visual Arts (IZO) of Narkompros (NKP) (People's Commissariat for Enlightenment).
July: Appointed editor of *Visual Art*, a periodical published by IZO NKP.
October: Teaches at Svomas (Free State Art Studios), Moscow. IZO NKP publishes *Text khudozhnika (Text of the Artist)*, a Russian translation of "Rückblicke" ("Reminiscences"). As a member of the committee that oversees the International Bureau of IZO, he establishes contact with German artists and the architect Walter Gropius.

1919
April 13–June: *Composition VI* included in the *First Free State Exhibition*, Saint Petersburg.
Appointed first director of Museums of Painterly Culture, Moscow.

1920
May: Participates in founding of Inkhuk (Institute of Artistic Culture), an organization devoted to the systemization of artistic theories developed under Communism.
September: Teaches at Vkhutemas (Higher State Art–Technical Studios), which replaces Svomas and consists of both private studios headed by faculty members and workshops open to the public.
October–December: *Composition VII* exhibited at the All-Russian Central Exhibiting Bureau, Moscow.
December: After his teaching program is rejected, leaves Inkhuk.

1921
October: Cofounder and vice president of Russian Academy of Artistic Sciences.
December: Leaves Russia for Berlin.

1922
June: Moves to Weimar where he has accepted professorship at the Bauhaus. Teaches "Theory of Form" and the workshop for mural painting.
Publishes *Kleine Welten (Small Worlds)*, a portfolio of prints, in Berlin.

1923
March 23–May 4: First one-man exhibition in New York held at the galleries of the Société Anonyme.
July: Completes *Composition VIII*.
Publication in Bauhaus anthology of his writings "The Basic Elements of Form," "Color Course and Seminar," and "Abstract Synthesis on the Stage."

1924
March: The *Blaue Vier* (Blue Four) exhibition group (Kandinsky, Klee, Lyonel Feininger and Alexei Jawlensky) formed by the art dealer Galka Scheyer, who becomes Kandinsky's representative in the United States.

1925
January 11–February 28: Exhibits *Composition VIII* in one-man exhibition at the Neues Museum, Wiesbaden.
March 12–November: One-man exhibition with venues in Barmen (Wuppertal), Bochum, and Dusseldorf.
April 1: Bauhaus forced to close by a political group that will later become the National Socialist Party.
June: Moves to Dessau, where the Bauhaus relocates.

1926
Punkt und Linie zu Fläche (Point and Line to Plane) published in Munich.
May 9–June 6: Jubilee exhibition in honor of Kandinsky's sixtieth birthday is held in Braunschweig.
December: The first issue of the periodical *Bauhaus* is dedicated to Kandinsky. It includes his "Der Wert des theoretischen Unterrichts in der Malerei" ("The Value of Theoretical Instruction in Painting").

1927
March 8: Kandinsky and his wife Nina become German citizens.

1928
February: *Cossacks* shown in a joint exhibition with George Grosz at the Kunsthaus Schaller, Stuttgart.

1931
Fall: The article "Reflections on Abstract Art" marks Kandinsky's first contribution to Christian Zervos' *Cahiers d'Art*.

1932
August 22: Nazi party closes Bauhaus in Dessau.
October: Moves with Bauhaus to Berlin.

1933

April 11: Bauhaus is again shut down by the Nazis. After efforts to reopen fail, it officially closes in July.
December: Arrives in Paris, to settle by the end of the year in the suburb Neuilly-sur-Seine.

1936

February: Completes *Composition IX*.

1937

February 21–March 29: One-man exhibition at the Kunsthalle Bern.
July 19: Kandinsky's work included in the exhibition *Entartete Kunst (Degenerate Art)* at Haus der Kunst, Munich.
Nazis confiscate 57 of Kandinsky's works from German museums.

1938

March: Publishes the article "L'Art concret" in the first volume of the periodical *XX Siècle*.
December–January 1939: Paints *Composition X*.

1939

April: *Composition IX* purchased by the French state.
Kandinsky and his wife become French citizens.

1940

German invasion of France.

1942

December 8–February 1943: *Works by Kandinsky: A Retrospective Show* held at the Nierendorf Gallery in New York.

1944

March: Becomes ill; completes the last painting catalogued in the Handlists; continues to work through June.
December 13: Kandinsky dies, Neuilly-sur-Seine.

List of Compositions and Related Studies

An asterisk indicates the work is in the exhibition. Height precedes width in all dimensions.

*1. Untitled (*Study for Composition I*)
1910
Pencil on paper
4½ x 7⅛" (11.3 x 18 cm)
Musée National d'Art Moderne,
Centre Georges Pompidou, Paris
Bequest of Nina Kandinsky, 1981

2. *Study for Composition I*
1910
Pencil on paper
6½ x 4⅛" (16.3 x 10.4 cm)
Städtische Galerie im Lenbachhaus,
Munich

3. *Composition I*
1910
Oil on canvas
47¼ x 55⅛" (120 x 140 cm)
No longer extant

*4. Untitled (*Study for a Woodcut on the Theme of Composition I*)
1910
Charcoal, blue pencil, and ink
on cardboard
4⅝ x 7⅛" (11.8 x 18.2 cm)
Musée National d'Art Moderne,
Centre Georges Pompidou, Paris
Bequest of Nina Kandinsky, 1981

5. *Sketch for Watercolor Study for Composition II*
1909
Page 66 of notebook;
pencil on paper
5¼ x 3⅛" (13.2 x 7.9 cm)
Städtische Galerie im Lenbachhaus,
Munich

*6. Untitled (*Study for Section of Composition II*)
1910
Pencil on paper
5⅞ x 3⅞" (14.8 x 10 cm)
Musée National d'Art Moderne,
Centre Georges Pompidou, Paris
Bequest of Nina Kandinsky, 1981

7. *Study for Composition II*
1910
India ink on paper
9⅜ x 11⅞" (23.8 x 30.2 cm)
Musée National d'Art Moderne,
Centre Georges Pompidou, Paris
Bequest of Nina Kandinsky, 1981

8. *Diagram for Composition II*
1910
Pencil on paper
8½ x 12" (21.7 x 30.3 cm)
Musée National d'Art Moderne,
Centre Georges Pompidou, Paris
Bequest of Nina Kandinsky, 1981

9. *Study for Composition II
(Two Riders and Reclining Figure)*
c. 1910
Watercolor and pencil on
cardboard
12⅞ x 12⅞" (32.9 x 32.9 cm)
Städtische Galerie im Lenbachhaus,
Munich

*10. *Study for Section of Composition II*
1910
Oil on cardboard
22⅞ x 18⅞" (58 x 48 cm)
Private collection, Switzerland

*11. *Sketch for Composition II*
1909–10
Oil on canvas
38⅜ x 51⅝" (97.5 x 131.2 cm)
Solomon R. Guggenheim Museum,
New York

12. *Composition II*
1910
Oil on canvas
78¾ x 108¼" (200 x 275 cm)
No longer extant

*13. *Composition II* (plate, folio 7)
from *Klänge* (Munich, 1911)
Woodcut, printed in black
Composition: 5⅞ x 8¼" (14.9 x
21 cm)
Page: 11 1/16 x 10⅞" (28.1 x
27.7 cm)
The Museum of Modern Art,
New York
The Louis E. Stern Collection

14. *Diagram for Composition III*
1910
Pencil on paper
9¾ x 11⅝" (24.8 x 29.7 cm)
Musée National d'Art Moderne,
Centre Georges Pompidou, Paris
Bequest of Nina Kandinsky, 1981

15. Untitled (*Diagram for Composition III*)
1910
Pencil on notebook page
6⅜ x 8¼" (16.2 x 20.9 cm)
Musée National d'Art Moderne,
Centre Georges Pompidou, Paris
Bequest of Nina Kandinsky, 1981

*16. Untitled (*Study for Composition III [Improvisation XV]*)
1910
Pencil on paper
3⅞ x 5⅞" (10 x 14.8 cm)
Musée National d'Art Moderne,
Centre Georges Pompidou, Paris
Bequest of Nina Kandinsky, 1981

*17a–b. Untitled (*Studies for Composition III*, recto and verso)
1910
Black and blue pencil on paper
6½ x 8¼" (16.5 x 20.9 cm)
Musée National d'Art Moderne,
Centre Georges Pompidou, Paris
Bequest of Nina Kandinsky, 1981

*18. *Drawing for Composition III*
1910
India ink on paper
9⅞ x 12" (25 x 30.4 cm)
Musée National d'Art Moderne,
Centre Georges Pompidou, Paris
Bequest of Nina Kandinsky, 1981

19. *Sketch for Improvisation XV
(Study for Composition III)*
1910
Oil on cardboard
Dimensions and location unknown

20. *Composition III*
1910
Oil on canvas
74¾ x 98⅜" (190 x 250 cm)
No longer extant

*21. *First Drawing for Composition IV*
1911
Pencil, charcoal, and india ink
on paper
4 x 7⅞" (10.2 x 20 cm)
Musée National d'Art Moderne,
Centre Georges Pompidou, Paris
Bequest of Nina Kandinsky, 1981

*22. Untitled (*Diagram for Composition IV*)
1911
Charcoal on paper
3⅞ x 5⅞" (10 x 14.9 cm)
Musée National d'Art Moderne,
Centre Georges Pompidou, Paris
Bequest of Nina Kandinsky, 1981

*23. Untitled (*Study for Detail of Composition IV*)
1911
Charcoal on paper
3⅞ x 5⅞" (10 x 14.9 cm)
Musée National d'Art Moderne,
Centre Georges Pompidou, Paris
Bequest of Nina Kandinsky, 1981

*24. Untitled (*Study for Detail of Composition IV*)
1911
Charcoal on paper
3⅞ x 5⅞" (10 x 14.9 cm)
Musée National d'Art Moderne,
Centre Georges Pompidou, Paris
Bequest of Nina Kandinsky, 1981

25. Untitled (*Study for Detail of Composition IV*)
1911
Pencil on paper
3⅞ x 5⅞" (10 x 14.9 cm)
Musée National d'Art Moderne,
Centre Georges Pompidou, Paris
Bequest of Nina Kandinsky, 1981

*26. *Drawing for Composition IV*
1911
Pencil and india ink on paper
9⅞ x 12" (24.9 x 30.5 cm)
Musée National d'Art Moderne,
Centre Georges Pompidou, Paris
Bequest of Nina Kandinsky, 1981

*27. Untitled (*Study for Composition IV*)
1911
Pencil, charcoal, and watercolor
on paper
7⅜ x 10⅝" (18.5 x 27.1 cm)
Musée National d'Art Moderne,
Centre Georges Pompidou, Paris
Bequest of Nina Kandinsky, 1981

28. *Study for Composition IV*
1911
Etching with watercolor and
india ink on paper
7½ x 10⅜" (19 x 26.3 cm)
Städtische Galerie im Lenbachhaus,
Munich

*29. *Cover Design for the Edition Salon Izdebsky*
(motif taken from *Composition IV*)
1911
Woodblock
11⅛ x 11 x 1" (28.2 x 27.9 x
2.5 cm)
Musée National d'Art Moderne,
Centre Georges Pompidou, Paris
Bequest of Nina Kandinsky, 1981

*30. *Cossacks*
1910–11
Oil on canvas
37 x 51⅛" (94 x 129.9 cm)
The Tate Gallery, London
Presented by Mrs. Hazel McKinley,
1938

*31. *Composition IV*
1911
Oil on canvas
62⅞ x 98⅝" (159.5 x 250.5 cm)
Kunstsammlung Nordrhein-
Westfalen, Düsseldorf

*32. *Sketch for Composition V*
1911
Oil on canvas
37¼ x 54¾" (94.5 x 139 cm)
The Hermitage Museum, Saint
Petersburg

33. Untitled (*Two Diagrams for Composition V*)
1911
Ink on paper (on reverse of
a letter)
8¾ x 11" (22.1 x 28 cm)
Musée National d'Art Moderne,
Centre Georges Pompidou, Paris
Bequest of Nina Kandinsky, 1981

*34. *Composition V*
1911
Oil on canvas
6' 3⅞" x 9' ¼" (190 x 275 cm)
Private collection

35. *Animals and People (Study for Deluge for Composition VI)*
c. 1912
Pencil on paper
13⅜ x 17¼" (33.8 x 43.8 cm)
Städtische Galerie im Lenbachhaus,
Munich

36. *Figure and Hand Studies (Study for Deluge for Composition VI)*
c. 1912
Pencil on paper
13⅜ x 17¼" (33.8 x 43.8 cm)
Städtische Galerie im Lenbachhaus,
Munich

37. *Study for Composition VI*
1912–13
Pencil on paper
13¼ x 17¼" (33.6 x 43.8 cm)
Städtische Galerie im Lenbachhaus,
Munich

38. *Study for Composition VI*
1912–13
Pencil on paper
8⅜ x 13" (21.1 x 33.2 cm)
Städtische Galerie im Lenbachhaus,
Munich

39. *Diagram for Composition VI*
1912–13
Pencil on notepaper
4⅛ x 6⅛" (10.3 x 15.3 cm)
Städtische Galerie im Lenbachhaus,
Munich

40. *Diagram for Composition VI*
1912–13
Pencil on notepaper
4⅛ x 5⅞" (10.3 x 14.9 cm)
Städtische Galerie im Lenbachhaus,
Munich

41. *Diagram for Composition VI*
1912–13
Pencil on notepaper
4⅛ x 6⅛" (10.3 x 15.6 cm)
Städtische Galerie im Lenbachhaus,
Munich

42. *Diagram for Composition VI*
1912–13
Pencil on notepaper
4⅛ x 6⅛" (10.3 x 15.3 cm)
Städtische Galerie im Lenbachhaus,
Munich

43. *Diagram for Composition VI*
1912–13
Pencil on notepaper
4⅛ x 6¾" (10.3 x 17 cm)
Städtische Galerie im Lenbachhaus,
Munich

44. *Principal Lines of Composition VI*
1913
Pencil on paper
7½ x 10⅝" (19 x 26.9 cm)
Musée National d'Art Moderne,
Centre Georges Pompidou, Paris
Bequest of Nina Kandinsky, 1981

*45. *Study for Detail of Composition VI*
1913
Charcoal on paper
6½ x 8½" (16.4 x 21.5 cm)
Musée National d'Art Moderne,
Centre Georges Pompidou, Paris
Bequest of Nina Kandinsky, 1981

46. *Improvisation Deluge (Large Study
for Composition VI [Deluge])*
1913
Oil on canvas
37⅜ x 59⅛" (95 x 150 cm)
Städtische Galerie im Lenbachhaus,
Munich

*47. *Composition VI*
1913
Oil on canvas
6' 4¾" x 10' (195 x 300 cm)
The Hermitage Museum, Saint
Petersburg

48a–b. Untitled recto: *Watercolor
Related to Section 1 for Composi-
tion VII (Center)*; verso: *Drawing
Related to Composition VII*, with
inscription
1913
Recto: Watercolor and india ink on
paper
Verso: Ink on paper
9⅜ x 12" (23.9 x 30.3 cm)
Städtische Galerie im Lenbachhaus,
Munich

49. *Two Sketches on the Theme of
Composition VII (Section)*
c. 1913
Pencil on paper
12 x 9¼" (30.3 x 23.8 cm)
Städtische Galerie im Lenbachhaus,
Munich

50. *Study for Composition VII*
1913
Pen and ink on paper
8¼ x 13" (21 x 33.1 cm)
Städtische Galerie im Lenbachhaus,
Munich

51. *Study for Composition VII*
1913
Watercolor on paper
9⅜ x 12½" (23.9 x 31.6 cm)
Städtische Galerie im Lenbachhaus,
Munich

52. *Study for Composition VII*
(Fragment)
1913
Watercolor and india ink on paper
mounted on cardboard
9⅜ x 12⅜" (23.9 x 31.5 cm)
Städtische Galerie im Lenbachhaus,
Munich

*53. *Watercolor (No. 13) (Related to
Composition VII)*
1913
Watercolor on paper
12½ x 16" (31.8 x 40.5 cm)
The Museum of Modern Art,
New York
Katherine S. Dreier Bequest

54. *Study for Composition VII*
1913
Ink on paper
8¼ x 13" (21 x 33 cm)
Städtische Galerie im Lenbachhaus,
Munich

55. *Study for Composition VII*
1913
Ink on paper
8¼ x 13⅛" (21 x 33.2 cm)
Städtische Galerie im Lenbachhaus,
Munich

56. *Study for the Center of
Composition VII*
1913
Ink on paper
10 x 13⅛" (25.2 x 33.3 cm)
Städtische Galerie im Lenbachhaus,
Munich

57. *Study for Composition VII*
1913
Pen and ink on paper
14¼ x 15¾" (36 x 40 cm)
Städtische Galerie im Lenbachhaus,
Munich

58. *Study for Composition VII*
1913
Watercolor, india ink, and pencil
on paper mounted on gray paper
9⅜ x 12½" (23.9 x 31.6 cm)
Städtische Galerie im Lenbachhaus,
Munich

59. *Study for Sketch 1 for
Composition VII*
1913
Watercolor, india ink, and pencil
on paper mounted on gray paper
7¼ x 10⅝" (18.4 x 27.1 cm)
Städtische Galerie im Lenbachhaus,
Munich

60. *Study for Composition VII*
1913
Watercolor and india ink on paper
mounted on gray paper
9⅞ x 13⅞" (24.9 x 35.2 cm)
Städtische Galerie im Lenbachhaus,
Munich

*61. *Sketch 14 (Study for
Composition VII)*
1913
Watercolor and india ink on paper
9½ x 12½" (24.1 x 31.7 cm)
The Museum of Modern Art,
New York
Katherine S. Dreier Bequest

62. *Drawing Related to Sketch 1 for
Composition VII*
1913
Pencil on paper
8¼ x 10⅞" (21 x 27.5 cm)
Städtische Galerie im Lenbachhaus,
Munich

63. *Drawing Related to Sketch 1 for
Composition VII*
1913
Ink on paper
13½ x 19¾" (34.2 x 50 cm)
Städtische Galerie im Lenbachhaus,
Munich

*64. *Study for Sketch 1 for Composition
VII*
1913
Watercolor and india ink on paper
mounted on cardboard
12 x 15" (30.4 x 38 cm)
Kunstmuseum Bern: Stiftung
Othmar Huber

65. *Sketch 1 for Composition VII*
1913
Oil on canvas
30¾ x 39⅜" (78 x 100 cm)
Private collection

*66. *Study for Composition VII*
1913
Watercolor and india ink on paper
15⅜ x 18⅛" (39.2 x 46 cm)
Private collection

67. *Study for Composition VII*
1913
Pen and ink on paper
8¼ x 13" (21 x 33.1 cm)
Städtische Galerie im Lenbachhaus,
Munich

*68. *Section 1 for Composition VII*
(*Center*)
1913
Oil on canvas
34½ x 38⅝" (87.5 x 98 cm)
Milwaukee Art Museum
Gift of Mrs. Harry Lynde Bradley

69. *Drawing for Composition VII*
1913
Pen and ink on paper
8¼ x 13" (21 x 33.1 cm)
Städtische Galerie im Lenbachhaus,
Munich

70. *Study for Composition VII*
1913
Pen and ink and red crayon on
paper
8¼ x 10⅞" (21 x 27.5 cm)
Städtische Galerie im Lenbachhaus,
Munich

71. *Study for Composition VII*
1913
Pencil on paper
4⅝ x 6⅞" (11.8 x 17.3 cm)
Städtische Galerie im Lenbachhaus,
Munich

72. *Study for Composition VII*
1913
Pencil on paper
9⅜ x 12" (23.8 x 30.4 cm)
Städtische Galerie im Lenbachhaus,
Munich

73. *Study for Composition VII*
1913
Pen and ink on paper
8¼ x 13" (21 x 33 cm)
Städtische Galerie im Lenbachhaus,
Munich

74. *Study for the Center of
Composition VII*
1913
Ink on paper
8¼ x 13" (20.9 x 33.1 cm)
Städtische Galerie im Lenbachhaus,
Munich

*75. *Section 2 for Composition VII*
(*Center and corners*)
1913
Oil on canvas
34½ x 39¼" (87.5 x 99.5 cm)
Albright-Knox Art Gallery, Buffalo,
New York: Room of
Contemporary Art Fund, 1947

76. *Sketch 2 for Composition VII*
1913
Oil on canvas
39⅜ x 55⅛" (100 x 140 cm)
Städtische Galerie im Lenbachhaus,
Munich

77. *Study for Composition VII*
1913
Oil and tempera on canvas
30⅝ x 39⅝" (78.5 x 100.5 cm)
Städtische Galerie im Lenbachhaus,
Munich

*78. *Watercolor with Red Spot
(Related to Composition VII)*
1913
Watercolor on paper
19 x 24⅞" (48.3 x 63.3 cm)
Deutsche Bank AG

*79. Untitled (*Study for
Composition VII*)
1913
Watercolor, india ink, and pencil
on paper mounted on cardboard
19⅝ x 25⅝" (49.8 x 65.1 cm)
Musée National d'Art Moderne,
Centre Georges Pompidou, Paris
Gift of Nina Kandinsky, 1976

80. *Sketch 3 for Composition VII*
1913
Oil on canvas
35¼ x 49¼" (89.5 x 125 cm)
Städtische Galerie im Lenbachhaus,
Munich

*81. *Composition VII*
1913
Oil on canvas
6' 6¾" x 9' 11⅛" (200 x 300 cm)
Tretyakov Gallery, Moscow

*82. Untitled (*Related to
Composition VIII*)
1923
Pencil and india ink on paper
14⅞ x 14½" (37.6 x 36.7 cm)
Musée National d'Art Moderne,
Centre Georges Pompidou, Paris
Bequest of Nina Kandinsky, 1981

83. *Study for Composition VIII*
1923
Watercolor on paper
18½ x 16¾" (47 x 42.5 cm)
Private collection

*84. Untitled (*Study for
Composition VIII*)
1923
Pencil, india ink, and watercolor
on paper
11 x 14⅞" (27.8 x 37.7 cm)
Musée National d'Art Moderne,
Centre Georges Pompidou, Paris
Bequest of Nina Kandinsky, 1981

*85. *Composition VIII*
1923
Oil on canvas
55⅛ x 79⅛" (140 x 201 cm)
Solomon R. Guggenheim Museum,
New York
Gift, Solomon R. Guggenheim,
1937

*86. *Composition IX*
1936
Oil on canvas
44⅝ x 76¾" (113.5 x 195 cm)
Musée National d'Art Moderne,
Centre Georges Pompidou, Paris;
Attribution de l'Etat

*87. Untitled (*Study Related to
Composition IX*)
n.d.
India ink and pencil on paper
12⅞ x 19⅞" (32.5 x 50.6 cm)
Musée National d'Art Moderne,
Centre Georges Pompidou, Paris
Bequest of Nina Kandinsky, 1981

*88. *Composition X*
1939
Oil on canvas
51⅛ x 76¾" (130 x 195 cm)
Kunstsammlung Nordrhein-
Westfalen, Düsseldorf

List of Exhibitions

The following is a selected exhibition history of the paintings.

1910

July, *The London Salon, Third Year*. London: Royal Albert Hall, Allied Artists Association, Ltd.; catalogue.
> *Composition I* (as cat. no. 961).

September 1–14, *Neue Künstlervereinigung München E. V., II. Ausstellung. Turnus 1910/11*. Munich: Moderne Galerie Thannhauser; catalogue. Traveled to Karlsruhe, Mannheim, Hagen, Berlin, Dresden, through 1911.
> *Composition II* (as cat. no. 57, ill.).

1911

January*, *Salon 2, 1910–11: International Art Exhibition*. Odessa: Vladimir Izdebsky; catalogue (includes Kandinsky's essay "Content and Form" and his Russian translation of excerpts from Schönberg's "Theory of Harmony").
(*Catalogue is dated December 1910, but the exhibition did not open until January 1911.)
> *Composition I* (as cat. no. 219).
> *Composition II* (as cat. no. 220).
> *Composition III* (as cat. no. 221).

January–February, *XIII. Jahrgang, VI. Ausstellung*. Berlin: Galerie Cassirer; catalogue.
> *Composition II* (as cat. no. 31).

November 18–January 31, 1912, *IV. Ausstellung: Gemälde*. Berlin: Neue Secession E. V.; catalogue.
> *Composition IV* (as cat. no. 91).

December 18–January 3, 1912, *Der Blaue Reiter: Die erste Ausstellung der Redaktion*. Munich: Moderne Galerie Thann-hauser; catalogue. Traveled to Cologne, January 23–31, 1912; Berlin, March 12–May 10, 1912; catalogue. Bremen, June 1912; Hagen, July 1912; Frankfurt, September 1912.
> *Composition V* (Munich as cat. no. 24; Berlin as cat. no. 46).

1912

January, *Exhibition of Paintings*. Moscow: Association of Artists "Jack of Diamonds"; catalogue.
> *Sketch for Composition V* (as cat. no. 65).

July 7–31, *Moderner Bund*. Zurich: Kunsthaus Zurich; catalogue.
> *Study for Section of Composition II* (as cat. no. 73).

October 2–28, *Kandinsky Kollektiv-Ausstellung 1902–1912*. Berlin: Galerie Der Sturm. First one-man exhibition; catalogue. First edition of the catalogue printed for showing at Neue Kunst Hans Goltz, Munich, which never took place; second edition published at Verlag Der Sturm, Berlin in 1913. Traveled in varying forms to Rotterdam, November 5–18; Leyden, opened

November 29; Utrecht, December; Hamburg, January 1913; Groningen, February–March 1913; Amsterdam, April 1913; Brussels, May 25–June 1913; Antwerp, June 1913; Karlsruhe, July 1913; Wiesbaden, September 1913; Frankfurt, October 1913; Aachen, November 1913; Munich, January 1914; Magdeburg, April 1914; Stuttgart, April–June 1914; Geneva, August 1914; Hanover, September 1914; Stockholm, February 1916. Selections traveled as a group show with the works of Gabriele Münter to Christiania (Oslo), April–June; catalogue. Helsinki; Saint Petersburg, through 1917; returned to Berlin, September 1916; catalogue.
> *Composition I* (first ed. as cat. no. 8; second ed. as cat. no. 7, ill.).
> *Composition II* (first ed. as cat. no. 40; second ed. as cat. no. 37; Berlin 1916 as cat. no. 13).
> *Composition III* (first ed. as cat. no. 16; second ed. as cat. no. 15; Berlin 1916 as cat. no. 14).
> *Composition VI* (added in Stockholm as cat. no. 17; Oslo as cat. no. 15; Berlin 1916 as cat. no. 30).
> *Composition VII* (added in Munich).

1913

February, *Der Blaue Reiter*. Amsterdam. Organized by Der Sturm, Berlin; catalogue. Traveled in varying forms to Prague, March; Budapest, as part of *International Postimpressionist Exhibition*, April–May; catalogue. Hungarian provinces, June–July; Königsberg, September; Christiania, January 1914; Lund, February 1914; Helsinki, February–March 1914; catalogue. Stockholm, March–April 1914; Trondheim, April–May 1914; Gothenburg, June–July 1914.
> *Composition V* (Budapest as cat. no. 106; Helsinki as cat. no. 27).

September 20–December 13, *Erster Deutscher Herbstsalon*. Berlin: Lepke-Räume, Potsdamer Strasse 75. Organized by Der Sturm, Berlin; catalogue.
> *Composition VI* (as cat. no. 181, ill.).
> *Oil Study for Composition VI* (Now destroyed; as cat. no. 186).

November 7–December 8, *3rd Exhibition of the Modern Art Circle* or *Ouvrages de peinture, sculpture, dessin, gravure*. Amsterdam: Stedelijk Museum/Suasso Museum, Moderne Kunstkring; catalogue.
> *Composition IV* (as cat. no. 91).

1914

January, *Expressionistische Ausstellung: Die neue Malerei*. Dresden: Galerie Ernst Arnold; catalogue.
> *Composition IV* (as cat. no. 63).
> *Composition VI* (as cat. no. 64).

January 30–February 15, *Kandinsky-Kollektiv Ausstellung*. Cologne: Kreis für Kunst Köln im Deutschen Theater; catalogue. Traveled to Barmen (Wuppertal) and Aachen through late March.
> *Composition II* (as cat. no. 4).
> *Composition VII* (as cat. no. 6).

March, *Spring Exhibition of Paintings*. Odessa: Museum of the Society of Fine Arts; catalogue.
> *Composition VII*.

May 15–October 4, *Baltiska Utstallningen*. Malmö; catalogue.
Composition VI (as cat. no. 3331, ill.).

1915
March 23–April 5, *Exhibition of Painting: The Year 1915*.
Moscow; catalogue.
Composition VII (as cat. no. 40).

1916
March 17–April 16, *Zweite Ausstellung Den Haag/Holland:
Expressionisten, Kubisten*. The Hague: Kunstzalen d'Audretsch.
Organized by Der Sturm; catalogue.
Composition II (as cat. no. 24).

1919
Spring, *Fifth State Exhibition of the Trade Union of Artist-
Painters of the New Art (From Impressionism to Nonobjec-
tivity)*. Moscow: Museum of Fine Arts, VZCB (Department of
Visual Arts of the People's Commissariat for Enlightenment);
catalogue.
Composition VI.

April 13–June, *First Free State Exhibition*. Saint Petersburg:
Palais der Künste.
Composition VI.

1920
October–December, *Ausstellung XIX*. Moscow: All-Russian
Central Exhibiting Bureau of the IZO Narkompros, Dmitrovka St.
Composition VII.

1923
August 15–September 30, *Bauhausausstellung*. Weimar:
Staatliches Bauhaus Weimar and Landesmuseum; catalogue.
Composition VIII.

1924
October, One-man exhibition. Dresden: Galerie Neue Kunst
Fides (Rudolf Probst).
Composition VIII.

1925
January 11–February 28, *Wassili Kandinsky*. Wiesbaden: Neues
Museum, Nassauischer Kunstverein, and Wiesbadener Gesell-
schaft für bildende Kunst; catalogue.
Composition VIII (as cat. no. 6).

Opened March 12, One-man exhibition of paintings, water-
colors, and graphic works. Barmen (Wuppertal): Ruhmeshalle.
Traveled to Bochum, April; Düsseldorf, October–November.
Composition VIII.

1926
May 9–June 6, *Jubiläums-Ausstellung W. Kandinsky*. Braun-
schweig: Gesellschaft der Freunde junger Kunst; catalogue.
Composition VIII (as cat. no. 2).

October 16–November 10, *Kandinsky: Jubiläums-Ausstellung
zum 60.Geburtstage*. Dresden: Galerie Arnold (Ludwig
Gutbier); catalogue. Traveled in varying forms to Berlin,
November 14–December 15; catalogue. Dessau, opened
December 19; Munich, March 14–April 14, 1927.

Study for Section of Composition II (as cat. no. 6).
Composition IV (as cat. no. 7; Munich as cat. no. 3).
Composition VIII (as cat. no. 18. Not shown in
Munich).

1927
January 30–March 27, *Wege und Richtungen der Abstrakten
Malerei in Europa*. Mannheim: Städtische Kunsthalle
Mannheim; catalogue.
Composition VIII (as cat. no. 81).

1928
February, George Grosz and Kandinsky joint exhibition.
Stuttgart: Kunsthaus Schaller.
Cossacks.

1936
March 1–April 12, *Solomon R. Guggenheim Collection of
Non-Objective Paintings*. Charleston: Carolina Art Association,
Gibbes Memorial Art Gallery; catalogue.
Composition VIII (as cat. no. 76, ill.).

1937
February 2–28, *Solomon R. Guggenheim Collection of Non-
Objective Paintings*. Philadelphia: Philadelphia Art Alliance;
catalogue.
Composition VIII (as cat. no. 87, ill.).

February 21–March 29, *Wassily Kandinsky* (shown simultane-
ously with *Französische Meister der Gegenwart*). Bern:
Kunsthalle Bern; catalogue.
Study for Section of Composition II or *Sketch for
Composition II* (as cat. no. 5?).
Composition IV (as cat. no. 6).

1938
March 12–April 17, *Solomon R. Guggenheim Collection of
Non-Objective Paintings*. Charleston, Gibbes Memorial Art
Gallery; catalogue.
Composition VIII (as cat. no. 117, ill.).

July 8–August 27, *Exhibition of 20th-Century German Art*.
London: New Burlington Galleries; catalogue.
Sketch for Composition II (as cat. no. 76).
Cossacks (not in catalogue).

1939
Opened June 1, *Art of Tomorrow*. New York: Museum of
Non-Objective Paintings; catalogue.
Composition VIII (as cat. no. 262, ill.).

1942
December 8–February 1943, *Works by Kandinsky:
A Retrospective Show*. New York: Nierendorf Gallery; cata-
logue.
Sketch for Composition II.

1943
March 13–April 10, *Paintings: 15 Early–15 Late*. New York:
Art of This Century; catalogue.
Sketch for Composition II (as cat. no. 215).

1944

March 18–April 16, *Konkrete Kunst*. Basel: Kunsthalle Basel; catalogue.

> *Sketch 1 for Composition VII* (as cat. no. 77).

1945

March 10–April 8, *Gedächtnisausstellung Wassily Kandinsky* (shown simultaneously with *Vierzehn Berner Künstler*). Basel: Kunsthalle Basel; catalogue.

> *Composition V* (as cat. no. 17).
> *Sketch 1 for Composition VII* (as cat. no. 22?).

March 15–summer, *In Memory of Wassily Kandinsky*. New York: Solomon R. Guggenheim Foundation, Museum of Non-Objective Paintings; catalogue. Traveled in reduced form to Chicago, November; catalogue. Milwaukee, late 1945–early 1946; Pittsburgh, April 11–May 12, 1946; catalogue.

> *Sketch for Composition II* (as cat. no. 7; Chicago as cat. no. 3; Pittsburgh as cat. no. 5).
> *Section 1 for Composition VII (Center)* (as cat. no. 13).
> *Composition VIII* (as cat. no. 57, ill.; Pittsburgh as cat. no. 21).

1946

March 13–April 13, *40 Peintures de Kandinsky*. Paris: Galerie René Drouin; catalogue.

> *Composition IV* (as cat. no. 3).

September 21–October 20, *Georges Braque, Wassily Kandinsky 1866–1944, Pablo Picasso*. Zurich: Kunsthaus Zurich; catalogue.

> *Composition IV* (as cat. no. 36).
> *Composition V* (as cat. no. 37).
> *Composition X* (as cat. no. 84).

1947

June 27–September 30, *Exposition de peintures et sculptures contemporaines*. Avignon: Palais des Papes; catalogue.

> *Composition IV* (as cat. no. 69).

December 8–end January 1948, *Kandinsky*. Amsterdam: Stedelijk Museum; catalogue. Traveled to The Hague, February 13–March 14, 1948; Rotterdam, April? 1948.

> *Composition IV* (as cat. no. 19).
> *Composition X* (as cat. no. 78, ill.).

1948

Contemporary Paintings from the Albright Art Gallery. Ann Arbor: University of Michigan; catalogue.

> *Section 2 for Composition VII (Center and Corners)* (as cat. no. 14).

1949

June 2–July 2, *Kandinsky: Époque parisienne*. Paris: Galerie René Drouin; catalogue.

> *Composition X* (as cat. no. 4).

September–October, *München und die Kunst des 20. Jahrhunderts. 1908–1914: Der Blaue Reiter*. Munich: Haus der Kunst; catalogue.

> *Composition IV* (as cat. no. 64, ill.).
> *Section 1 for Composition VII (Center)* (as cat. no. 65).
> *Study for Composition VII* (as cat. no. 69).

1950

January 21–February 26, *Der Blaue Reiter 1908–14, Wegbereiter und Zeitgenossen: Kandinsky, Marc, Macke, Klee*. Basel: Kunsthalle Basel; catalogue.

> *Composition IV* (as cat. no. 173).
> *Composition V* (as cat. no. 175, ill.).
> *Sketch 1 for Composition VII* (as cat. no. 179).

Opened June 8, *Retrospettiva di Kandinsky*. Venice: XXV Biennale de Venezia; catalogue.

> *Composition IV* (as cat. no. 6).
> *Composition X* (as cat. no. 28, ill.).

October 25–November 26, *Five Modern Old Masters: Kandinsky, Matisse, Mondrian, Picasso*. Providence: Museum of Art, Rhode Island School of Design; catalogue.

> *Section 1 for Composition VII (Center)* (as cat. no. 6).

1951

November 30–December, *Kandinsky 1900–1910*. Paris: Galerie Maeght; catalogue.

> *Study for Section of Composition II* (as cat. no. 48).

1952

March 27–April 27, *Kandinsky: Retrospective Exhibition*. Boston: Institute of Contemporary Art; catalogue. Traveled to New York, May 10–June 6; San Francisco, July 20–August 26; Minneapolis, September 14–October 26; catalogue. Cleveland, November 6–December 7.

> *Composition X* (as cat. no. 23).

May–June, *L'Oeuvre du XXe siècle*. Paris: Musée National d'Art Moderne; catalogue. Traveled to London, July 15–August 17; catalogue.

> *Composition VIII* (as cat. no. 44; London as cat. no. 39).

May 10–June 29, *Expressionism in American Painting*. Buffalo: Albright Art Gallery; catalogue.

> *Section 2 for Composition VII (Center and Corners)* (as cat. no. 18, ill.).

1953

October 10–November 15, *Wassily Kandinsky: Arbeiten aus den Jahren 1912–1942*. Hamburg: Kunsthalle, Kunstverein Hamburg. Traveled to Cologne, November 21–January 16, 1954; catalogue (published in *Blätter der Galerie Ferdinand Möller*, new series, no. 12, 1953); Stuttgart, March 13–April 11, 1954; Munich, opened April 15, 1954; Mannheim, opened May 29, 1954; Berlin, opened July 24, 1954; Dortmund, September 1-26, 1954; Nuremberg; Ulm; Wiesbaden.

> *Composition IV* (Cologne as cat. no. 11, ill.).
> *Composition X* (Cologne as cat. no. 26).

1954

April 2–May 9, *A Loan Exhibition from the Solomon R. Guggenheim Museum*. Toronto: Art Gallery of Toronto; catalogue.

> *Sketch for Composition II* (as cat. no. 19).

November 16–December 12, *The Solomon R. Guggenheim Museum: A Selection from the Museum Collection*. Vancouver:

Vancouver Art Gallery; catalogue.
>*Sketch for Composition II* (as cat. no. 18).

December 7–January 8, 1955, *Der Blaue Reiter*. New York: Curt Valentin Gallery; catalogue. Traveled to Cambridge, Mass. January 21–February 26, 1955 (as *Artists of the Blaue Reiter*); catalogue.
>*Sketch for Composition II* (Cambridge only, as cat. no. 17, ill.).
>*Section 2 for Composition VII (Center and Corners)* (as cat. no. 16; Cambridge as cat. no. 19).

1955

March 19–May 1, *Gesamtausstellung Wassily Kandinsky*. Bern: Kunsthalle Bern; catalogue.
>*Composition IV* (as cat. no. 27).
>*Composition V* (as cat. no. 29, ill.).
>*Composition X* (as cat. no. 92).

June 17–July 10, *Art in the Twentieth Century*. San Francisco: San Francisco Museum of Art; catalogue.
>*Composition VIII*.

June 24–August, *Kandinsky: Période dramatique 1910–1920*. Paris: Galerie Maeght; catalogue (published in *Derrière le Miroir*, nos. 77–78, July–August 1955).
>*Composition IV* (as cat. no. 5).

Art 1955, Peinture, musique, architecture, sculpture, mobilier. Rouen: Musée des Beaux-Arts; catalogue.
>*Composition IX* (as cat. no. 50).

1957

February 16–April 30, *Kandinsky und Gabriele Münter: Werke aus fünf Jahrzehnten*. Munich: Städtische Galerie im Lenbachhaus; catalogue.
>*Improvisation Deluge* (as cat. no. 135, ill.).
>*Sketch 2 for Composition VII* (as cat. no. 133).
>*Study for Composition VII* (as cat. no. 132).
>*Sketch 3 for Composition VII* (as cat. no. 134).

March–April, *Wassily Kandinsky*. Copenhagen: Statens Museum for Kunst; catalogue. Traveled to Odense.
>*Composition IV* (as cat. no. 16, ill.).
>*Composition X* (as cat. no. 45, ill.).

May 17–June 30, *45 Oeuvres de Kandinsky Provenant du Solomon R. Guggenheim Museum, New York*. Brussels: Palais des Beaux-Arts; catalogue. Traveled to Paris, November 15–January 5, 1958; catalogue. London, January 15–February 28, 1958; catalogue. Lyon, March 8–April 6, 1958; catalogue. Oslo, April 18–May 4, 1958; catalogue. Rome, May 15–June 30, 1958; catalogue.
>*Sketch for Composition II* (as cat. no. 18; withdrawn after London).

October 1–December 8, *German Art of the Twentieth Century*. New York: The Museum of Modern Art; catalogue. Traveled to Saint Louis, January 8–February 24, 1958; catalogue.
>*Section 2 for Composition VII (Center and Corners)* (as cat. no. 64, ill.).
>*Composition VIII* (as cat. no. 67, ill.).

Arte tedesca dal 1905 ad oggi. Rome: Palazzo delle esposizioni and Milan, Palazzo della permanente; catalogue.
>*Sketch 1 for Composition VII*.

Some Points of View in Modern Painting. Kansas City: William Rockhill Nelson Gallery of Art; catalogue.
>*Section 2 for Composition VII (Center and Corners)* (as cat. no. 14).

1958

April 17–July 21, *50 Ans d'art moderne*. Brussels: Palais des Beaux-Arts de Bruxelles; catalogue.
>*Sketch for Composition II* (as cat. no. 142, ill.).

Summer, *XXIX Biennale Internazionale d'Arte*. Venice; catalogue.
>*Improvisation Deluge* (as cat. no. 135).

September 25–November 30, *Kandinsky*. Cologne: Wallraf-Richartz-Museum; catalogue.
>*Composition IV* (as cat. no. 12, ill.).
>*Sketch 3 for Composition VII* (as Supplement no. 14b).
>*Composition X* (as cat. no. 52, ill.).

November 22–January 11, 1959, *Wassily Kandinsky, Gabriele-Münter Stiftung—Gabriele Münter*. Hamburg: Kunstverein; catalogue.
>*Improvisation Deluge* (as cat. no. 85).
>*Sketch 2 for Composition VII* (as cat. no. 84).

1959

July 11–October 11, *Documenta II*. Kassel; catalogue.
>*Composition IV* (as cat. no. 19).
>*Composition X* (as cat. no. 23, ill.).

1960

March 6–April 3, *Art from Ingres to Pollock: Painting and Sculpture since Neoclassicism*. Berkeley: University of California; catalogue.
>*Section 2 for Composition VII (Center and Corners)* (ill.).

Summer, *The Blue Rider Group*. Edinburgh: Royal Scottish Academy, International Festival 1960; catalogue. Traveled to London, September 30–October 30.
>*Cossacks* (as cat. no. 60).
>*Improvisation Deluge* (as cat. no. 63, ill.).
>*Study for Composition VII* (as cat. no. 64).

November 4–January 23, 1961, *Les Sources du XXe siècle: Les Arts en Europe de 1884 à 1914*. Paris: Musée National d'Art Moderne; catalogue.
>*Composition IV* (as cat. no. 288).

From Gauguin to Gorky. Houston: Museum of Fine Arts; catalogue.
>*Section 2 for Composition VII (Center and Corners)* (as cat. no. 28, ill.).

1961

January 19–February 26, *The Logic of Modern Art*. Kansas City, Missouri: Nelson Gallery and Atkins Museum; catalogue.
>*Composition VIII* (as cat. no. 27).

April–May, *Kandinsky: The Road to Abstraction*. London: Marlborough Fine Art Limited; catalogue.
> *Sketch 2 for Composition VII* (as cat. no. 37, ill.).
> *Study for Composition VII* (as cat. no. 39).
> *Sketch 3 for Composition VII* (as cat. no. 38).

April 23–June 11, *Der Blaue Reiter und sein Kreis*. Winterthur: Kunstmuseum Winterthur; catalogue. Traveled to Vienna, August 2–September 24; catalogue. Linz, September 30–October 29.
> *Composition V* (as cat. no. 10).
> *Improvisation Deluge* (as cat. no. 16, ill.).
> *Sketch 1 for Composition VII* (Vienna and Linz as cat. no. 8, ill.).

November 2–January 7, 1962, *Guggenheim Museum Exhibition: A Loan Collection of Paintings, Drawings, and Prints from The Solomon R. Guggenheim Museum, New York*. Philadelphia: Philadelphia Museum of Art; catalogue.
> *Sketch for Composition II* (as cat. no. 48).

Paintings and Sculpture from the Albright Art Gallery. New Haven: Yale University Art Gallery.
> *Section 2 for Composition VII (Center and Corners)*.

Paintings from the Albright Art Gallery. Pittsburgh: Carnegie Institute.
> *Section 2 for Composition VII (Center and Corners)*.

1962

October–November, *Der Blaue Reiter—Le Cavalier bleu*. Paris: Galerie Maeght; catalogue (published in *Derrière le miroir*, nos. 133–134, October–November 1972).
> *Composition IV* (as cat. no. 1).
> *Study for Composition VII* (as cat. no. 5).

1963

January 15–February 15, *Vasily Kandinsky 1866–1944: A Retrospective Exhibition*. Pasadena: Pasadena Art Museum. Organized by The Solomon R. Guggenheim Museum; catalogue. Traveled to San Francisco, March 1–April 1; Portland, Oregon, April 15–May 15; San Antonio, June 1–July 1; Colorado Springs, July 15–August 25; Baltimore, September 19–October 20; Columbus, November 5–December 5; Saint Louis, December 22–January 1, 1964; Montreal, February 5–March 5, 1964; Worcester, March 20–April 20, 1964.
> *Section 1 for Composition VII (Center)* (as cat. no. 21, ill.).

January 25–April 7, *Vasily Kandinsky 1866–1944: A Retrospective Exhibition*. New York: Solomon R. Guggenheim Museum; catalogue with supplement: *Special Loan of Paintings from the U.S.S.R.* Traveled in varying forms to Paris, April 29–June 24; catalogue. The Hague, July 1–August 30; Basel, September 7–November 7; catalogue.
> *Sketch for Composition II* (as cat. no. 13, ill.).
> *Composition IV* (as cat. no. 21, ill.).
> *Composition V* (Basel only, as Supplement no. 94).
> *Sketch 2 for Composition VII* (as cat. no. 34, ill.).
> *Composition VII* (as Supplement no. G, ill.).
> *Composition VIII* (as cat. no. 53, ill.).
> *Composition IX* (as cat. no. 73, ill.).
> *Composition X* (as cat. no. 81, ill.).

February 19–March 30, *Der Blaue Reiter*. New York: Leonard Hutton Galleries; catalogue.
> *Study for Section of Composition II* (as cat. no. 6, ill.).

1964

October 23–November 29, *Marcel Duchamp, Wassily Kandinsky, Kasimir Malewitsch, Josef Albers, Tom Doyle*. Bern: Kunsthalle Bern; catalogue.
> *Sketch 1 for Composition VII* (as cat. no. 5).

1965

January 24–March 7, *Years of Ferment: The Birth of Twentieth-Century Art*. Los Angeles: University of California at Los Angeles Art Galleries; catalogue. Traveled to San Francisco, March 28–May 16; Cleveland, July 13–August 22.
> *Sketch for Composition II* (as cat. no. 89, ill.).

April 10–May 23, *Kandinsky*. Stockholm: Moderna Museet; catalogue.
> *Study for Section of Composition II* (as cat. no. 19).
> *Composition X* (as cat. no. 60, ill.).

Expressionisme allemand, 1900–1920. Marseilles: Musée Cantini; catalogue.
> *Study for Composition VII* (as cat. no. 90, ill.).

1966

April 19–September 18, *Vasily Kandinsky, 1901–1914*. New York: Solomon R. Guggenheim Museum. Collection and loan exhibition; loans returned, exhibition reinstalled, November; reinstalled, December 4–February 12, 1967.
> *Sketch for Composition II*.

June 15–July 31, *50 Years of Modern Art: 1916–1966*. Cleveland: Cleveland Museum of Art; catalogue.
> *Composition VIII* (as cat. no. 26, ill.).

July 23–September 30, *Kandinsky centenaire 1866–1944*. Saint-Paul-de-Vence: Fondation Maeght; catalogue.
> *Study for Section of Composition II* (as cat. no. 16).
> *Composition X* (as cat. no. 101).

1967

November 16–March 31, 1968, *Selections from The Solomon R. Guggenheim Museum*. New York: Metropolitan Museum of Art.
> *Sketch for Composition II*.

1968

May 5–July 28, *50 Jahre Bauhaus*. Stuttgart: Württembergischer Kunstverein; catalogue. Traveled to London, September 21–October 27; Amsterdam, November 30–January 8, 1969; Paris, April 1–June 22, 1969; Chicago, August 25–September 26, 1969; Toronto, December 5, 1969–February 8, 1970; Pasadena, Calif., March 16–May 10, 1970; Buenos Aires, September 1–October 10, 1970.
> *Composition VIII* (as cat. no. 111).

October–February 1969, *The Collection of Mrs. Harry Lynde Bradley*. Milwaukee: Milwaukee Art Center; catalogue.
> *Section 1 for Composition VII (Center)* (as cat. no. 12, ill.).

Paintings from the Albright-Knox Art Gallery. Washington, D.C.: National Gallery of Art; catalogue.

 Section 2 for Composition VII (Center and Corners) (ill.).

Painting in France, 1900–1967. Washington, D.C.: National Gallery of Art; catalogue. Traveled to New York, Boston, Chicago, San Francisco, Montreal, Detroit.

 Composition IX (as cat. no. 18, ill.).

1969

June, *Kandinsky: Période parisienne 1934–1944*. Paris: Galerie Maeght; catalogue (published in *Derrière le miroir*, no. 179, June 1969).

 Composition IX (as cat. no. 5, ill.).
 Composition X (as cat. no. 12, ill.).

October 21–November 22, *Kandinsky: Parisian Period 1934–1944*. New York: M. Knoedler & Co., Inc.; catalogue.

 Composition IX (as cat. no. 10, ill.).
 Composition X (as cat. no. 20, ill.).

109 Works from the Albright-Knox Art Gallery. Buenos Aires: Museo Nacional de Bellas Artes; catalogue.

 Section 2 for Composition VII (Center and Corners) (as cat. no. 36, ill.).

1970

July 10–September 27, *Wassily Kandinsky: Gemälde 1900–1944*. Baden-Baden: Staatliche Kunsthalle Baden-Baden; catalogue.

 Study for Section of Composition II (not in catalogue).
 Composition IV (as cat. no. 30, ill.).
 Sketch 1 for Composition VII (as cat. no. 39, ill.).
 Study for Composition VII (as cat. no. 40, ill.).
 Composition IX (as cat. no. 141, ill.).
 Composition X (as cat. no. 151, ill.).

1971

February 7–April 18, *Paul Klee und seine Malerfreunde. Die Sammlung Felix Klee*. Winterthur: Kunstmuseum Winterthur. Traveled to Duisberg, May 25–August 22; catalogue.

 Sketch 1 for Composition VII (as cat. no. 22, ill.).

March 18–May 9, *Il Cavaliere Azzurro—Der Blaue Reiter*. Turin: Galleria Civica d'Arte Moderna; catalogue.

 Study for Composition VII (as cat. no. 184, ill.).

October 30–January 9, 1972, *Klee—Kandinsky*. Humlebaek: Louisiana Museum; catalogue (published in *Louisiana-Revy*, no. 2, October 1971).

 Composition X (as cat. no. 36, ill.).

1972

January 29–March 12, *Wassily Kandinsky: Rétrospective*. Charleroi: Palais des Beaux-Arts; catalogue.

 Composition X (as cat. no. 43, ill.).

May 12–September 5, *Kandinsky at the Guggenheim*. New York: Solomon R. Guggenheim Museum; catalogue. Traveled to Los Angeles, October 3–November 19; Minneapolis, May 5–July 15, 1973.

 Sketch for Composition II (New York only, ill.)
 Composition VIII (New York only, ill.).

June 7–July 30, *Hommage de Paris à Kandinsky: La conquête de l'abstraction, l'époque parisienne*. Paris: Musée d'Art Moderne de la Ville de Paris; catalogue.

 Composition IX (as cat. no. 28).
 Composition X (as cat. no. 39, ill.).

October 28–December 9, *Kandinsky: Peintures, dessins, gravures, éditions, oeuvres inédites*. Paris: Galerie Karl Flinker; catalogue.

 Study for Section of Composition II (as cat. no. 2, ill.).

November 15–February 11, 1973, *Masterpieces from the Solomon R. Guggenheim Museum*. Cleveland: Cleveland Museum of Art; catalogue.

 Sketch for Composition II (as cat. no. 6, ill.).

1973

September 9–November 4, *Wassily Kandinsky: Aquarelle, Gouachen, Zeichnungen*. Bielefeld: Kunsthalle Bielefeld; catalogue. Traveled to Munich, December 4–January 27, 1974.

 Study for Section of Composition II (as Supplement no. 1).

1974

May 16–July 14, *Was war—Was ist? 25 Jahre Ruhrfestspiele*. Recklinghausen: Kunsthalle; catalogue.

 Study for Composition VII (as cat. no. 117, ill.).

September 11–November 4, *Homage à Schönberg. Der Blaue Reiter und das Musikalische in der Malerei der Zeit*. Berlin: Nationalgalerie, Staatliche Museen Preussischer Kulturbesitz; catalogue.

 Study for Composition VII (as cat. no. 19).

October 2–November 24, *Picasso to Lichtenstein: Masterpieces of Twentieth-Century Art from the Nordrhein-Westfalen Collection in Düsseldorf*. London: Tate Gallery; catalogue.

 Composition IV (as cat. no. 51, ill.).

1975

August 15–September 15, *Wassily Kandinsky 1866–1944*. Edinburgh: Scottish National Gallery of Modern Art, Edinburgh International Festival 1975; catalogue.

 Composition X (as cat. no. 28, ill.).

1976

January 2–February 11, *Kandinsky*. Tokyo: Seibu Museum of Art; catalogue.

 Composition X (cat. no. 35, ill.).

May 7–September 1, *Wassily Kandinsky à Munich: Collection Städtische Galerie im Lenbachhaus*. Bordeaux: Galerie des Beaux-Arts; catalogue.

 Sketch 2 for Composition VII (as cat. no. 36, ill.).

November 13–January 30, 1977, *Wassily Kandinsky 1866–1944*. Munich: Haus der Kunst; catalogue.

 Sketch for Composition II (as cat. no. 31, ill.).
 Improvisation Deluge (as cat. no. 42, ill.).
 Sketch 2 for Composition VII (as cat. no. 43, ill.).
 Sketch 3 for Composition VII (as cat. no. 44, ill.).
 Composition VIII (as cat. no. 60, ill.).
 Composition IX (as cat. no. 87, ill.).
 Composition X (as cat. no. 94, ill.).

December 17–March 1, 1977, *European Master Paintings from Swiss Collections. Post-Impressionism to World War I.* New York: The Museum of Modern Art; catalogue.
> *Composition V* (ill.).

Paul Klee und seine Malerfreunde. Tokyo: Takasake, Tamakura; catalogue.
> *Sketch 1 for Composition VII* (as cat. no. 196, ill.).

1977
March 18–May, *Der Blaue Reiter und sein Kreis.* New York: Leonard Hutton Galleries; catalogue.
> *Study for Section of Composition II* (as cat. no. 29, ill.).
> *Sketch 1 for Composition VII* (as cat. no. 30, ill.).

December 16–February 5, 1978, *Forty Modern Masters: An Anniversary Show.* New York: Solomon R. Guggenheim Museum; catalogue.
> *Sketch for Composition II* (as cat. no. 60).
> *Composition VIII* (as cat. no. 64).

New Acquisitions of the Hermitage. Leningrad: Hermitage; catalogue.
> *Sketch for Composition V* (as cat. no. 34).

1979
February 1–March 26, *Kandinsky: Trente peintures des musées sovietiques.* Paris: Musée National d'Art Moderne, Centre Georges Pompidou; catalogue.
> *Composition VI* (as cat. no. 17, ill.).

May 31–November 5, *Paris—Moscou 1900–1930.* Paris: Centre National d'Art et de Culture Georges Pompidou; catalogue.
> *Composition VII.*

1980
February 6–April 13, *Abstraction: Towards a New Art in Painting.* London: Tate Gallery; catalogue.
> *Cossacks* (as cat. no. 165, ill.).
> *Sketch 1 for Composition VII* (as cat. no. 181, ill.).
> *Study for Composition VII* (as cat. no. 182, ill.).
> *Sketch 3 for Composition VII* (as cat. no. 183, ill.).

December 2–February 3, 1981, *Wassily Kandinsky. Drei Hauptwerke aus drei Jahrzehnten. Eine Didaktische Ausstellung. Bilder. Fotos. Texte.* Düsseldorf: Kunstsammlung Nordrhein-Westfalen; catalogue.
> *Composition IV* (as cat. no. 1, ill.).
> *Composition X* (as cat. no. 3, ill.).

1981
Moscow—Paris 1900–1930. Moscow: Pushkin State Museum of Fine Arts.
> *Composition VI.*
> *Composition VII.*

1982
January 22–March 21, *Kandinsky in Munich: 1896–1914.* New York: Solomon R. Guggenheim Museum; catalogue. Traveled to San Francisco, April 22–June 20; in extended form to Munich, August 18–October 17; catalogue.
> *Sketch for Composition II* (as cat. no. 285, ill.; Munich as cat. no. 391, ill.).

1983
December 9–February 12, 1984, *Kandinsky: Russian and Bauhaus Years.* New York: Solomon R. Guggenheim Museum; catalogue. Traveled in varying forms to Atlanta, March 15–April 29, 1984; Zurich, May 30–July 15; catalogue. Berlin, August 9–September 23, 1984; catalogue.
> *Composition VIII* (as cat. no. 147, ill.).

1984
November 1–January 28, 1985, *Kandinsky.* Paris: Musée National d'Art Moderne, Centre Georges Pompidou; catalogue and album de l'exposition.
> *Sketch for Composition II* (ill.).
> *Composition IV* (ill.).
> *Composition VIII* (ill.).
> *Composition IX* (ill.).
> *Composition X* (ill.).

1985
February 15–April 14, *Kandinsky in Paris 1934–1944.* New York: Solomon R. Guggenheim Museum; catalogue. Traveled to Houston, June 8–August 11; Milan, September 19–November 10; catalogue. Vienna, December 6–January 26, 1986.
> *Composition IX* (as cat. no. 7, ill.).
> *Composition X* (as cat. no. 105, ill.).

1986
November 21–February 15, 1987, *Der Blaue Reiter.* Bern: Kunstmuseum Bern; catalogue.
> *Composition V* (as cat. no. 55, ill.).

1987
May 28–August 9, *Kandinsky.* Tokyo: National Museum of Modern Art; catalogue. Traveled to Kyoto, August 18–October 4.
> *Composition IX* (as cat. no. 87, ill.).

November 5–January 17, 1988, *Kunst und Revolution. Russische und Sowjetische Kunst 1910–1932 (Art and Revolution. Russian and Soviet Art 1910–1932).* Budapest: Műcsarnok; catalogue. Traveled to Vienna, March 11–May 15, 1988.
> *Composition VI* (ill.).

1989
April–May, *Vassily Vasilevich Kandinsky 1866–1944.* Moscow: State Tretyakov Gallery; catalogue. Traveled in varying forms to Frankfurt, June 18–August 20, as *Wassily Kandinsky: Die erste Sowjetische Retrospektive. Gemälde, Zeichnungen und Graphik aus Sowjetischen und Westlichen Museen*; catalogue. Leningrad; State Russian Museum, September–October.
> *Sketch for Composition II* (as cat. no. 15, ill.; Frankfurt as cat. no. 37, ill.).
> *Sketch for Composition V* (as cat. no. 30, ill.; Frankfurt as cat. no. 49, ill.).
> *Composition VI* (as cat. no. 33, ill.; Frankfurt as cat. no. 57, ill.).
> *Composition VII* (as cat. no. 36, ill.; Frankfurt as cat. no. 61, ill. Shown only in Moscow.)
> *Composition IX* (as cat. no. 61, ill.; Frankfurt as cat. no. 146, ill.).

October 21–December 10, *Kandinsky and Sweden, Malmö 1914–Stockholm 1916*. Malmö: Malmö Konsthall. Traveled to Stockholm, December 26–February 18, 1990; catalogue.
 Composition VI (as cat. no. 15, ill.).

Arte Russa e Sovietica. 1870–1930. Turin: Lingotto; catalogue.
 Composition VI (as cat. no. 113, ill.).

1990
May 31–July 16, *Les Territoires de l'art*. Leningrad: Russian Museum; catalogue.
 Composition VI (not in catalogue).

1992
July 4–October 15, *L'Art en mouvement*. Saint-Paul-de Vence: Fondation Maeght; catalogue.
 Sketch 1 for Composition VII (as cat. no. 41, ill.).
 Composition IX (as cat. no. 42, ill.).

Selected Bibliography

Avtonomova, Natalia. *Kandinsky*. Moscow: Tretyakov Gallery, 1993.

Avtonomova, Natalia, Vivian Endicott Barnett, et al. *New Perspectives on Kandinsky*. Exh. cat. Malmö: Malmö Konsthall, Sydsvenska Dagbladet, 1990.

Barnett, Vivian Endicott. *Kandinsky Watercolors, Catalogue Raisonné*. 2 vols. Ithaca: Cornell University Press, 1992–94.

Barnett, Vivian Endicott. *Kandinsky at the Guggenheim*. New York: Solomon R. Guggenheim Museum and Abbeville, 1983.

Barnett, Vivian Endicott. "Kandinsky: From Drawing and Watercolor to Oil." *Drawing* 3 (July–August 1981), pp. 30–34.

Barnett, Vivian Endicott and Armin Zweite. *Kandinsky: Kleine Freuden, Aquarelle und Zeichnungen*. Exh. cat. Düsseldorf: Kunstsammlung Nordrhein-Westfalen, 1992.

Barnett, Vivian Endicott, et al. *Kandinsky in Paris, 1934–1944*. New York: Solomon R. Guggenheim Foundation, 1985.

Der Blaue Reiter. Exh. cat. Bern: Kunstmuseum Bern, 1986.

Bowlt, John E., and Rose-Carol Washton Long, eds. *The Life of Vasilii Kandinsky in Russian Art: A Study of "On the Spiritual in Art."* Newtonville, Mass: Oriental Research Partners, 1980.

Brisch, Klaus. "Wassily Kandinsky (1866–1944): Untersuchungen zur Entstehung der gengenstandslosen Malerei an seinem Werk von 1900–1921." Diss. University of Bonn, 1955.

Derouet, Christian and Jessica Boissel. *Kandinsky: Oeuvres de Vassily Kandinsky (1866–1944)*. Exh. cat. Paris: Collections du Musée National d'Art Moderne, Centre Georges Pompidou, 1984.

Düchting, Hajo. *Wassily Kandinsky 1866–1944. Revolution der Malerei*. Cologne: Benedikt Taschen, 1993.

Eichner, Johannes. *Kandinsky und Gabriele Münter: Von Ursprüngen moderner Kunst*. Munich: F. Bruckmann, 1957.

Gollek, Rosel. *Der Blaue Reiter im Lenbachhaus München. Katalog der Sammlung in der Städtischen Galerie*. Munich: Prestel, 1982.

Grohmann, Will. *Wassily Kandinsky: Life and Work*. New York: Harry N. Abrams, 1958.

Haftmann, Werner, Theodor W. Adorno, et al. *Homage à Schönberg. Der Blaue Reiter und das Musikalische in der Malerei der Zeit*. Exh. cat. Berlin: Nationalgalerie, Staatliche Museen Preussischer Kulturbesitz, 1974.

Hahl-Koch, Jelena. *Kandinsky*. New York: Rizzoli, 1993.

Hahl-Koch, Jelena. "Kandinsky und der 'Blaue Reiter.'" In *Vom Klang der Bilder. Die Musik in der Kunst des 20. Jahrhunderts*. Exh. cat. Stuttgart: Staatsgalerie Stuttgart, 1985.

Hahl-Koch, Jelena, ed. *Arnold Schönberg—Wassily Kandinsky. Letters, Pictures and Documents*. Trans. John C. Crawford. London and Boston: Faber and Faber, 1984.

Hanfstaengl, Erika, ed. *Wassily Kandinsky: Zeichnungen und Aquarelle. Katalog der Sammlung in der Städtischen Galerie im Lenbachhaus München*. Munich: Prestel, 1974.

Heller, Reinhold. "Kandinsky and Traditions Apocalyptic." *Art Journal* 43 (Spring 1983), pp. 19–26.

Hofmann, Werner. "Beziehungen zwischen Malerei und Musik." In *Schonberg-Webern-Berg. Bilder-Partituren-Dokumente*. Vienna: Museum des 20. Jahrhunderts, 1969.

Homage to Wassily Kandinsky. New York: Leon Amiel, 1975. Eng. trans. of "Centenaire de Kandinsky." In *XXe siècle* 27 (December 1966).

Jelavich, Peter, Peg Weiss, et al. *Kandinsky in Munich: 1896–1914*. Exh. cat. New York: Solomon R. Guggenheim Museum, 1982.

Kandinsky, 1901–1913. Berlin: Der Sturm, 1913.

Kandinsky: Trente Peintures des Musées Sovietiques. Exh. cat. Paris: Musée National d'Art Moderne, 1979.

Kandinsky Watercolors: A Selection from The Solomon R. Guggenheim Museum and The Hilla von Rebay Foundation. New York: Solomon R. Guggenheim Foundation, 1980.

Kandinsky, Nina. *Kandinsky et moi*. French trans. J. M. Gaillard-Paquet *Kandinsky und Ich* (Munich, 1976). Paris: Flammarion, 1978.

Lankheit, Klaus, ed. *The Documents of 20th-Century Art. The Blaue Reiter Almanac. Edited by Wassily Kandinsky and Franz Marc*. New York: Viking, 1974.

Lindsay, Kenneth C. "The Genesis and Meaning of the Cover Design for the First *Blaue Reiter* Exhibition Catalogue." *Art Bulletin* 25 (March 1953), pp. 47–52.

Lindsay, Kenneth C. and Peter Vergo, eds. *Kandinsky: Complete Writings on Art*. Boston, 1982. Rev. ed. New York: Da Capo Press, 1994.

Levin, Gail, and Marianne Lorenz. *Theme and Improvisation: Kandinsky & the American Avant-Garde, 1912–1950*. Exh. cat. Dayton: Dayton Art Institute, 1992.

"München leuchtete." Karl Caspar und die Erneuerung christlicher Kunst in München um 1900. Exh. cat. Munich: Haus der Kunst, 1984.

Poling, Clark V. *Kandinsky: Russian and Bauhaus Years 1915–1933*. Exh. cat. New York: Solomon R. Guggenheim Foundation, 1983.

Ringbom, Sixten. "Transcending the Visible: The Generation of the Abstract Pioneers." In *The Spiritual in Art: Abstract Painting 1890–1985*. Exh. cat. Los Angeles: Los Angeles County Museum of Art. New York: Abbeville, 1986, pp. 144–153.

Ringbom, Sixten. *The Sounding Cosmos: A Study in the Spiritualism of Kandinsky and the Genesis of Abstract Painting*. Abo: Abo Akademi, 1970.

Roethel, Hans K. and Jean K. Benjamin. *Kandinsky: Catalogue Raisonné of the Oil-Paintings*. 2 vols. Ithaca: Cornell University Press, 1982–1984.

Roethel, Hans K., and Jean K. Benjamin. *Kandinsky*. New York: Hudson Hills, 1979.

Roethel, Hans K. *Kandinsky: Das graphische Werk*. Cologne: M. DuMont Schauberg, 1970.

Roethel, Hans K. *Vasily Kandinsky. Painting on Glass (Hinterglasmalerei)*. Exh. cat. New York: Solomon R. Guggenheim Museum, 1966.

Rudenstine, Angelica Zander. *The Guggenheim Museum Collection: Paintings 1880–1945*. 2 vols. New York: Solomon R. Guggenheim Foundation, 1976.

Strauss, Monica. "Kandinsky and *Der Sturm*." *Art Journal* 43 (Spring 1983), pp. 31–35.

Vergo, Peter. *Kandinsky: Cossacks*. London: Tate Gallery, 1986.

Vergo, Peter. "Music and Abstract Painting: Kandinsky, Goethe and Schönberg." In *Towards a New Art: Essays on the Background to Abstract Art 1910–20*. London: Tate Gallery, 1980, pp. 41–63.

Washton Long, Rose-Carol. "Occultism, Anarchism, and Abstraction: Kandinsky's Art of the Future," *Art Journal* 46 (Spring 1987), pp. 38–45.

Washton Long, Rose-Carol. "Expressionism, Abstraction, and the Search for Utopia in Germany." In *The Spiritual in Art: Abstract Painting 1890–1985*. Exh. cat. Los Angeles: Los Angeles County Museum of Art. New York: Abbeville, 1986, pp. 201–17.

Washton Long, Rose-Carol. "Kandinsky's Vision of Utopia as a Garden of Love." *Art Journal* 43 (Spring 1983), pp. 50–60.

Washton Long, Rose-Carol. *Kandinsky: The Development of an Abstract Style*. Oxford: Clarendon Press, 1980.

Washton Long, Rose-Carol. "Kandinsky's Abstract Style: The Veiling of Apocalyptic Folk Imagery." *Art Journal* 34 (Spring 1975), pp. 217–28.

Washton Long, Rose-Carol. "Kandinsky and Abstraction: The Role of the Hidden Image." *Artforum* 10 (June 1972), pp. 42–49.

Wassily Kandinsky: 1866–1944. Exh. cat. Munich: Haus der Kunst, 1976.

Wassily Kandinsky: Die Erste sowjetische Retrospektive. Gemalde, Zeichnungen und Graphik aus sowjetischen und westlichen Museen. Exh. cat. Frankfurt: Schirn Kunsthalle, 1989.

Watts, Harriet. "Arp, Kandinsky, and the Legacy of Jakob Böhme." In *The Spiritual in Art: Abstract Painting 1890–1985*. Exh. cat. Los Angeles: Los Angeles County Museum of Art. New York: Abbeville, 1986.

Weiss, Peg. *Kandinsky and "Old Russia": The Artist as Ethnographer and Shaman*. New Haven: Yale University Press, (forthcoming) 1995.

Weiss, Peg. "Kandinsky's Shamanic Emigrations." *Künstlerischer Austausch*. Akten des XXVIII. Internationalen Kongresses für Kunstgeschichte, July 15–20, 1992. Berlin: Akademie Verlag, 1992, pp. 187–202.

Weiss, Peg. "Kandinsky: The Artist as Ethnographer." *Münchner Beiträge zur Völkerkunde* 3 (1990), pp. 285–329.

Weiss, Peg. "Kandinsky and 'Old Russia': An Ethnographic Exploration." In Gabriel P. Weisberg and Laurinda S. Dixon, eds. *The Documented Image. Visions in Art History*. Syracuse: Syracuse University Press, 1987, pp. 187–222.

Weiss, Peg. "Kandinsky and the Symbolist Heritage," *Art Journal* 45 (Summer 1985), pp. 137–45.

Weiss, Peg. "Books in Review." Reviews of Washton Long, *Kandinsky: The Development of an Abstract Style*; Roethel and Benjamin, *Kandinsky: Catalogue Raisonné of the Oil Paintings*, vols. 1 and 2; Roethel and Hahl-Koch, eds., *Kandinsky. Die Gesammelten Schriften. I. Autobiographische Schriften. Art Journal* 44 (Spring 1984), pp. 91–99.

Weiss, Peg. *Kandinsky in Munich: The Formative Jugendstil Years*. Princeton: Princeton University Press, 1979.

Zweite, Armin. *The Blue Rider in the Lenbachhaus Munich*. Munich: Prestel, 1989.

Lenders to the Exhibition

Kunstmuseum Bern

Albright-Knox Art Gallery, Buffalo, New York

Kunstsammlung Nordrhein-Westfalen, Düsseldorf

The Tate Gallery, London

Milwaukee Art Museum

Tretyakov Gallery, Moscow

Städtische Galerie im Lenbachhaus, Munich

The Museum of Modern Art, New York

Solomon R. Guggenheim Museum, New York

Musée National d'Art Moderne, Centre Georges Pompidou, Paris

The Hermitage Museum, Saint Petersburg

Deutsche Bank AG, Frankfurt

Werner and Gabrielle Merzbacher, Küsnacht, Switzerland

Private collections

Photograph Credits